BEST PLACES
TO PHOTOGRAPH
NORTH AMERICAN
WILDLIFE

D0444499

BEST PLACES
TO PHOTOGRAPH
NORTH AMERICAN
WILDLIFE

MARK WARNER

AMPHOTO
an imprint of Watson-Guptill Publications/New York

For my mother

Mark Warner is a professional photographer and writer
whose work has appeared in *Audubon*, *International
Wildlife*, *Natural History*, *Outdoor and Travel Photogra-
phy*, and many other magazines. He has a Master's
degree from Wesleyan University, and has taught high-
school biology and conducted nature-photography
workshops for many years.

Editorial concept by Robin Simmen
Edited by Liz Harvey
Designed by Bob Fillie, Graphiti Graphics
Graphic production by Ellen Greene

The photographs appearing in this book were taken with
Kodachrome 25 or 64, except for the picture on the top of page
150, which was shot with Fujichrome Velvia RVP 50.

Copyright © 1993 by Mark Warner
First published in 1993 in New York by AMPHOTO,
an imprint of Watson-Guptill Publications,
a division of BPI Communications, Inc.,
1515 Broadway, New York, NY 10036

PRINTED IN SINGAPORE

Library of Congress Cataloging-in-Publication Data
Warner, Mark.
 Best places to photograph North American wildlife: how to get there,
 when to go, what to shoot, where to stay and buy supplies / by Mark Warner.
 Includes index.
 ISBN 0-8174-3556-5
 1. Wildlife photography—United States. 2. National parks and reserves—
 United States—Guidebooks. 3. Natural areas—United States—Guidebooks.
 I. Title.
 TR729.W54W37 1993 92-39905
 778.9'32—dc20 CIP

All rights reserved. No part of this publication may be reproduced or
used in any form or by any means—graphic, electronic, or mechanical,
including photocopying, recording, taping, or information-storage-and-
retrieval systems—without written permission of the publisher.

1 2 3 4 5 6 7 8 9/01 00 99 98 97 96 95 94 93

I would like to express my appreciation to the following people for recommending particular areas, for steering me away from others or for just helping out in some way: William Conway, Buff and Jerry Corsi, Terry Eggers, John Green, Darrell Gulin, Richard Hansen, Dorothy and Leo Keeler, George Lepp, Joe McDonald, Bill McRae, Jim Morgan, Leonard Lee Rue, John Shaw, and Glenn Van Nimwegen.

Special thanks to Kent Madin and Baja Expeditions; the Professional Photography Division of Eastman Kodak Company; Kodalux Processing Services; and Nikon, Inc.

Thanks also to Chris, Helen, and Kathy for the word processor; to Helen and Kathy for reading parts of the text and for their suggestions; and especially to Helen, for too many reasons.

CONTENTS

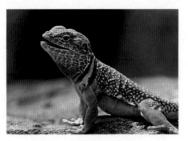

OTHER PLACES OF INTEREST

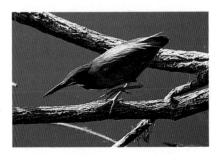

INTRODUCTION

NOT SO VERY LONG AGO, after the light levels had dropped too low for me to take any more photographs, I stood on the edge of a large pond and watched wave after wave of snow geese pass over my head. They were coming in to rest for the night. Tens of thousands of geese had already reached the water behind me. As each group descended the geese broke formation, crazily zigging, zagging, reeling, and tumbling out of the air to a landing. One theory contends that this behavior helps geese break out of the slip stream of the bird in front, but it could also be an expression of the sheer joy of coming to the end of a tiring day's flight. Finally, it became so dark I could no longer clearly see the snow geese as they continued to stream in overhead, but the air still vibrated with the sound of wing beats and geese calling other geese. It was a truly magical experience. &ª There aren't many places left in North America where you can go and see wildlife like this anymore. Much of the wildlife has been shot off, trapped out, victimized by habitat destruction, or otherwise pushed off the land. Most of the animals and birds that are still around are rightfully nervous when humans are in the vicinity. There are, however, some places where animals and birds feel relatively safe and allow people to get fairly close to them. This book is intended as a guide to these areas—the best places in North America where wildlife *can* be found and easily photographed. &ª The idea for this book surfaced during a workshop on nature- and wildlife-photography techniques. Although the participants found the information useful, the question was where could they go to put it into practice. I thought about all the places I'd gone over the years and realized just how few were actually suitable. I joked about it at the time and said I didn't have a list yet, but that someday I would and would put it all in a book. I don't remember who asked the question, but see what it led to!

GETTING THE BEST SHOTS AT THE BEST SPOTS

The United States has about 100 national parks; more than 400 national wildlife refuges; and countless acres of state and private parks and of Audubon, nature-conservancy, national, and state forests. And there are many more parks and forests in Canada and Mexico. But the overwhelming majority of these places aren't suitable for wildlife photography because the animals are too wary or stay out of shooting range for the most part (with the possible exception of using very long telephoto lenses).

I used the following criteria to determine which areas to call the best places to photograph North American wildlife. First, the majority of the wildlife found in each area can be counted on to be there. Second, the animals or birds are able to tolerate people; they don't run or fly away when humans approach or drive close to them. Third, the wildlife in these places can be photographed without having to resort to very long telephoto lenses. Fourth, the areas are relatively easy to get to, and there are places to stay and eat at in the vicinity. The final consideration, and what prevented me from including otherwise excellent places, is that no lotteries or special permits are required for access to the area. All of the places described in the book are public lands or belong to nonprofit organizations.

There are two levels of information in this guidebook. I discuss certain places more extensively because they offer the most in terms of quantity of wildlife or scenic beauty or because the place is unique. And although I cover other areas in considerably less detail, this doesn't mean they are less suitable for good wildlife photography. Some of these areas are superb, but they may call for you to spend only half a day at them and aren't worth planning a vacation around. Other places may be near one of the major areas, so I emphasized it instead because of, for example, better accommodations.

The book also contains an extensive appendix that lists addresses for the appropriate sources of information for all the areas. Write or call and request everything available, such as maps, brochures, chamber-of-commerce information, accommodation listings, and resident-wildlife information. In addition to knowing where to go to photograph North American wildlife, you need to bring the proper equipment, the right kind of film, and adequate support for your camera and lens.

EQUIPMENT AND FILM

My philosophy about photo equipment is simple. I think that it is better to effectively use fewer pieces of equipment than to hope lots of equipment will enable you to shoot better photographs. In other words, simple is best. I also believe that you should buy the finest equipment you can because it will produce better results and last longer than less-expensive brands. It doesn't matter which manufacturer makes the equipment as long as you like it and it is dependable.

LENSES

One exception does, however, apply to my equipment philosophy. Of all the pieces of photographic equipment you get, you should buy the very best lenses you can. You're reproducing something from real life onto a very small piece of film, and the only way to successfully do this is to use the best optics available. In order to photograph wildlife, you'll need a telephoto lens. Unfortunately the longer the focal length of the lens, the more critical the quality of the optics is. This is because the lens will magnify any imperfections.

Another consideration is the type of glass found in today's lenses. Although optical glass is fine, you should think about buying a lens with the newer, extra-low-dispersion (ED) glass if you want the very best. These lenses cost considerably more but reproduce the three colors of light better and are noticeably sharper, especially when you use them wide open.

And speaking of aperture, you might be wondering if the faster telephoto lenses are worth their high prices. It isn't unusual for a one-stop-faster lens to cost twice as much as its slower counterpart of the same focal length. Some people argue that it is better to buy the less-expensive, slower lens and use a faster film to compensate for the lost light, while others argue that the extra stop of light passing through the faster lens permits them to shoot in dimmer light. If

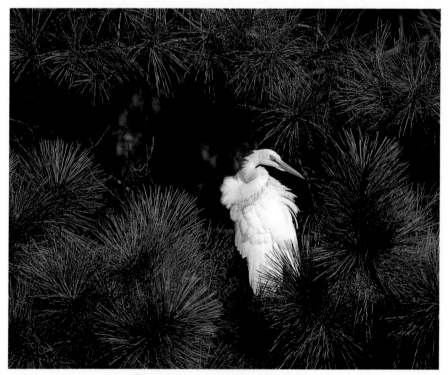

Great egret in a pine tree in Chincoteague.

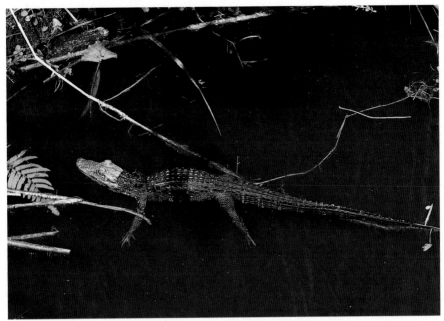

Baby alligator swimming in the Everglades.

you can afford to, buy the faster lens. If you can't, and you can't wait until you can afford the faster lens, buy the slower one and use a faster film.

How long a telephoto lens should you get? The answer depends on what you like to photograph. If the majority of your subjects are large and easy to approach, you won't need the longer lenses; a 200mm lens will suffice. For other subjects keep in mind that not only can a longer lens bring distant subjects closer, but also the longer the lens is, the farther away you can be. And as a result, most wildlife will act more naturally. If you already have a 200mm lens (or a 70-210mm zoom lens), you'll find that the jump to a 300mm lens isn't that great. So I would suggest that you get a 400mm lens. If you don't have a 200mm lens, you might want to consider a 300mm lens. You'll find that it is much easier to use than a 400mm lens. Furthermore if you approach wildlife slowly or use a photographic blind, you can get the same picture you would if you had a 400mm lens. In fact, I shot the majority of photographs for this book with a 300mm lens.

CAMERA AND LENS SUPPORTS

You can have the best lenses, use the proper film, and do everything right, but the results can still be miserable if your camera-and-telephoto-lens support system is lacking. The problem is that longer focal lengths magnify not only the image, but also any camera movement. So of all the pieces of equipment that can improve the quality of your photographs, a decent tripod heads the list.

Nevertheless, I can't tell you the number of times I've seen very long lenses perched on top of flimsy tripods. I wish that I had the chance to see some of the resulting pictures. I bet that most of them go into the wastebasket or that the photographer's standards are a lot less demanding than mine. Unfortunately many people don't want to carry around a good tripod because of the relationship between weight and effectiveness.

My favorite camera-and-lens support is a wooden Carl Zeiss surveyor's transit tripod that I bought used for $85 dollars. It weighs 12 pounds without a head and even I don't like to carry it any distance. But this tripod is sturdy! When not lugging around the woodie, I use one of the two Gitzo tripods I own. You probably see more wildlife photographers using this French product than all others combined. Obviously there must be good reasons for this popularity; I think it is a combination of sturdiness and quality. Regardless of which manufacturer's tripod you select, keep in mind that heavy is best.

The better tripods don't come equipped with a head because your choosing one is a matter of personal individual preference. There are two types of heads, and both options are popular. With the monoball, the camera is mounted on top of a large metal ball. The idea behind the single locking device is that since you have only one control to fuss with, a monoball is simpler and quicker to use than a pan-tilt head. This other type of head has three locking handles that control horizontal, vertical, and tilt axes. Like tripods, the bigger and sturdier the head, the better.

I prefer the pan-tilt head over a monoball head because I find that it gives me more control over the lens and camera. By leaving the locking controls slightly loose, I can override them in order to change the camera position. One of the most popular pan-tilt heads is the Bogen 3047. It is reasonably sturdy, has conveniently short handles, and features a quick-release plate that allows fast changing of lenses.

Regardless of the tripod and tripod head you decide on, you need something else in order to get especially crisp images with longer lenses (400mm and up). Most photographers develop a critical lean or pull-down technique to further steady the camera. By leaning or pulling on the camera, in effect, they're making the system heavier and therefore steadier. The result: better pictures. Some people hang bags filled with water or sand over their lenses to get this extra support, but I find such bags awkward to use and carry around.

Of course there are times when using a tripod isn't convenient, such as when you're shooting from inside a car being driven along a road near wildlife. You might find that the animals will stay around longer if you remain inside the vehicle. A window mount usually works well in this situation. This device, which is available from a variety of sources or which you can build yourself, rests on the window frame and has some means of attaching the camera to it. Another method, and my favorite, is a simple beanbag. I use a medium-sized

leather pouch filled with about 1½ pounds of split peas. Although I've used it for many years, it is still holding up. I generally lay the beanbag on the window ledge and then nestle the lens and camera into it. Also, if I can get out of my vehicle without scaring away the wildlife, I place the beanbag on top of the car. Once again it provides an exceptionally steady platform.

FILM

I think that if you're going to portray any sort of wildlife on film, you should show as much clear detail as possible. To do this the film should be as fine-grained as you can handle. Keep in mind that the smaller the grain, the sharper the image. Since you'll be taking pictures of wildlife, why not go for the best renditions of your subjects possible? The finer grain is found in the slower films. My favorite film is Kodachrome 25, and I use it as often as I can. Sometimes, however, another stop of light is necessary, so I switch to my "fast" film, Kodachrome 64. Why slide film? Because that is what the magazine industry prefers (except for black-and-white print film). In addition it has the best stability in terms of longevity and is convenient to work with, and the resulting images are easy to store.

The same principle about grain versus image sharpness holds true for print films. I think that a film speed of ISO 100 is fast enough to get practically anything you want on film, and your photographs will be noticeably sharper than pictures taken with a faster but grainier film.

After selecting the proper film, you have to think about its processing. Many people send their film to a cut-rate processor in order to save some money. There is nothing wrong with that if being economical is your main concern, but you should ask yourself why XYZ Photo Lab is less expensive. Usually the reasons are because the lab's quality control isn't as stringent as that of more expensive labs, the lab runs more film through a batch of chemicals, and the temperature requirements aren't as stiff. If you want the very best results from whatever film you use, send it for processing to the manufacturer or to a first-class independent processing lab. When I travel, I prefer to send my film in for processing as soon as possible. A convenient method is to use a mailer for that particular film. I don't have to carry the film back with me, I don't have to hand it over at airport check-ins, and sometimes I find it waiting for me when I return home. If you want your film back in a real rush, the fastest way to get film to a processing lab is to use an overnight service with Federal Express, the United Parcel Service, or the Postal Service. If you include the appropriate fees, most processing labs will return your film the same way with the same carrier.

I've rarely needed such fast service. I usually send my film in for processing in mailers via Priority Mail at the nearest post office. For $2.90 you can send up to 2 pounds of film in mailers; this is about 20 rolls. This is much safer and less expensive than sending in each mailer separately. You can use either the Postal

Service's Priority Mail envelope or a small carton. For safety reasons, I always place one of my address labels on every film cartridge I trust to the Postal Service. While none of my film has been lost or damaged over the years, accidents can and do happen. I like to think that if a shipping container is damaged or even if the film canister itself is lost, at least someone will know who the film belongs to and, perhaps, return it.

THE ETHICS OF SHOOTING

Before you go on your next wildlife-photography adventure, you should give some thought to photographic ethics. First, you need to consider the wildlife itself. All animals and birds have certain tasks that they must do each day: feed, rest, and care for their young. As responsible human beings and photographers, we have no right to affect this behavior for our own gains. Throwing things, waving our arms, or using other means to get animals and birds to move or otherwise alter their actions is frowned upon. All the places discussed in this book are protected havens for wildlife, and the penalties for ignoring protection-enforcement policies range from fines to expulsion from the grounds. Most animals will exhibit all the activity you could possibly ask for if you just let them alone and wait for them to exhibit it. The relationship between humans and wildlife in refuges is of increasing concern as more harassment takes place.

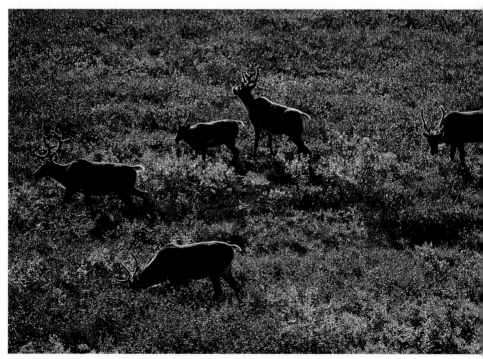

Caribou grazing at Denali National Park and Preserve.

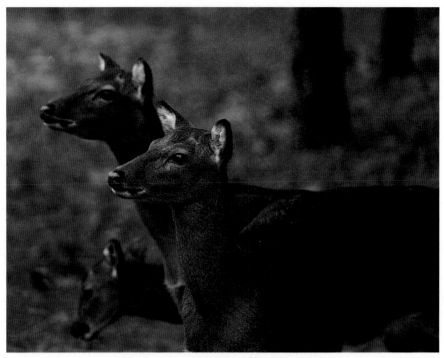

Sika deer along the refuge road in Chincoteague.

Many refuges are shortening their visiting hours in order to allow their wildlife more time to themselves. If you happen to witness harassment of wildlife, report the situation to the proper authority.

The second ethical consideration I want to mention involves an unwritten code of behavior among photographers. A photographer working with a particular animal might have spent considerable time locating it and waiting for better light or for a certain type of behavior. In most cases the animal becomes used to that person's presence. Your arrival can scare the animal away as well as incur the wrath of the photographer! As a matter of simple courtesy, don't rush up to or barge in between a photographer and a subject. Most photographers will recognize your desires and signal you to either join them or wait a little longer.

So now you know where the idea for this book came from, and you have some suggestions for the right film and equipment to use. You are all set to visit one or more of the best places to photograph North American wildlife—and you should get some great pictures!

ARIZONA-SONORA DESERT MUSEUM

F OUNDED IN 1952, the purpose of the Arizona-Sonora Desert Museum (ASDM) is to educate people about desert life. Because the plant and animal habitats are so intertwined, the museum exhibits both. There are about 200 species of animals and more than 400 species of plants here. The plants are in separate displays; some grow naturally on the grounds, and others are mixed into the animal enclosures. Again it is impossible to tell what has been planted and what is part of the desert grounds. Most of the animal enclosures are constructed in such a way that the inhabitants don't seem to be confined. With the extensive use of native plants and the many artificial rock formations (many are cast from originals in the desert), you have the feeling that you are actually in the Sonoran Desert. For these reasons, the ASDM is consistently referred to as one of the 10 best zoos in the United States, if not the world. About 600,000 visitors come each year.

SHOOTING A DIVERSITY OF DESERT DWELLERS

I've always wanted to visit the ASDM, and when I finally managed to get there, I wasn't the least bit disappointed. First, all of the animals found at this museum are alive—not stuffed—and are native to the area. Also, you see more Sonoran Desert wildlife in one day's visit to the ASDM than you would in a lifetime on your own in the desert, partly because some of the animals at the ASDM are now extinct in the wild. I was also impressed by the grounds themselves at the ASDM, which are actually out in the desert. The blending of artificial and natural settings is so well done that it is difficult to tell the difference between the manmade and the real areas. Much of the ASDM isn't even fenced off from the surrounding desert, and such wild creatures as rabbits, snakes, coyotes, small rodents, lizards, and various birds continually wander in and out of the grounds. It is hard to to tell what actually belongs in an exhibit and what doesn't. In fact, the ASDM is so realistic that zoo and museum curators from around the world come to study the construction design.

GETTING THERE

 The ASDM is situated about 14 miles west of Tucson in the southeastern part of Arizona. Route 89 leads directly from the airport to downtown Tucson. The quickest way to reach the ASDM from Tucson is to go over Gates Pass. Follow Speedway Boulevard west toward the Tucson Mountains. The twisting, two-lane road over Gates Pass is narrow and climbs quickly up and over the mountains. Fallen rocks are often a hazard. For safety reasons both vehicles towing anything and large motor homes are prohibited from using the pass. There are a few turnoffs on Gates Pass as well as a rest area with hiking trails at the top.

After descending Gates Pass, the road winds around for a bit and finally comes to a dead end at Kinney Road. Make a right on Kinney Road. The museum entrance is a mile or so on the left. It is difficult to see the museum grounds from a distance because they blend so well into the Sonoran Desert itself.

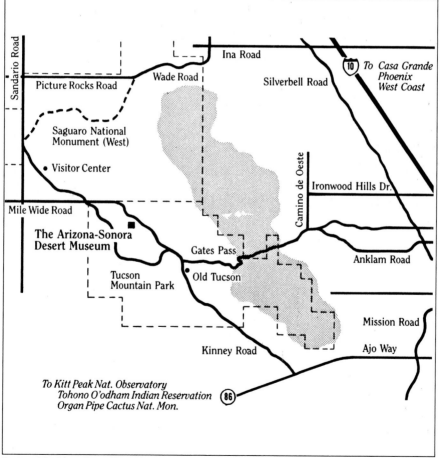

Courtesy of the Arizona-Sonora Desert Museum.

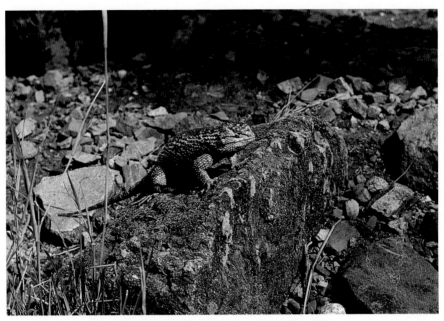

Lizard enjoying the morning sun in the Lizard Pit.

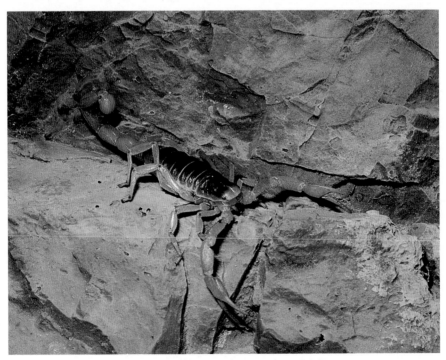

Giant hairy scorpion in the Invertebrate Exhibit.

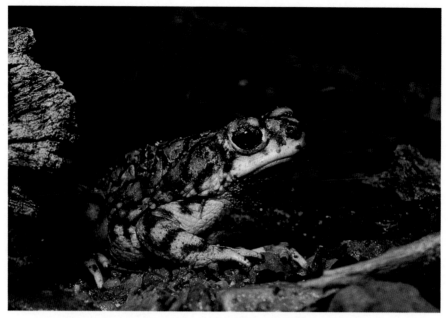

Sonoran green toad in the Entrance Building, photographed through glass.

NEAREST AIRPORT

Tucson International Airport is located about 10 miles south of Tucson and is served by most major airlines. Taxi, limousine, and bus services to the airport are available.

CAR RENTALS

Practically all the standard car-rental agencies can be found at the Tucson International Airport. Keep in mind that Tucson is a popular travel destination, so it is advisable to reserve a car either through a travel agent or directly through an agency.

EXPLORING THE MUSEUM GROUNDS

 The grounds occupy 15 developed acres on a 186-acre plot leased from nearby Tucson Mountain Park. The museum and park are part of the vast Sonoran Desert, which comprises 120,000 square miles across southwestern Arizona, southeastern California, Baja (Mexico), and part of northwestern Mexico. One of the four deserts in North America, the Sonoran is distinguished by having the most extensive variety of plants and animals. It is actually considered one of the richest biological regions in the world. I always thought of deserts as being hot and sandy places until I saw the Sonoran; it includes woodland, prairie, meadow, mountain, pond, and stream habitats. Most Sonoran Desert soil is composed of coarse sand and gravel. The more than 1,500 plant species found in the Sonoran support a vast range of animal life.

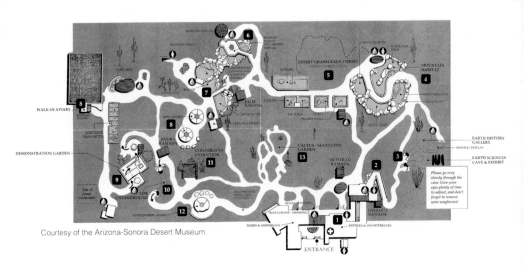

Courtesy of the Arizona-Sonora Desert Museum.

Surprisingly few buildings make up the ASDM proper; the two main ones are the entrance building and the saguaro-cactus exhibit. The rest of the museum includes two underground areas, a mountain habitat, a grotto habitat, two aviaries, a wonderful cactus garden, some enclosures for large birds, a riparian exhibit, and a series of wire enclosures. (These wire enclosures are referred to as "chain link alley" and are scheduled for removal to new habitats in the near future—see page 21.) And to simplify the the process of recognizing the wildlife, the genus and species of each animal and bird are identified.

After leaving the parking lot, you first pass through the fairly large entrance building. This houses the amphibian and reptile exhibits, lizard pit, museum offices, gift shop, restaurant, and restrooms. The jaguar enclosure is attached to the entrance building but will be moved into a new location in the very near future. A quick tour of the exhibits in the entrance building lets you know that there is indeed life in the desert. In fact, you're confronted with desert life even before you pass through the pay booth. You have to walk by a large pit that encloses a variety of lizards. Only a low wall keeps these agile animals inside. Of course, this exhibit is quite popular.

A variety of snakes, frogs, turtles, spiders, and insects is found naturally in the Sonoran Desert, and these creatures are attractively displayed inside the entrance building. In addition, several species of fish are found in large tanks. You might wonder about fish living in the desert, but you have to remember that the diverse habitats found in the Sonoran include ponds and rivers.

When you leave the entrance building, swing to the right and follow the signs to the Earth Sciences Cave. This replica of a limestone cave is a cool, dark tunnel that takes you through 500 million years of the earth's history. The walk is mostly downhill on a smooth concrete floor that winds its way through various rock formations. Again the cave is artificial, but it looks so realistic that

native bats and pack rats have moved in. In addition to the geologic formations, there are live exhibits, including a pack-rat nest and an underground stream and pool complete with cave-dwelling fish. Toward the end of the cave is a large room containing an excellent mineral collection.

After you leave the Earth Sciences Cave (or bypass it above ground), the next major section of the ASDM that you come upon is the Mountain Habitat. It represents the mountains of the Sonoran Desert that rise abruptly from the desert plain and extend to 4,000 feet or higher. This exhibit consists of four separate enclosures that contain at least one or two typical inhabitants: mountain lions (or pumas), bears, wolves, deer, and wild turkeys.

The next stop is one of the more popular exhibits, the Prairie Dog Colony, or Town (it is scheduled to be incorporated into a new grasslands exhibit in 1993— see below). Prairie dogs build burrows that are marked by low mounds surrounding the entrance. These mounds serve as dams to keep flood waters out; they also give the prairie dogs some elevation, which is necessary for keeping watch. The animals take turns on top of the mounds searching for predators, which are primarily hawks. When a prairie dog perceives a threat, it utters a shrill whistle; this is a signal for all of the prairie dogs to disappear underground.

Next to the Prairie Dog Colony is the "chain link alley" destined for elimination. As of this writing construction of a new grasslands habitat is scheduled, and the animals will be moved. When construction is complete, there will be a large prairie-dog town, a burrowing-owl aviary, coyotes, and badgers. At present javelina, coati, mule deer, kit fox, and coyote are in large, chain-link enclosures. Although it is possible to shoot some good photographs here, the animals are often hidden by vegetation or go inside to escape the desert heat.

I found the Small Cat Grotto to be one of my favorite spots at the ASDM. The four exhibits house margays, ocelots, jaguarundis, and bobcats.

Despite the difficulty of associating rivers with a desert, the Sonoran Desert does have rivers. And, in turn, the museum has a Riparian Habitat (the word "riparian" means river bank). This excellent exhibit has two large pools that contain river otters, beavers, an assortment of ducks, as well as whatever wanders by. I saw a roadrunner and several wild birds drop in.

The Bighorn Sheep Exhibit is another favorite of just about everyone who visits the ASDM. Realistically constructed of concrete, the exhibit houses about six of these agile rock dwellers. The access path leaves you at eye level with the upper section of the exhibit, and a short set of stairs brings you to the lower level.

The Aviary at the ASDM isn't the largest in the world, but it is considered one of the best. There are more than 40 species of birds, all of which are native to the Sonoran, and an extensive collection of native trees and shrubs. A paved path wraps around the aviary in a loose oval and provides a couple of places where you can sit down and watch the birds. And a small stream winds through the aviary.

Another section of the ASDM reveals a technique some desert dwellers use to escape the sun; they tunnel or burrow underground where it is cooler. The Life Underground Tunnel accurately displays this type of survival. You enter a tunnel that takes you underground past several glassed-off dens and burrows. Behind the glass you can see kit foxes, bats, pack rats, snakes, and geckos. What you might not realize is that each burrow or den is actually connected to the ground above. The inhabitants are free to pursue their typical nocturnal activities outside whenever they want. However, the surface-level areas are enclosed so that the animals can't leave the museum grounds.

HOW TO PHOTOGRAPH THE WILDLIFE

Photographing wildlife at the ASDM is relatively easy in terms of the availability of the animals because they're trapped and used to having people around. Since the exhibits are so realistic, you can readily utilize the surrounding vegetation, rocks, and other background elements to show the inhabitants in natural settings. In addition visitor access to the animals is outstanding, with low walls for photographers to shoot over. And because the inhabitants are captive, they are often asleep or hidden from view behind a natural feature. Keep in mind that most of the animals are more active during certain times of the day. If you experience any difficulty photographing a particular animal, check with a docent or handler to see if there is a better time to visit that exhibit.

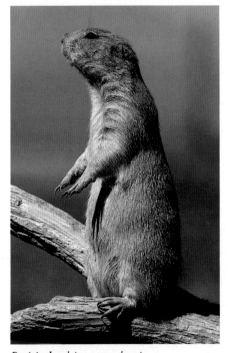

Prairie dog doing sentry duty in the Prairie Dog Colony.

As you begin to shoot, you'll find that Gates Pass is quite photogenic. Early-morning or late-afternoon light is best for picture-taking. The small parking lot at the bottom of the west side is a good spot for watching and photographing sunsets over the desert mountains and is usually crowded with people at that time of day. Picnicking seems popular, and as the sun sets a noticeable hush falls over the area. Watching a sunset at Gates Pass can be a moving experience.

In the entrance building, the lizard pit can provide a perfect opportunity for some great pictures. Shaped in a half circle, the pit is surrounded by a low wall that keeps the inhabitants inside the enclosure and is convenient

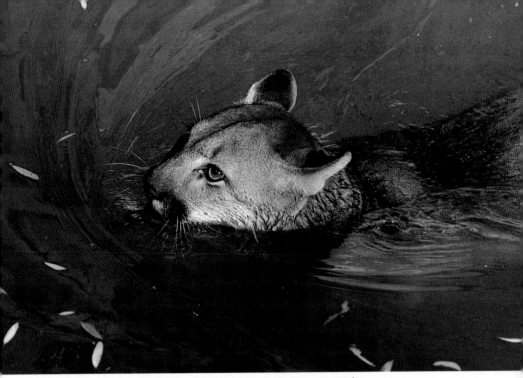

Mountain lion swimming in the Mountain Habitat.

for shooting. You can use a tripod here or simply the wall with a beanbag on it for additional support. The lizards are generally within 5 or 6 feet of you, so flash photography is another option.

All the other exhibits, which are to the right and the left of the main entrance, are behind glass. This arrangement, of course, presents some photographic difficulties. Here are my guidelines for simple glass-tank photography. First, place the lens right up against the tank. This eliminates any reflections from bouncing off the glass and entering the lens. Also, keep the lens flat to the glass to reduce distortion. This is especially important if the tank is full of water (not all tanks are because many house amphibians in a terrarium type of exhibit).

Second, use electronic flash. It is impossible to tell what kind of lighting is used in the tanks. It can vary from incandescent to fluorescent, and it can even be a mixture. Flash cancels out the existing lighting and is a known color balance for daylight film. I usually place a single flash slightly above and a bit to the left or right of the lens. Put the flash right up against the glass, too. If you don't do this, the majority of the light will reflect off the glass. Angle the flash down to illuminate your subject. I use a short PC cord to connect the flash to the camera. Hotshoe flash mountings generally don't work. All you'll get is a big glare spot in the middle of an underexposed picture.

Before spending any time and film on glass-tank photography, make sure that the tank you're planning on shooting isn't a double tank. A couple of exhibits at the ASDM utilize a second glass plate in front of the actual tank. The purpose is

to form an air barrier to reduce condensation if the exhibit's temperature is significantly different from that of the viewing area. You can place the flash up against the outer glass only. Then when the flash fires, the light passes through this outer pane but merely reflects off the front of the actual tank glass. The results can be disappointing to say the least. If you discover a double-glass tank, try aiming the flash straight into the tank by placing the flash unit alongside the lens. This should drive the light straight through both panes of glass.

How can you tell if a particular exhibit has single or double glass? A careful look around the edges of the tank often reveals the two seams of the double-glass tank. Also, see if there is any condensation between the glass surfaces. If you are still in doubt, locate one of the museum workers and ask. Finally, you have to consider lenses. Good lens choices are 50mm and 100mm macro lenses because the subjects are close to the camera and are relatively large. Depending upon the subject, even a standard lens can work well in glass-tank exhibits.

Generally photography in the Earth Sciences Cave also requires the use of flash because it is quite dark underground. One notable exception in this exhibit is the mineral display. The entire setup is illuminated with incandescent rather than fluorescent light. Although this section appears to be bright, in reality it isn't, so a tripod and cable release are necessary for long exposures. Meter off a neutral-color mineral display, and then bracket. The magnificent colors of some of the various minerals should reproduce well.

The enclosures in the Mountain Habitat are situated so that they are in shade during the afternoon. As a result, shooting during the early-morning hours provides the best natural light. Knowing this, I spent every day of the week I was at the ASDM visiting the Mountain Habitat first. Not only is the light better, the animals are more active first thing in the morning. By afternoon it usually gets pretty hot, and the animals sleep in the shade or go inside out of sight. Photographic access to the habitat is great because there are no tall fences or bars that you have to get a lens through. Although you're separated from the enclosures by a low iron fence, you'll find that it is very easy to photograph the wildlife using either a beanbag on top of the fence or a tripod.

Similarly at the ASDM, prairie dogs are so used to people that they are continuously above ground, which makes capturing them on film easy. In the wild, however, photographing prairie dogs can be difficult because they disappear into their burrows as soon as you approach.

Each of the four exhibits in the Small Cat Grotto is fully open at the top, where there is a visitor walkway. I didn't have much success shooting from above because of the poor camera angle, but an underground viewing area provides excellent access to the cats. Each enclosure has a large plate-glass viewing area as well as a large opening laced with thin vertical wires. A small electric fence just inside the frame prevents the cats from getting out. There is plenty of room to get a lens close to the wire spaces and shoot without any restrictions. I had the

most luck photographing the jaguarundis, ocelots, and bobcats. The margay was raising a kitten at the time and stayed well hidden back in the cliffs. As with the Mountain Habitat, I found that the light was best in the morning. My routine was to shoot at the Mountain Habitat first and then to scoot over to the Small Cat Grotto.

In the Riparian Habitat both the otter and beaver pools have underwater viewing ports, so you can watch what goes on from below the surface of the water. But when I realized that you have to shoot down on the otters, I decided not to try. I thought the angle was a poor one. In addition otters are pretty active underwater, although it might be possible to get some decent underwater shots with fast film. There is much better access to the beaver pool, which you can shoot from about surface level. This access is from the shaded remada of the Bighorn Sheep Exhibit next door.

In the wild you have to work pretty hard to make good shots of handsome bighorn sheep, but at the ASDM they are easy to achieve. The sheep enclosure has two levels. The upper area provides an excellent view; you look straight across at the sheep. A flight of stairs leads to an underground viewing area with a large barred opening. Bighorn sheep love to climb, and their quarters provide plenty of space for them to do just that. They seem to be active most of the day, so you don't have to rush there first thing in the morning. But remember, the light isn't good late in the day.

Shooting in the Aviary isn't easy despite the availability of its inhabitants. First, the coarse netting of the Aviary itself results in a loss of one stop of light. Another problem is the contrast between the bright Arizona sun and the shade created by tree and shrub leaves. In addition the birds are in continual motion flying around inside the Aviary. Finally, I was able to find a sunny branch against a good background. So I set up my tripod and waited for subjects to come to me! A cloudy day or even a cloud or two would have helped to minimize the contrast problem.

In spite of these difficulties, the Aviary is a great spot for bird photography. Here is a partial listing of the birds I saw when I was there: cactus wrens, cardinals, thrashers, quails, bobwhites, doves, hummingbirds, tanagers, sparrows, killdeer, buntings, bluebirds, and orioles. I also saw several species of native birds as well as some rather tame mice running around and trying to get into the Aviary!

I had a wonderful time in the Life Underground Tunnel, too. No one else visiting the ASDM that day seemed to realize that this exhibit existed—it is hard to find—so I had the place to myself for about an hour. The exhibit is hard to notice because its entrance lies off to the side of the main path. (And I think that by the time most visitors reach this side of the museum grounds, they're thinking about lunch and rush right by.) The animals enjoy this cool retreat either by sleeping or just being quiet. Since their dens are small, they

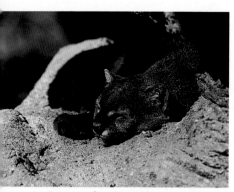

Jaguarundi resting early one morning in the Small Cat Grotto.

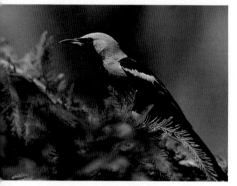

Hooded oriole perching on a shaded shrub in the Aviary.

can't move around much. In addition they have the security of being behind glass. To compensate for the very dim light, I used electronic flash following the techniques I employ for glass-tank photography. With this recommended flash technique or an effective one of your own, you should be able to shoot good picture of creatures that are ordinarily unavailable.

Some other exhibits are also worth checking out, such as the three separate enclosures for vultures, owls, and hawks. Although I wasn't able to eliminate the very fine wire-mesh screening from my pictures, a number of the ASDM volunteers, or *docents*, brought a few of the inhabitants out of their enclosures, including some of the larger birds. This gives visitors an opportunity to get their pictures. Check the schedule at the museum entrance for specific viewing times. The docents are also around to answer questions or to provide other forms of assistance.

In addition to the hummingbirds in the Aviary, the ASDM has a smaller, separate aviary just for "hummers." More of these little flitters are found in southeastern Arizona than anywhere else in the United States. Around eight species are found in this aviary, which is considered to be the finest of its kind anywhere. The more common hummingbirds are free to fly around in the aviary while the rarer ones are in separate flight cages. The aviary is full of plants that hummingbirds like. And the birds even nest in the shrubbery, often in full view. A hummingbird garden located outside the aviary attracts native species that might be in the area.

If you like to photograph flowers, be sure to visit the cactus garden. More than 140 species of native cacti and other succulents can be found here, many in bloom. As with the animals, the genus and species of most of the plants are indicated, which takes the guesswork out of identifying them.

PHOTOGRAPHIC EQUIPMENT AND FILM

 Despite the small size of the ASDM, I seemed to spend a great deal of energy lugging equipment around. In addition to the burden of my gear's weight, I had to contend with the weather, which can get quite

Bighorn sheep in the desert-like exhibit.

hot in Arizona. I suggest renting a baby stroller for your gear; strollers are available at the entrance building.

In terms of lens requirements, a good 200mm or 300mm lens works fine at the ASDM. Longer lenses might be better, but you really don't need them. If you have a little patience, you'll find that most of the museum inhabitants eventually wander close enough so that you can effectively use shorter lenses. I also recommend a macro lens of some type, especially if you like shooting closeups. Cactus flowers, amphibians, reptiles, and minerals, for example, lend themselves to this type of photography.

The only filter I used at the ASDM was a polarizer, for some of the outdoor exhibits. And I always haul a tripod of some sort around with me, so I was prepared at the ASDM. The tripod came in especially handy for my camera setup in the aviary where I had to wait until a bird landed on a particular branch. My tripod was also necessary for longer exposures of a couple of animals in the shade and of the mineral exhibit.

PHOTOGRAPHIC SUPPLIES AND REPAIRS

If you happen to be at the museum and run out of film, you'll be relieved to know that the gift shop carries Kodachrome 64; Ektachrome 100; the usual assortment of Kodak print films with film speeds of ISO 100, 200, and 400; and a limited supply of batteries. For other needs, you can go to one of the two dozen or so photo-supply stores in Tucson that carry Canon, Minolta, Nikon, Olympus, and Pentax equipment. Check the *Yellow Pages* for locations.

For camera repairs, you have several choices. Tucson Camera Repair is the only Nikon factory-authorized camera-repair facility in that city (see page 183). Unfortunately, I had to call one of the repair shops. I am, of course, very careful with all my equipment and was more than dismayed when I managed to drop my Nikon F2 and 55mm macro lens onto the slate-floor entrance to the ASDM. The camera and lens landed with a crash loud enough to be heard by several museum visitors. In a confident voice I said, "Not to worry, folks. It's a Nikon." But inside I wasn't feeling so calm. I picked up my camera and carefully checked it out. There was no apparent damage but to be on the safe side, I took it to one of the listed repair shops. The staff looked it over right away, found the metering and shutter-speed indications to be within Nikon's specifications, and sent me on my way. I was very lucky. (After this incident, however, the camera produced a little glitch now and then, and I finally had to send it in for some internal repairs.)

THE BEST TIME TO VISIT

 Tucson boasts of 360 days of sunshine a year, and many local people would pretty much agree. But the summertime brings on the true desert heat, which is pretty uncomfortable and can wreak havoc with

slide films. The animals stay in the shade and are hard to photograph at best. The busiest months at the museum are March and April, but high numbers of visitors aren't really a problem. In fact, the grounds seem to swallow them up with ease. And if you arrive early in the day, you shouldn't have any trouble with crowds.

If I had to pick a time, I think I would choose between mid- and late April. The animals' coats are good, and it hasn't gotten really hot yet. In addition many of the desert wildflowers are in bloom and are lovely.

I want to point out here that school groups do visit the museum but are under the strict control of an ASDM docent. In fact, the group that was there when I was turned out to be one of the best-behaved school groups I've ever run across at any museum or zoo.

HOW LONG TO STAY

 A visit of four to five days is a good time frame to work with. There is so much to see at the ASDM and the surrounding area that you can easily spend that much time here. You might even want to plan on staying a full week. I routinely was at the entrance when the museum opened its doors in the morning and worked until late morning. Then I left the grounds to check out some of the other attractions in southeastern Arizona. Once in a while I returned to the museum for an hour or so late in the day.

LODGING AND DINING

 Tucson is an attractive city of approximately 500,000 residents. All kinds of lodging and a wide variety of restaurants are available. And if you like Mexican food, Tucson is a great place to be! For an informative visitors' guide, simply jot a short note to the Metropolitan Tucson Convention and Visitors Bureau (see page 183).

Gilbert Ray, the closest campground to the ASDM, is located about 3 miles east of the museum just off Kinney Road. The 130 campground sites are laid out around the Sonoran Desert cacti and shrubs. Most have electricity, and there are water faucets at many locations. Gilbert Ray can accommodate tents and recreational vehicles (RVs). There are toilets but no showers. The Catalina State Park Campground is about 10 miles north of Tucson on Route 89. This campground has 50 sites and can accommodate both tents and RVs.

NEARBY PLACES OF INTEREST

 There are so many other places of interest around Tucson that it is impossible to list them all here. I particularly liked the following attractions.

The **Saguaro National Monument** consists of about 84,000 acres of the Sonoran Desert that are characterized by large saguaro cacti. The monument is split

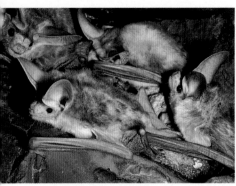

*Pallid bats in the Life
Underground Tunnel.*

into two sections; these are separated by the city of Tucson. Saguaro East is the larger of the two and is higher in elevation. It is referred to as the Rincon Mountain District. There is a visitor center and an 8-mile paved loop through the desert. Because of the altitude, other plants, trees, and shrubs are able to grow in Saguaro East.

Saguaro West, also called the Tucson Mountain District, features an especially dense stand of giant cacti. The entrance to Saguaro West is only 2 miles west of the ASDM. There is a visitor center and a paved road through part of the preserve. A well-maintained 6-mile-long dirt road passes through some of the denser saguaro cacti and provides access to hiking trails and scenic overlooks. Try the little trail that is adjacent to the visitor center and weaves through a well-labeled cactus garden.

Mount Lemmon is located in the Coronado National Forest northeast of Tucson. A steep mountain road winds up from the hot, dry desert to a coniferous forest at a cool altitude of 9,000 feet. Although the highway is only 35 miles long, you should plan on setting aside at least half a day in order to drive to Mount Lemmon and back.

Sabino Canyon is also in the Coronado National Forest, just outside Tucson. The only access to the canyon is by shuttle bus from the ranger station next to the parking lot. The canyon is a popular spot because of its impressive cliffs, boulder-laden stream that runs alongside the shuttle-bus route and very pretty scenery. Stops along the way provide photographic opportunities, as well as perfect places to hike or enjoy a picnic lunch.

Old Tucson, located a few miles east of the ASDM, is a famous movie studio. The town is a re-creation of Tucson in the late 1800s. More than 100 movies and many television shows were made here; today, in fact, many commercials are filmed at Old Tucson. The studio is open to the public daily and you might like to know that there may even be some filming going on.

Puma Air Museum is one of the finest museums for aviation buffs in the United States. It is located just east of Tucson, across from Davis Monthon Air Force Base. A buff myself, I spent a wonderful half day or so wandering around the more than 150 aircraft from World War II and the Korean and Vietnam wars. Inside the center building is a carefully preserved B-17 as well as plenty of bomber memorabilia.

Getting farther afield from the Tucson area is **Madera Canyon**, considered one of the birding hot spots in the country. To get there take Route 19 south from Tucson and then follow the signs. The canyon is known for humming-

birds; just check the feeders at the Santa Rita Lodge. The Bog Springs campground, also located nearby, is part of the Coronado National Forest.

If you have any interest in the mining that played an important role in Arizona's history, block out an afternoon and run down to **Bisbee**. This old copper town is about 100 miles southeast of Tucson near the Mexican border. To get there from Tucson, take Interstate 10 east and Route 80 south through Tombstone, another well-known historical site. Bisbee is still inhabited and is a great place to visit. There are many shops and historic buildings. The old open pit mine lies next to the town, and there are tours down into it. I took a fun and informative underground tour of the old Queen Mine.

Here is a brief list of a few other attractions. Tucson's **Reid Park Zoo** is small but has some good exhibits. I found the Grasslands Exhibit the best for photography. The **International Wildlife Museum**, which is on the way to the ASDM in Tucson, is basically a building filled with stuffed animals. It has some excellent dioramas, but I feel there is too much emphasis on trophy hunting. The **Tucson Botanical Garden** is dedicated to the display and propagation of native plants, and I spent a pleasant morning there. Just east of Tucson is **Colossal Cave**; possibly the largest dry cave in the world, it can be an ideal place to escape the hot Arizona sun. Farther east is the **Chiricahua Wilderness**, one of the premier bird-watching areas of the United States. Although I drove and hiked around, I didn't spend as much time there as I wanted to and took no pictures. Finally, about 100 miles west of Tucson is the **Organ Pipe National Monument** with its scenic dirt-road access, campground, and visitor center.

Saguaro National Monument cacti at sunset.

BAJA, MEXICO

I T IS TO THE WESTERN, or Pacific, coast of this warm and mostly uninhabited place that the gray whales come, seeking out protected bays and lagoons. This is where they give birth to their young and rear them until they are strong enough for the migration to Alaska. Gray whales have the longest migration of all the whales; extending from the Bering Sea off the coast of Alaska to Mexico, this annual round trip is about 10,000 miles long. When gray whales are seen off America's West Coast, they are in the process of migrating. You can often spot the whales from shore, even without binoculars. Whale-watching boats all along the coast can bring you closer to the whales, but they are in a hurry to get to Mexico and aren't anxious to pose for pictures. After the whales reach their southern destination, they remain in relatively small geographic areas and can be easily photographed. These are the gray whales that people have actually been able to touch. And if you can get that close, you certainly should be able to shoot some decent photographs! ❧ The west coast of Baja has only three areas suitable for gray whales: Magdalena, or Mag, Bay; San Ignacio Lagoon; and Scammons Lagoon. They are under the strict control of the Mexican government. Of the three breeding areas just Mag Bay and San Ignacio Lagoon are accessible by tour boat, and special permits are required. Boats are currently forbidden to whale watch at Scammons Lagoon, which is located about 250 miles to the north of Magdalena Bay. Other restrictions apply to the Baja area as well. Only a specified number of boats is allowed in the area at one time, and the number of whale-watching skiffs setting off from these boats is also limited. ❧ The southernmost breeding area is Mag Bay, about 200 miles north of the tip of Baja. This area is formed by a series of offshore islands and is one of the largest deep-water bays in the world. About 250 miles north of Mag Bay is Scammons Lagoon, where the whales are protected. ❧ San Ignacio, the third lagoon, lies about halfway down the Pacific coast of the Baja Peninsula. Roughly 15 miles long and 3 miles wide, this protected area was created by the formation of barrier beaches across its mouth. (Barrier beaches are usually either sandbars or consist of a series of islands that close off all or part of bays or

SAILING IN SEARCH OF GRAY WHALES

marshland.) San Ignacio is surrounded by flat desert and sand dunes. There are a few islands in the lagoon, and you can see the mountains of Baja in the distance. San Ignacio is quite shallow; its greatest depth, about 70 feet, lies just inside the entrance. The channel leading to the head of the lagoon is very narrow, but the baby whales are born in this inner sanctuary. Because of the shallowness and the narrow channel, whale watching is strictly forbidden in the inner part of the lagoon. In fact, whale watching is actually allowed only in the vicinity of the area behind the entrance to the lagoon, a space just a couple of square miles in size.

GETTING THERE

There really is only one way to get to the Baja whales: with an organized tour group. Even if you were to manage to drive to one of the lagoons, could speak the language, and found someone to take you out to the whales, the number of boats allowed might already be filled with members of a group. I'm not saying that reaching the whales when traveling independently can't be done, but I strongly recommend going with a group, especially the first time.

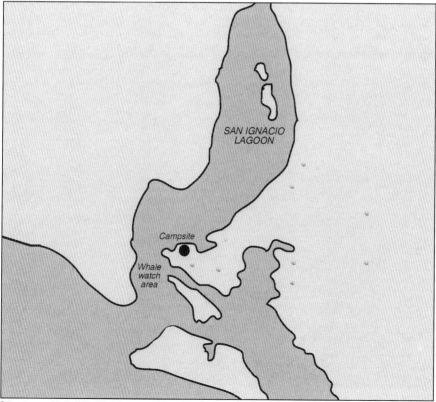

SAN IGNACIO
LAGOON

Campsite

Whale
watch
area

Computer graphic by Kathy Warner.

Most tour groups originate at San Diego, California, and proceed from there to the whales in one of two primary ways. One method is to fly to La Paz or some other southern Baja port and then get on a boat. Another way to make the trip is to travel on a boat from San Diego to San Ignacio or even on to Magdalena Bay. Most boats make stops at a few islands on the way, which provides extra photo opportunities. Make sure that the trip operators have permits to land people ashore! If yours doesn't, you'll spend all your time on board the boat or in a skiff because you won't be allowed onto Mexican soil.

Variations of these trips do exist, such as flying in a DC-3 (see page 35). Other alternatives include a couple of trips that fly into Baja from San Diego or Tijuana, Mexico, and then transport you to San Ignacio by van. These shore-based excursions use local guides to get participants out to the whales and is a good way to make the trip if you don't like living on a boat. Another option might be a one-way flight to southern Baja and a boat trip back to San Diego, or vice versa. Baja Expeditions also has its own 16-passenger vessel for Mag Bay trips. In effect this boat becomes a floating hotel for the duration of the trip and can move around with the whales (see page 183).

NEAREST AIRPORT
Because the areas where gray whales go to bear and raise their young are remote, there are no airports nearby. San Diego International Airport and Tijuana International Airport are the jumping-off places for air trips to San Ignacio or to La

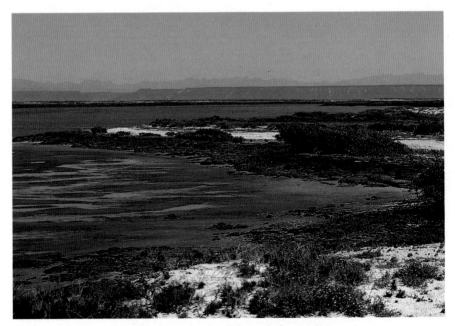

San Ignacio Lagoon and the sandy shores at Baja.

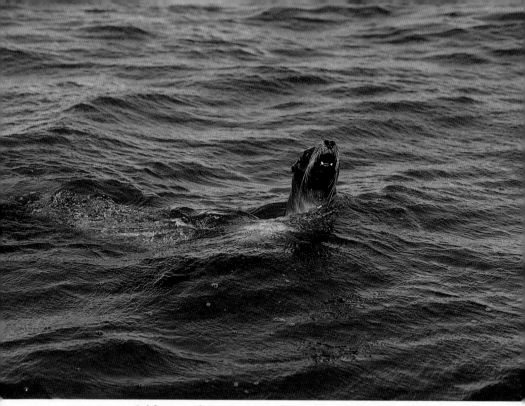

California sea lion swimming in the San Ignacio Lagoon.

Paz, which is at the southern tip of the Baja Peninsula. The Tijuana airport is the major point of departure for Magdalena Bay trips, although many San Diego boat trips go there as well.

EXPLORING THE PENINSULA

 San Ignacio is the focus of this discussion for two reasons. First, this is the lagoon where gray whales initially allowed humans to touch them. In the years since that exciting moment, female whales have been observed actually herding their calves over to the boats for contact. The second reason is personal: I had the opportunity to join Baja Expedition's inaugural five-day trip on a DC-3 to the lagoon. As a fan of both older aircraft and whales, I just had to go to San Ignacio rather than Mag Bay. Ten trip participants, the trip leader, and I flew from Tijuana, Mexico, to the town of San Ignacio in the chartered 24-seat DC-3. There was plenty of room for our equipment, luggage, and food, as well as for us to stretch out and enjoy the three-hour-long flight. At one point during the trip, the pilot banked around a mountain peak, giving everyone a spectacular closeup view.

Because of recent rains and the uncertain condition of the landing strip at the lagoon itself, my traveling companions and I landed outside the town of San Ignacio instead. From there we traveled by van and pickup truck over desert ter-

rain that was covered with wildflowers, a result of the rainstorms. An impressive array of tents had been set up for us on the edge of the lagoon, and an even more impressive evening meal followed. The weather was perfect, and we could see whales spouting out in the lagoon. I knew that the next day would be a rewarding one.

The experience was pretty unreal: winging along over a Mexican mountain chain in a 1944 twin-engine DC-3. These rugged aircraft saw a great deal of service during World War II and around the globe afterward. Many DC-3 planes are still flying and despite its age, I hoped mine would continue to do so. The inspiration for this particular trip wasn't aviation nostalgia but a desire to fulfill a lifelong ambition to see and photograph the gray whales of Baja.

Baja is a long, skinny peninsula about 800 miles in length and ranges from 30 to 140 miles wide. Running roughly north and south, it originates on the California border and is slightly longer than the boot of Italy. Technically Baja is a desert with fewer than 10 inches of annual rainfall, but it often receives much less. The Sea of Cortez forms the eastern coast of Baja while the Pacific lies along the western coast. A mountain chain runs down the middle of the peninsula, and the coasts are primarily alluvial plains chopped up by canyons. The area is so desolate that it is considered to be one of the least-traveled areas on the planet. The highway connecting Tijuana to the southern tip of Baja wasn't opened until 1973. The few other roads in the area are made up of either dirt or sand and often wash out. The inhabitants live mainly at the northern or southern portions of the Baja Peninsula, with a scattering of villages along the coasts.

HOW TO PHOTOGRAPH THE WILDLIFE

At San Ignacio you gain access to the gray whales via outboard-powered skiffs guided by local fisherman. These open Fiberglas skiffs, locally called *pangas*, are about 18 feet long with plenty of room for five or six people and are quite stable. The technique is to cruise slowly around looking for whales. Once a gray is spotted, you slowly approach in the skiff, let the engine idle down or shut it off, and just sit there. The whale decides whether to draw near or to avoid the boat. If the whale approaches, it might actually come to the surface right next to the skiff.

While you're bobbing around in the lagoon, you are likely to see whales passing on either side of the panga. To photograph them, I think that a 200mm lens is sufficient. As a matter of fact, I wouldn't recommend a longer lens because of the movement of the boat, a result of wave action and people shifting around. A longer lens will magnify the motion and blur your pictures.

WHAT TO WATCH FOR

When photographing the whales you should look for several behavioral patterns, such as breaches. During these spectacular leaps, the whales suddenly

appear from the depths, throw themselves partially out of the water, and fall back in with a tremendous splash. Whales often repeat this action, so be ready once a whale starts to breach (assuming that the whale is close to your boat). Unfortunately breaches always seem to take place in front of another boat or out of acceptable camera range. Another behavioral pattern to look for is called spy hopping. Here, a whale gets into vertical position with its head sticking out of the water. About 6 to 8 feet of the whale show above the surface of the lagoon. Many times, a whale slowly rotates while looking around. A good spy hop lasts up to 20 or 30 seconds, which gives you plenty of time to shoot several frames—even without an autowinder or motor drive.

At San Ignacio gray whales don't seem to show as much fluke as other whales do when diving. This might be because the lagoon is so shallow. In any event gray whales do show some flukes. Watch for a series of knuckles or bumps to appear along the whale's back (grays have no dorsal fin); this indicates an approaching dive. Time your shot, but wait for the whale's tail to actually show before shooting the picture. You have plenty of time to get it just right, so don't rush.

For the most part other gray-whale behavior involves close approaches. If the water surface is calm and clear, you might be able to get some shots while the whale approaches underwater. If the whale makes a close approach, it might break the surface next to the boat to get scratched, hugged, or kissed—to elicit some positive form of human behavior. This certainly can make for spectacular photography!

SOLVING EXPOSURE PROBLEMS

When you photograph the gray whales at Baja, you need to consider two exposure factors. The first is the reflection from the surface of the sea. The meter sees all this brightness, "thinks" there is more light than there actually is, and compensates by underexposing the scene. To avoid these wasted shots, I manually set the exposure using the information provided in the film box or the "sunny $f/16$" rule. This principle states that on a sunny day, you should set the lens to $f/16$ and use a shutter speed roughly equal to the film speed. For example, with ISO 100 film you would use a shutter speed of 1/125 sec. If your camera has only automatic-exposure capability (with no way for you to manually adjust settings), try not to aim it at parts of the scene that contain a lot of reflections.

The other potential exposure problem you have to think about is movement, either due to the skiff itself or by people moving around in the boat. I suggest using the standard guideline: the shutter speed should equal the focal length of the lens. In other words if you use a 70-210mm zoom lens set at 210mm, you need a shutter speed of at least 1/250 sec. Then you simply set the lens to the appropriate aperture for your particular film and the light conditions. As a safety factor I usually shoot one shutter speed faster because of the motion expect-

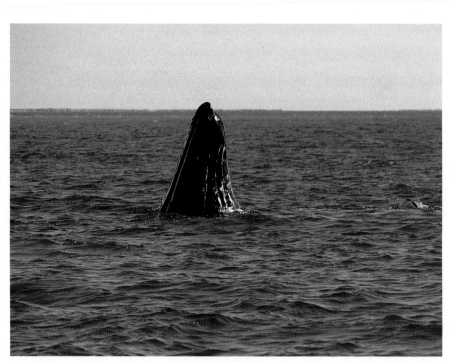

Gray whale spy hopping.

ed. So for a 200mm lens I use a shutter speed of 1/500 sec. If this isn't fast enough for the action, you probably wouldn't want to be out on the water in a skiff anyway!

SPECIAL PRECAUTIONS

I suppose the possibility of a whale dumping a skiff and its occupants exists, but this is extremely rare. The local guides are quite skilled around whales, so the risk of this particular danger is very minimal. What is a real danger, however, is you and your camera gear getting covered with warm, salty whale breath! This happened to me several times in a three-day period, and I quickly learned to keep in mind the wind direction at all times. If a whale surfaces directly upwind, cover your equipment and forget the shot! If it is windy out, which is a common occurrence at Baja, there will also be some spray as the skiff moves from one area to another.

What worked out best for me was to bring a large trash bag that I opened and placed on the bottom of the skiff. I put my camera bag into the trash bag; this prevented any water in the bottom of the boat from soaking up into the camera bag. When spray flew I was able to flip the top of the trash bag over the camera bag. I was also able to quickly shove a camera and lens into the trash bag when whale breath or some other spray headed my way.

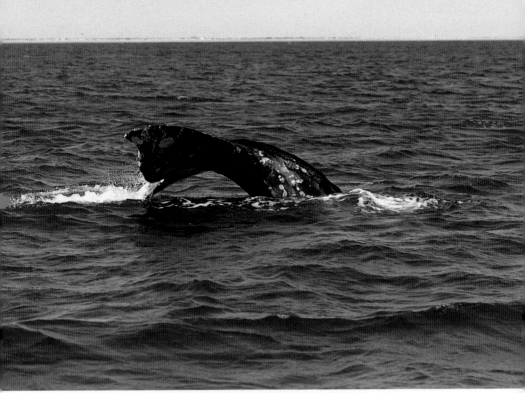

Gray whale diving and showing some fluke.

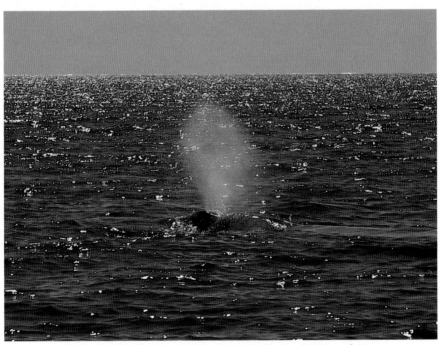

Gray whale blowing, or exhaling moisture-laden breath upon surfacing.

PHOTOGRAPHIC EQUIPMENT AND FILM

 For my trip to Baja I packed my favorite films, Kodachrome 25 and Kodachrome 64, and a polarizer. You might also want to consider using a skylight or plain optical-glass filter in order to keep sea water off the lens' outer element. Based on my experiences I don't think that you need to lug a tripod to Baja. I brought a small tripod with me and rarely used it. The movement of the boat you shoot from will completely negate any advantage in terms of steadiness that the tripod offers. And for some strange reason, it is actually illegal to bring tripods into Mexico; however, this rule is rarely enforced. But in the event that you need a tripod on shore, you'll probably be able to borrow one from someone or to use whatever support is handy.

There are few times I recommend a motor drive or an autowinder because I feel that they make you use too much film. I prefer to slow down and time the shot perfectly. But I definitely recommend bringing a motor drive on a whale trip. I find that the following technique works well. I keep the motor drive for my Nikon F2 set on "continuous," but I fire it in single bursts for carefully timed shots. If a whale suddenly breaches or exhibits some other behavior that involves lots of action, I merely keep my finger pushed down and fire off a series of pictures.

Although I don't own any zoom lenses, I strongly advise having one with you on a whale-watching trip. Action often occurs with no warning, and unless you are ready you might miss the best shot of the trip. A 70-210mm lens or perhaps a 35-70mm lens for close encounters or scenics would be ideal.

PHOTOGRAPHIC SUPPLIES AND REPAIRS

There are absolutely no photo supplies or repair shops to be had at San Ignacio! Buy anything you need in San Diego before leaving for Mexico. In addition to the six repair shops in San Diego, Canon, Minolta, and Nikon have authorized warranty-service shops. And if you forget a piece of equipment, there are literally dozens of camera shops in San Diego.

THE BEST TIME TO VISIT

Although some whales reach Baja in December, you should really try to be there after some of the calves are born in late January/early February. Although a few calves are born in the open water during the migration south, the vast majority of them are born in the shallow parts of the Baja lagoons. By February and March, these young whales and their mothers have moved out into the deeper waters of the lagoons, which are accessible to whale watchers.

Newly pregnant females start northward around mid-February; adult males follow shortly afterward. New mothers and calves wait until May and sometimes even June before heading north. This cycle fluctuates slightly from year to

year, so it is best to get advice as to what is happening from whatever group you join. If you go to Baja too early, you'll discover that the weather can be nasty. If on the other hand you go too late, you'll learn that the temperature can get pretty hot. As a rule early February to early April is the optimum time to visit Baja to photograph gray whales.

HOW LONG TO STAY

 The outfitters pretty much dictate the length of the whale-watching excursions in the Baja area. Most trips last from 5 to 12 days. You don't have much choice once you sign up for a trip and arrive at a particular destination. You return when the group does because in most cases there is no other way back.

LODGING AND DINING

 There are no restaurants, campgrounds, or other lodging facilities in the area. I realize that it is difficult to imagine, but there actually are places left on this planet where there is absolutely nothing, and whale-watching lagoons are such places. As a result, lodging and dining plans are left up to the individual outfitters organizing the trips. You might find yourself eating in a large meeting tent—I did, and I enjoyed some of the best meals that I've ever had—or having a cookout on the beach.

NEARBY PLACES OF INTEREST

 Because whale-watching trips are expeditions into remote sections of real wilderness, there aren't any places of interest in the immediate area to recommend.

SPECIAL CONSIDERATIONS

Remember that, at least for most whale-watching trips in the Baja area, you're going to be traveling in a foreign country and then returning to the United States. Although I wasn't asked to produce either my passport or birth certificate, I urge you to take both with you just in case there are any difficulties along the way. If you have any trouble, contact the American Embassy.

My traveling companions and I had no problems with the skiff operators. Either they spoke adequate English, someone else on board spoke Spanish, or there was an interpreter along. Although brushing up on any Spanish you know or taking a course in Spanish will be useful, neither one is necessary.

In terms of the weather, it is important to keep in mind where you're going. Baja is technically desert country with typically warm-to-hot days and cool-to-cold nights. Bring a jacket or light parka for the evenings and a windbreaker for windy days. Be sure to bring two pairs of sneakers in order to be able to switch off; they'll definitely get wet. In addition I wished that I'd brought a light-

weight, full-length plastic raincoat for the one nasty morning at San Ignacio. It would have been ideal for keeping me dry and shielding my camera equipment from the elements. Since you'll be spending the greater part of your trip on water, I strongly recommend that you wear a long-sleeved shirt, long pants, plenty of sunscreen, a lip balm that offers protection from ultraviolet radiation, and a hat. The sun's rays are quite strong and are intensified by the reflective nature of the water.

I am sure that you've heard many dire warnings about drinking Mexican water, but none of us had any problems at San Ignacio. The water there comes from deep wells and was trucked in daily to our camp. If, however, you still feel nervous about drinking the water, you might have to resort to drinking the local and very excellent beers! All in all I had a delightful experience in Mexico and never felt uncomfortable because of a language barrier or for any other reason!

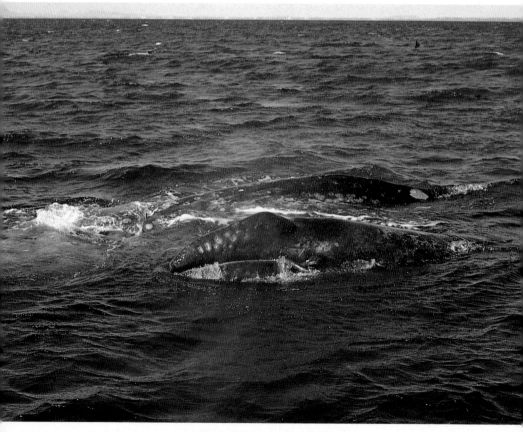

Gray whale and calf herding.

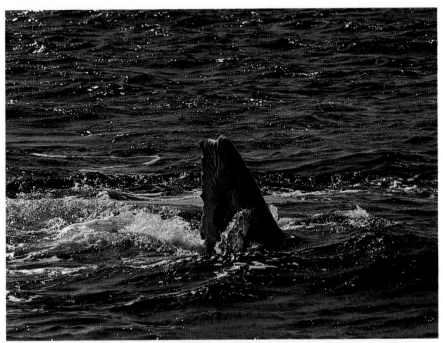

Gray whale thrashing its fin and rolling around in the ocean.

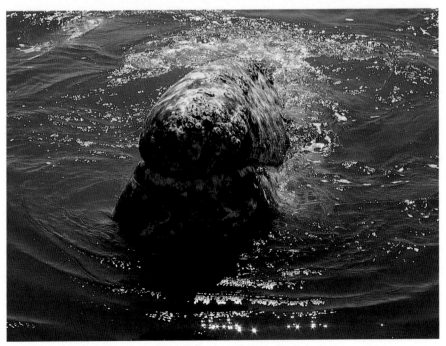

Gray whale approaching the boat.

BONAVENTURE ISLAND

J

UST 2 MILES off the shores of Percé on the Gaspé Peninsula in Québec, Canada, is a truly wonderful wildlife area: Bonaventure Island. Not only is Bonaventure the home of the largest gannet colony in North America, with an average of 50,000 seabirds, it is also the most accessible. Together these features make the island one of the best places in the world to photograph these handsome seabirds. Bonaventure Island is roughly circular in shape and about 2 miles wide in diameter. As seen from the mainland the island's profile is low and gently rounded, but the eastern side has 300-foot-high cliffs. This is where the seabirds have their nests. ❧ It wasn't always so idyllic on Bonaventure, and the island has a stormy historical past. Originally used as a summer base by Norman and Breton fishermen, the island was permanently settled in 1672. English privateers ravaged the area in 1690, driving the settlers off the island and burning down their church. By the late 1700s the colonists had returned, and four families set up year-round residence. By 1831 35 families lived on Bonaventure, but this number slowly declined; by 1963 the last of the families moved off the island. These early settlers exerted an influence on the seabird colonies: the fishermen and their families used the birds and their eggs for food. The result was a noticeable decline in gannet populations by the turn of the century, and the cliffs were declared a sanctuary in 1919. ❧ Also, a few summer residents occupied the island early in this century until the Québec government purchased it for a provincial park in 1971. Past human influence is still evidenced by a few old roads, but they are being allowed to disappear, so only walking trails will remain. The house of LeBouthillier, a former fishing-company manager, is preserved as part of the island's history and is open to the public. A couple of other houses are still standing, but like the roads, these are being allowed to decay into eventual oblivion. A movie company made an historical documentary on island living a few years ago and brought some buildings from the mainland. These have been removed, but the stairway to a beach remains.

CAPTURING

THE GRACE

OF GANNETS

IN FLIGHT

GETTING THERE

The village of Percé, which is in effect part of the Bonaventure adventure, is one of Québec's most popular resort areas. Its population of about 900 swells to 2,000 or so during the summer months. Percé is located on the eastern tip of the Gaspé Peninsula and is reached by taking Canadian Highway 132. This scenic route winds along the northern and southern coasts of Gaspé, and like most other visitors you'll probably arrive via the southern route.

The jumping-off point for Percé is the city of Campbellton, which is located at the base of the southern coast of the peninsula. Plan on around three hours for the drive because traffic on the two-lane highway can be slow going, especially near some of the resort areas en route. In addition you'll pass several colorful fishing fleets that you might want to photograph, particularly late in the day when the warm light enhances the already vivid colors of their hulls.

Percé is a very scenic village, located at sea level. Upon first glimpse as you make the final turn into town, Percé is breathtaking. At this point the highway

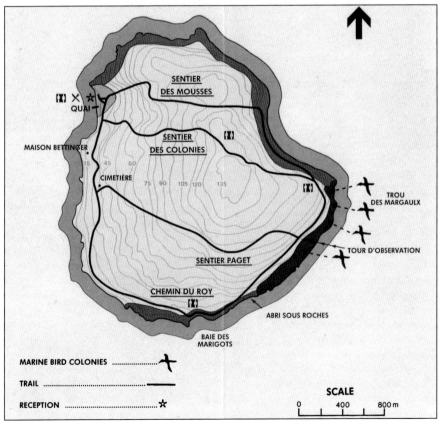

Courtesy of the Gouvernement du Québec—Ministère du Loisir, de la Chasse et de la Pêche.

is far above the sea, so you get an exceptionally graphic view. Bonaventure Island is visible just offshore, and you can see famous Percé Rock between the island and the mainland. Another promontory forms the other end of Percé and offers an equally spectacular view. The main dock, from which the tour boats that link Bonaventure and Percé set sail for the gannet colonies, is also clearly visible. Since Percé is a small village, you shouldn't have any trouble walking around, finding accommodations, or getting into one of the campgrounds. There are no overnight facilities on Bonaventure Island itself.

NEAREST AIRPORT

Unfortunately there are no large airports anywhere near Percé. The closest jet-ports are in Montreal, but even that is 400 miles away. Dorval, on the west side of the city, handles primarily domestic flights and flights from the United States, and Mirabel, to the north, handles all international flights. However, the Munici-pal Airport of Gaspé, a small airport just outside the town of Gaspé, is about a half-hour drive from Percé and is serviced from Montreal and other points.

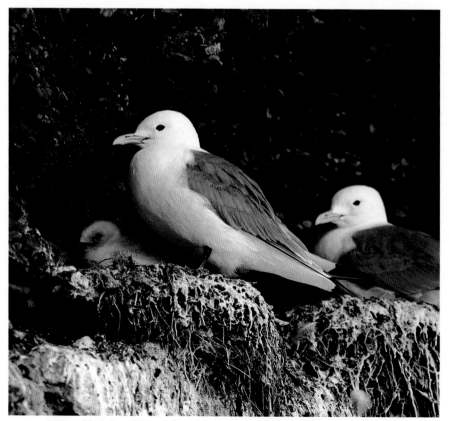

Nesting black-legged kittiwakes, photographed from the rocks at Baie des Marigots.

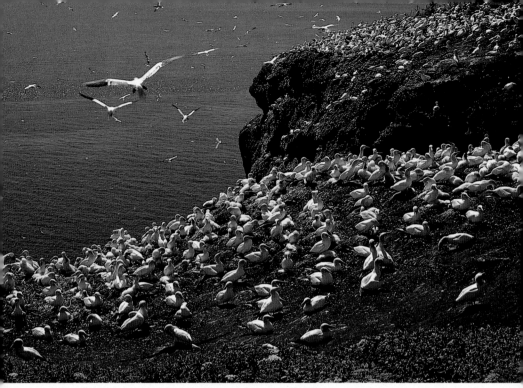
Gannet colony on a cliff top.

CAR RENTALS

A car-rental agency is located at the airport in Gaspé. Ask your travel agent about this option if you plan to fly to Canada.

TAKING A TOUR BOAT

The only way to get to Bonaventure Island is via tour boat. The boats leave from the dock located in the center of town as well as from the little jetty off the beach behind the Normandy Hotel. Keep in mind that only two tour-boat companies have permits to land passengers on Bonaventure: Les Bateliers de Percé and the Percé Ferry. Make sure that you get on one of the right boats or all you'll get is a tour around the island and a trip back to Percé. Les Bateliers de Percé and other tour companies have ticket offices at the head of the main dock, so it is essential that you pay close attention when buying your ticket. You'll find tickets for the Percé Ferry at the booth in the parking lot next to the Normandy Hotel.

After purchasing your ticket, walk out on the dock and hand the pass to the dispatcher or simply give it to the captain on the Percé Ferry. You'll then be directed to the appropriate boat. Les Bateliers de Percé has six or seven boats, but I prefer the smaller wooden ones because they are more stable and carry fewer people. These are *Papinachois, Neptune Percé Cruiser*, or *Traversier*. All of the boats start their trips at 8 A.M., including the Percé Ferry. The boats at the

town dock leave every hour on the hour, while the Percé Ferry leaves every hour and 15 minutes: for example, 8 A.M. (0800), 9:15 A.M. (0915), 10:30 A.M. (1030), and 11:45 A.M. (1145).

On a typical tour the boat first swings past Percé Rock and then makes a clockwise trip around the backside of Bonaventure. Nesting murres, kittiwakes (which are small gulls), razorbills, and gannets are found on the cliffs on the eastern side of the island, and the boats often linger there, depending upon the weather and sea conditions. Then the boats complete the circuit and stop at the dock on Bonaventure to enable people who want to go ashore to disembark. (Remember, only two companies are permitted to do this.) If you decide to see Bonaventure on foot, keep in mind that the last tour boat leaves the island at 4:30 P.M.! You should plan on allowing at least an hour to get back to the dock from the gannet colony, and much more time if you hike the Chemin du Roy Trail. You'll probably want to explore the island, do some shooting, and enjoy the walk.

EXPLORING THE ISLAND

 Because the tour boats drop off passengers on the western side of Bonaventure and the gannets are on the eastern side, you're faced with a considerable hike of about 1¾ miles. Before you begin, pick up one of the brochures that contain a map of the island. You'll find these either on the tour boat or at the booth at the head of the island dock.

When you look at the map, you'll notice that there are only four trails to the gannet colony on Bonaventure. Sentier des Colonies is the shortest, most direct, and most frequently used trail—and the one I recommend. It is also wide and well packed. And since you're starting at sea level and need to get to the 300-foot-high cliffs, the trail is mostly uphill. Parts of Sentier des Colonies are fairly steep but only for a short distance. And, conveniently, there are benches for rest stops along the way as well as a strategically located outdoor privy. The trail goes through coniferous woods, so it is shaded most of the way. About three-quarters of the way to the cliffs the trail levels off, and if the wind is right you can hear the noise of birds from the colony. Gannets are very vocal birds and can be heard from a considerable distance. Similar to the "gobble, gobble" sound turkeys make, the gannets' "gabble, gabble" call is a nasal sound. Of course, you might smell the gannets first, depending on whether your nose or ears are more sensitive!

When the trail leaves the woods, you'll finally see the gannet colony. Many visitors halt here, briefly taken aback by the sight of tens of thousands of gannets spread out along the top of the cliffs. The colony itself is protected behind a wooden fence, but this won't hamper your photographic efforts. There are only a couple of fence rails, and you can shoot through them at any level. And the gannets are so used to people being around that your presence won't bother

them a bit. You'll even discover that a few of the birds will occasionally wander onto the other side of the fence. In addition they often build their nests right next to the fence, so access is exceptional. In fact, the Canadian Wildlife Service, which manages the island, once had a photographic blind built into a corner section of the fence but eventually removed it because the gannets quickly appropriated it for their own use!

Most people plan on spending an entire day on Bonaventure and bring their lunch. (You can, however, get something to eat at the snack bar now operating on the island. Restroom facilities are located at the snack-bar complex, on the trails, and at the gannet colony.) The natural-history exhibit has a flora-and-fauna display and provides some information about Bonaventure's history. The Wildlife Interpretation Center also has personnel on the island who can answer questions or assist you with any problems. The staff members even offer guided walks around the island and to the colony.

HOW TO PHOTOGRAPH THE WILDLIFE

Although you shouldn't have any real trouble getting great photographs of the gannets, some difficulties do exist despite the apparent ease of accessibility. One of the biggest problems is that the subjects are white, and their brightness throws exposure meters way off! This extra light will result in underexposures unless you compensate for it. I suggest that you set your camera manually, not use your light meter. If you follow the exposure guidelines that come with your film, you won't go wrong. You can apply the "sunny $f/16$" rule while photographing the gannets on Bonaventure also. For example, on a bright sunny day you would expose Kodachrome 25 at $f/16$ for 1/30 sec. But in order to photograph moving birds, you would need a faster shutter speed. For these shooting situations I usually expose at $f/8$ for 1/125 sec. or $f/5.6$ for 1/250 sec. (The exposure for all of these combinations is exactly the same.)

A second problem associated with photographing white birds in bright sun is the contrast between their feathers and shadow areas. This is especially difficult for slower films to handle. Either shadow detail will be lost or the birds' feathers will be washed out. Slightly hazy or overcast conditions provide ideal light at Bonaventure. Unfortunately my trips to the island don't seem to coincide with this type of weather, so I often face beautiful, bright skies and plenty of contrast. But sometimes clouds appear in the afternoon on these days, and I wait for them to materialize in order to reduce the amount of contrast in the scene.

Another problem you are likely to encounter while shooting at the colony is finding a seabird off by itself because there are so many of them. Gannets are very social, and their nests are spaced only about a yard apart. This makes for extremely crowded conditions. The best way around this dilemma is to walk along the edge of the colony where there is more room for the birds. You can

also check the meadow at the north end of the colony. To get there, head to your left as you approach the cliffs from the Sentier des Colonies trail. Ordinarily I find individual gannets that have left the colony and wandered into the grasses on the meadow.

HOW TO OPTIMIZE YOUR SHOOTING TIME

Here are some tips for getting the best results possible on Bonaventure Island. First, you should be familiar with your subject before you leave on your trip.

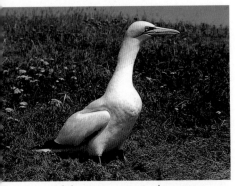

Adult gannet resting in the grass.

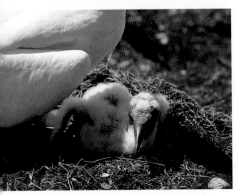

Gannet on a nest, protecting a chick.

The more you know about the gannets, the better your pictures should be. A gannet is a large, handsome bird with a 3-foot-long body and a 6-foot-wide wingspan. Gannets belong to the same family as red-footed and blue-footed boobies. Adult gannets are almost completely white with a pale yellow head and black wing tips, and juveniles are speckled with black; these spots diminish in intensity and eventually disappear as the gannets get older. Gannets are diving seabirds, often plunging into the sea from as high as 100 feet. For streamlined motion underwater, their wings are narrow and their feet are set far back on their body. Graceful birds in the air, gannets are clumsy on landings. In fact, rather comical crashes into the colony aren't unusual.

Gannets build their shallow nests out of seaweed and grasses and are very aggressive when defending their territory, which is only a few square feet. They exhibit distinctive behavior patterns that have been widely studied because the birds can be observed and photographed easily. Typical displays are skypointing, bowing, fencing, fighting, and mutual preening. When skypointing, a gannet points its beak skyward, alternately lifts its feet, and utters a squawking sound. This is how the gannet communicates to its mate that it wants to leave the nest for awhile. Bowing is a territorial display to warn off other gannets. Here the bird lowers its head, shakes its head from side to side, and then alternately tucks it under each wing (the wings are raised halfway). Fencing is a form of greeting that takes place when one of a pair of gannets returns to the nest. When this happens, both mates point their bills skyward and clack them together. Fighting, of course, is

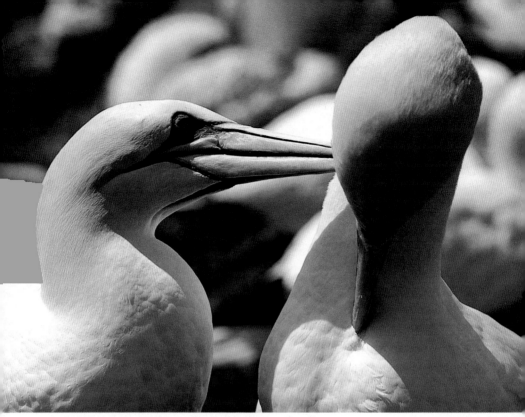

Gannets grooming at the colony.

easily recognizable. Two gannets grab each other's beaks and pull. Finally, during mutual preening the birds caress and smooth each other's feathers, especially near the head region. For more information about the gannets' displays, read the set of signs tacked to the fence; these provide an excellent depiction of the birds' behavior. (You might also want to read *The Gannet of Bonaventure Island* by Lucie Lagueux. Published by the Club des Ornithologues de la Gaspésie and available locally, this is one of the best reference books on gannet behavior.)

Another way to optimize your time on Bonaventure is to catch the very first ferry. The early-morning light is best then, and the island is far less crowded. But if you really want to get to the colony early and don't want to make the time-consuming trip all the way around the island, ask the locals about catching the worker boat that leaves at 8 A.M. and goes directly to Bonaventure. The fare is the same, and you'll end up being just about the first person to reach the cliffs. I've done this more than once and found that I was the only one at the colony, which was a wonderful experience in itself.

Regardless of when you arrive at the colony, head to the north end first by following the fence around to your left as you approach the cliffs. A jog in the fence there provides you with the best—and really the only—view of the actual side of the cliff with its nesting gannets and kittiwakes. Once again the light is

best here early in the day. And you'll see plenty of gannets right in front of you, too. Most visitors never bother to walk around to the corner, so this spot is less crowded even later in the day.

A gannet in flight is a beautiful sight, but successfully capturing this image on film isn't easy. The best place to try is, once again, at the north end of the colony. If the wind is right (parallel to the cliffs), walk to the small hill just to the north of the colony. Here gannets will be flying right at you on their way into or out of the colony. I used a great deal of film while shooting from this spot, and it was also one of the few times that I used a motor drive. This requires carefully following the bird and gently squeezing the shutter while moving the camera at the same speed as the subject. The result: great photographs.

The observation tower isn't visible from the spot where you first see the gannet colony, so many people miss it. This three-story platform places you high enough to get a good view of the birds below. To reach the tower you simply follow the colony fence and path to the south; these are on your right when you face the cliffs. This path is actually the beginning of the Chemin du Roy trail. Although this is the longest route back to the dock, it is mostly downhill. When you pass through the first set of trees, you'll see the tower.

When it is time for you to head back to Percé, you can backtrack to the Sentier des Colonies trail if you want to take the shortest and easiest way to the dock. If, however, you have both the time and a sense of adventure, continue on the Chemin du Roy trail. It winds around the southern side of Bonaventure Island and eventually leads you back to the dock area. Allow at least an hour for this trip. On the way you'll pass Baie des Marigots, which is a popular bathing beach. If you decide to go to the beach, walk down a set of steep steps, and note the set of rocks on your left. Kittiwakes nest in the cliffs on the other side. Even a 300mm lens produces good results here. Be particularly careful if you decide to shoot from the rocks because they are very slippery. The combination of the continuous drizzle from the springs above them, ocean spray, seaweed, and algae is dangerous.

The tour boat itself can provide some excellent picture possibilities, especially when it passes close by the cliffs. Here you usually see a variety of birds: murres, razorbills, gannets, kittiwakes, guillemots, and sometimes even puffins. As you approach the island, try to get on the starboard side of the boat and as far forward as possible for the best view. The following suggestion will also help you optimize your shooting time. Usually all the passengers head out of the cabin and jam up the stern area when the boat approaches the cliffs, making it difficult to maneuver with a camera. Most of the boats have a door at the forward end of the cabin that leads to the side deck. If the captain gets in very close to the cliffs (and he generally will if the sea is calm), stand in that doorway. This will give you the closest, and best, view.

Keep in mind that when you shoot from a tour boat you're on a very unsteady camera platform. So a tripod is of no use on the boat, but a fast shutter speed is. And since the cliffs are vertical, there is little problem with depth of field. Simply open up the lens and use a faster shutter speed to cancel out any boat motion. Don't forget that a telephoto lens magnifies motion. To be on the safe side, shoot much faster than you think you need to when using this type of lens.

One final point: it isn't unusual to see minke whales on the way to the island, so keep an eye out for them. On my last trip to Bonaventure I came across three of these small whales, and one was right next to the tour boat.

PHOTOGRAPHIC EQUIPMENT AND FILM

Gannets are large birds and since you can get right up to the colony, you really don't need particularly long lenses. (Besides, you don't want to lug them up there!) A 70-210mm zoom lens is a good choice for shooting on Bonaventure Island, and a standard or medium-wide-angle lens is ideal for group shots and scenics. A little searching usually reveals some chicks close enough to the fence for a medium-telephoto shot. If you can't locate a chick, ask one the naturalists for help. You can usually find these individuals in the vicinity of the fence. If, however, you feel strong and prefer using longer lenses, a 300mm or 400mm lens will work well on the island. But I know people who lug longer lenses to the colony and admit that they don't use the lenses that often.

I recommend using a tripod while shooting on the island, even for a 200mm lens. Although using the fence for support seems like a viable alternative, people usually lean or sit on the fence and cause it to shake. Try not to let your equipment even touch the fence because those slight movements will make your camera vibrate and produce soft pictures.

I've found that on some days, humidity in the air from the ocean tends to wash out the sky. So using a polarizer here comes in handy to restore some blue to the background. On a crisp, clear day, however, the sky can be a very deep blue, so using a polarizer would make the sky an unnaturally dark blue.

When planning your trip you can pack whatever film you usually shoot. But keep in mind that you'll need at least several rolls of relatively fast film in order to successfully capture boats in motion and birds in flight. Most of the time I shoot Kodachrome 25, yet I usually switch to Kodachrome 64 when I visit Bonaventure. You might even want to pack a few rolls of Kodachrome 100 or even 200, just in case the boat passage is rough. The important consideration in this shooting situation is film speed. Shoot at a minimum shutter speed of 1/250 sec. or perhaps even 1/500 sec. if the water is particularly choppy. (If you think that you'll need to shoot any faster, you probably won't want to be on the boat that day anyway.)

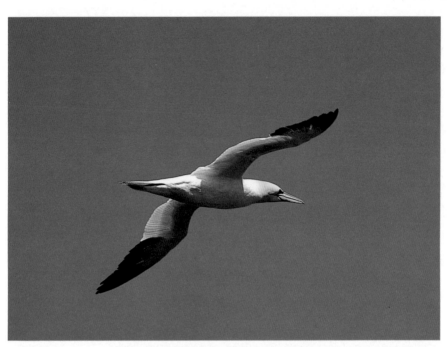

Gannet in flight, one of nature's masterpieces.

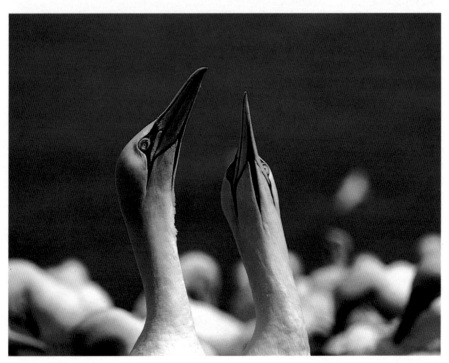

Gannets sky pointing, another of their distinct behavioral habits.

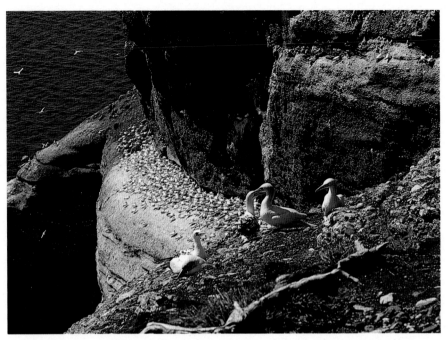

Nesting gannets, photographed from the extreme left corner of the fence around the colony.

PHOTOGRAPHIC SUPPLIES AND REPAIRS

There is plenty of film available in Percé but it is quite expensive, so bring a large quantity with you. On a recent trip, for example, I found Kodachrome 64, Ektachrome 100 and 200, and various print films (but no Kodachrome 25). However, the price of Kodachrome was almost three times as high as it was in the United States, and the other brands seemed to be comparably expensive. One-hour print processing is available in Percé, and Photo Cassidy, Inc., a large print-processing lab in Gaspé, is about 45 minutes north of Percé (see page 184). Photo Cassidy also carries a good supply of batteries and a limited selection of photographic supplies. There are no repair facilities anywhere in the area.

THE BEST TIME TO VISIT

 Gannets spend their winters at sea. Because the weather is warmer and the fish are more plentiful, they travel as far south as Florida and even the Gulf of Mexico. Working their way up the coast in the spring, the birds arrive on Bonaventure in early April. They don't straggle to the island, but in one of those marvels of nature they arrive all at once—much to the frustration of researchers who try to be on the island when the gannets arrive. One evening there is no sign of a single gannet, and the next morning all the gannets are there.

Egg laying begins the middle of May, with the first chicks hatching by the end of June. While most of the gannets in the colony synchronize their egg-laying action, young adults aren't attuned to this cycle and lay eggs all summer. Eggs laid in the fall usually don't hatch, so chicks from these eggs might not develop enough in time for the migration south. Try to arrive on Bonaventure after the chicks begin to hatch, around the end of June.

When you plan your trip to Bonaventure, you should also find out the dates of the major Canadian holidays. There is no point trying to get to Percé when the place is completely booked up or even very crowded. June 24 is the National Day of Québec and July 1 is Canada Day, so try to avoid these dates as well as corresponding weekends. Because the period from mid-July to about mid-August is when most Canadians take their vacations, this is also a good time to avoid Percé. If you must go to Bonaventure during either of these time frames, be sure to make reservations well ahead of time.

At this point you might be wondering if there actually is a "best time" to visit Bonaventure. The answer is yes. I like to get there the second week in July. The weather is warmer and more stable then than earlier (keep in mind that the Gaspé Peninsula is quite far north). The first chicks have already hatched, but there are still eggs around. Also, wildflowers are in bloom, and the tourist crunch hasn't occurred yet. Another "ideal time" might be after the middle of August. I've never been on the island then, but I've heard from several reliable sources that the weather is even more stable. The shorebirds start to migrate through the area, and the quality of light is superb. There is very little humidity, and the skies are clear and deep blue. The sun is getting lower as autumn approaches, and the light is warmer because the cooler wavelengths of light are filtered out.

HOW LONG TO STAY

 It is difficult to offer advice on the length of time to visit Bonaventure. This depends on whether or not you plan to visit other parts of the Gaspé Peninsula. If you're driving, you have to consider the distance because Percé is a long way from anywhere. The drive from the United States border to Percé takes a good day by car, so you need to block out two days for the trip itself. I usually plan on spending three or four days on Bonaventure, which allows a day or so for any bad weather to clear up. All together, you need a minimum of a week to visit Bonaventure.

LODGING AND DINING

A resort village, Percé has about 36 motels and hotels, more than a dozen restaurants, as well as grocery stores and gift shops. In addition, there are three or four campgrounds in the village or immediately on the outskirts of town. I've always camped at the Baie de Percé because it is con-

veniently located in the middle of town. And it is only a short walk from the campground to the ferry dock, so I can leave my car at the campsite. Request a copy of the *Gaspésie Tourist Guide* from the Tourist Information Office (see page 184). In the back is a listing of accommodations, number of rooms, and approximate prices. The guide also includes campgrounds, the facilities available, and the number of campsites at each one.

NEARBY PLACES OF INTEREST

 When you first arrive in Percé, visit the **Wildlife Interpretation Center**. This is one of the best ways to learn about the area. Follow the brown signs in French that say "Centre d'interpretation"; these start about one-third mile south of the center of town. You can also hike the short distance from a lower parking lot on Highway 132 to the center. The Wildlife Interpretation Center has a good film on gannets, various displays on the Gulf of Saint Lawrence and its influence on Bonaventure, and an excellent bookstore. Naturalists are on hand to answer any questions. Another good place to stop before exploring the area is the **Tourist Information Office** in town. It is located across the street, just to the north of the main dock. The building has a large blue-and-white sign with a question-mark on it in front.

Another option exists for going out on the ocean at Percé. A small group, Observation Littoral Percé, Inc., operates very stable, high-speed inflatable boats that make trips to Bonaventure and go on whale-watching expeditions farther out to sea. Although the group doesn't have permits to land passengers on the island, it can get you very close to the cliffs. The boats can hold only about 10 people, and I suspect that you can pretty much tailor the trip to wherever the passengers want to go. Just like the Percé Ferry, Observation Littoral Percé operates from a booth near the Normandy Hotel and from a jetty off the beach.

Try the salt marsh about 8 miles north of Percé if you want to see shorebirds, great blue herons, and scenic beauty. You can't miss the marsh as you drive north on Route 132. Then continue past the marsh, and take the first right turn to the old bridge. Cross over the bridge—it should hold your car up despite its looks—and continue along the marsh. Four small rivers feed into the area and provide excellent canoeing. A railroad track separates the marsh from the ocean. Check the beach on the ocean side for shorebirds.

Farther north of Percé is **Pointe Saint-Pierre**. The point of land has a small rocky island off of it, which you can see from Highway 132. The road to the point is just opposite the motel on the left. You can sometimes see whales between the island and the point; these are separated by only a few hundred yards. The last time I was there I saw several gray seals, some cormorants, and eider ducks, all within the range of a 300mm telephoto lens.

And, of course, no one should go to Percé and miss **The Rock**, which locals call "Le Rocher Percé." This monstrous limestone formation was once located

near the equator where tropical marine life became fossilized. In fact, The Rock is loaded with marine fossils. Later, tectonic-plate movement brought this monolith to the Percé area. At low tide, a sandbar provides access to this popular attraction. Its 300-foot-high walls are nearly perpendicular, so don't plan on a climb. Even more important, climbing is forbidden anyway because the top of Percé Rock is a bird sanctuary. The best places to look for fossils, including trilobites, are along the base of the rock itself and the lower portion of the cliff at the mainland end of the sandbar. Stairs leading down to the beach and sandbar are located at the parking lot at Mont-Joli. Look for the building with the red roof.

For one of the most spectacular views of the village, The Rock, and Bonaventure, take the Rue Saint-Anne road up to **Mont Saint-Anne** behind the large church in the middle of Percé. Simply follow the signs, and you won't get lost. Watch for the two turnouts on the way (you walk along a path to see the view from the upper lot). If you want to get to the very top of the mountain, leave your car in the upper parking lot and make the half-hour hike. On the way up (or down) from Mont Saint-Anne, you might want to check out The Grotto. This is a particularly attractive natural bowl in the rocks with small waterfalls cascading over moss-covered ledges. To get to the grotto, drive in from the bottom of the Mont Saint-Anne road as far as you can, and then walk the last 200 or so feet.

Finally, if you have the time you might want to go to **Forillon National Park**. This forms the bulk of the other tip of the Gaspé Peninsula (Percé is the southern tip). You can even see the park from Bonaventure if you look to the north. Forillon is a narrow, mountainous peninsula and a very popular place for enjoying such activities as riding, diving, sport fishing, hiking, camping, and swimming. Forillon is also spectacularly beautiful. If you go, stop at one of the visitor reception centers to get maps and information.

SPECIAL CONSIDERATIONS

Québec is a province in a foreign country. And although I've never been asked to produce either my passport or birth certificate, bring yours with you just in case you have any difficulty getting back into the United States. If you're bringing just your camera gear, clothing, and perhaps camping equipment, you don't have to worry about traveling to Canada. But if you're planning to bring weapons, medicines with narcotics, monkeys, agricultural products, lottery tickets, or obscene literature, contact Canadian or United States Customs for guidelines.

It is best to convert American money into Canadian currency as soon as possible. Remember that the exchange rate varies from day to day and that the best place to make the exchange is at a national bank. If you spend more than $100 dollars on accommodations and most consumer goods, beware of the "Goods and Service Tax," or "GST." This 7-percent levy is refundable when you leave

the country. Save your receipts, and pick up GST Form 176E at a duty-free shop or at the Tourist Information Office in Percé. You can then get your money back at a duty-free shop, or you can request the refund from the Visitor's Rebate Program in Ottawa. Excluded from the tax are camping fees, meals, restaurant bills, wine, beer, groceries, and fuel.

Communicating with the inhabitants also deserves special consideration. French is the language of Québec, including Percé. Some of the locals insist on speaking only that language, while others bend over backward to assist you with a combination of French, English, sign language, and help from anybody nearby. But almost everyone speaks a little English, so you shouldn't have any major language difficulties. You might even find it fun to remember or brush up on your high-school French.

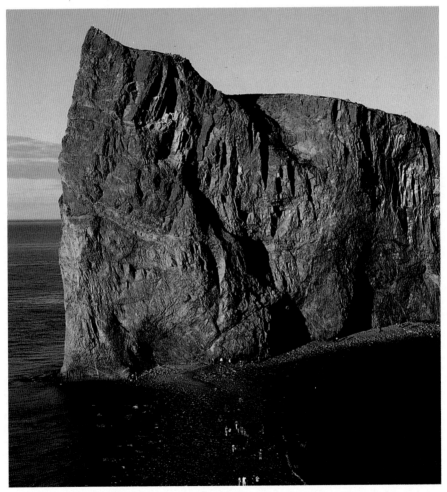

Percé Rock, a favorite spot of fossil hunters and sightseers alike.

BOSQUE DEL APACHE
NATIONAL WILDLIFE REFUGE

ONE OF THE BEST places to photograph snow geese and sandhill cranes, among other types of wildlife, is the Bosque del Apache National Wildlife Refuge in New Mexico. The geese and sandhills are found in this area during their migration from and to their northern breeding and nesting grounds. The birds prefer the climate in the middle section of the state, and the Bosque refuge gives them a source of food and water. Pronounced "bosskay," the name of this wildlife refuge has Spanish origins and translates into "woods of the Apache." It seems that the Indians used to like to camp among the cottonwoods along the Rio Grande River. 🙠 Bosque is at an altitude of about 4,500 feet in the flat, wide valley of the Rio Grande, about 90 miles south of Albuquerque. The Chupaduras, a small but spectacular group of mountains, lie just outside the western border of the refuge, and there are some distant mountains to the east. 🙠 Bosque originally became federal land in 1936 and was set aside as part of the National Wildlife Refuge System in 1939. The refuge was primarily established to protect sandhill cranes as well as waterfowl and other wildlife. As the years went by land formerly occupied by these birds became unavailable because of development, farming, and other human uses. Recognizing the relative safety of Bosque, the birds now concentrate on this 57,000-acre preserve as they migrate both north- and southward. 🙠 To give you an idea of how many birds come to the refuge, the following numbers represent the daily count of a typical visit in late November: snow geese, 39,000; various ducks, 18,000; sandhill cranes, 13,000; Canada geese, 320; and whooping cranes, 6. In addition I saw between 50 and 75 wild turkeys, 3 coyotes, 12 mule deer, many red-tailed hawks, several roadrunners, a pheasant, and a prairie dog.

APPROACHING
SNOW GEESE
AND SANDHILL
CRANES

GETTING THERE

The Bosque refuge is located just to the west of the Rio Grande River, perhaps a mere 100 yards or so. This once majestic river, now tamed and harnessed for irrigation and flood control, originates in Colorado, flows south through the middle of New Mexico, then southeast along the Mexico-Texas border, and eventually empties into the Gulf of Mexico. Migrating waterfowl find the river a favorable place for food and rest, and it is an important part of the Central Flyway.

In order to get to Bosque del Apache, most people fly into Albuquerque International Airport (see below). From there, pick up Interstate 25, which is just west of the airport, and follow the road south for about 90 miles to Socorro. Continue south on Interstate 25 for about 10 miles until you reach San Antonio. Then turn left onto Route 380 East. At the blinking light in the center of San Antonio, turn right and follow the signs to the Bosque refuge.

NEAREST AIRPORT

Albuquerque International, the nearest major airport to the refuge, is about 90 miles to its north. It is serviced by most major airlines. (Try to get a window

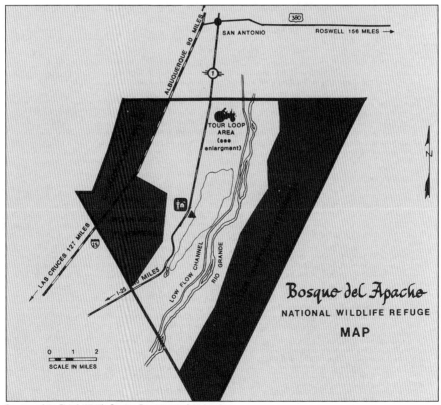

Courtesy of the Fish & Wildlife Service, Department of the Interior.

seat as the surrounding scenery is pretty spectacular.) Just a few blocks from the airport, which is conveniently on the south side of the city, is Interstate 25. This road leads south to Bosque.

CAR RENTALS
You'll find most of the major car-rental agencies at Albuquerque either on the airport grounds or located just outside. Shuttle buses run to the off-site car-rental agencies every 5 minutes or so.

EXPLORING THE REFUGE

 Bosque is a highly managed wildlife refuge. As historic feeding areas dwindle to the north, migrating birds congregate in ever-increasing numbers at Bosque. To feed all of the birds, local farmers grow a variety of crops. Taking part in a cooperative venture, they're allowed to grow corn, alfalfa, malt, barley, and wheat on these federal lands. They keep two thirds of the crop; the rest is for the wildlife. This arrangement provides food for waterfowl and helps local farmers. Several of these fields are visible in the area. In addition the refuge management regularly floods and drains certain parts of the refuge in order to encourage new plant growth and to diversify habitats.

Public access to Bosque is provided by a 15-mile-long dirt road that loops through wetlands, marshes, fields, woods, and grasslands. This tour road is oriented north and south, paralleling the Rio Grande immediately to the east, and

Snow geese *in flight, a memorable sight.*

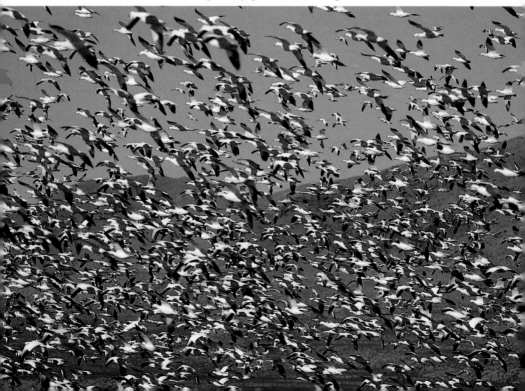

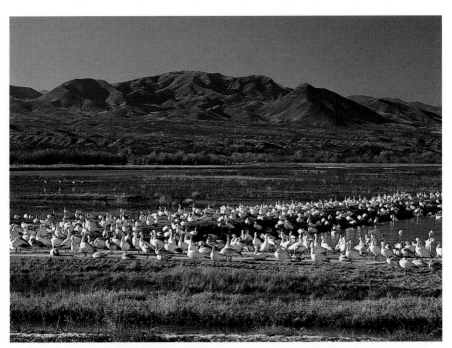

Snow geese with the Chupadera Mountains as a backdrop.

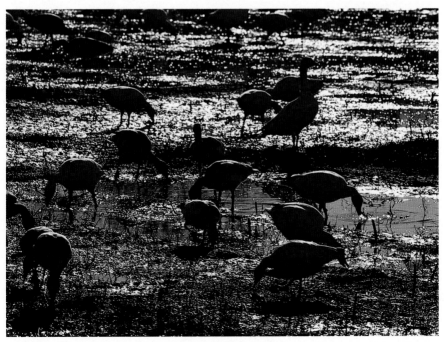

Snow geese in the mud.

from the air it looks like an elongated lamb chop with the larger portion to the north. References to specific parts of the tour loop are made by compass direction. For example, the south loop and the north loop are connected by a short east-west cross road that bisects the lamb chop. These two main tour loops are one-way roads that you drive on in a counterclockwise direction, while the cross road is a two-way road. This simplifies the traffic flow and enables you to choose either loop and to return to the entrance area without having to drive the entire 15 miles of the tour loop.

The headquarters compound, which has a visitor center, restrooms, and maintenance and living quarters, lies at the middle of the lamb chop on the west side of the cross road. Stop in and chat with a knowledgeable volunteer or member of the Bosque staff. These individuals can tell you which types of wildlife are at Bosque that day and where you might find them. Pick up a copy of the refuge map that shows the tour route. And be sure to look at the informative exhibit at the visitor center; studying it is well worth your time.

DRIVING ALONG THE TOUR ROAD

The wildlife tour begins on the other side of the main gate. After you pay the entrance fee, turn right and follow the road south to the south loop. (The refuge itself will always be on your left throughout the tour loops.) This loop passes through flooded areas, marshes, and wooded places. Drive slowly, and keep your eyes open. You'll go by an observation tower on your left, one of two on the refuge. (Neither one is particularly high but if I were to choose which one to climb, I'd opt for the taller one on the north loop.) Continue on past the observation tower. To your right, almost at the end of this road, is a freshwater pond that can be a good spot for photographing shorebirds. There is a ditch between you and a road alongside the pond. At first you won't think that there is any way to cross the ditch. Just keep going south. Eventually you'll come upon an access road to the pond.

Courtesy of the Fish & Wildlife Service, Department of the Interior.

Once you pass the pond crossover, the tour loop swings to the east. This is a very short leg, but it provides you with a good look northward into the refuge. When you pass the southern-most part of the tour loop, the road heads north. As you make the turn, you are on the east side of the refuge. Keep a lookout for prairie dogs in this area. There are usually several burrows along the edges of the road. The entrances to the burrows are holes about 4 inches in diameter. Prairie dogs can be quite bold and sit for pictures, but they can also be very skittish and disappear into the burrows in a second. So drive very slowly as you approach the prairie-dog area. It is possible to get good pictures from your car.

Continuing north (still on the east side of the south loop) you eventually come to the main cross road. Here you can return to either the headquarters area or the south loop, or continue straight ahead to the north loop. In general I find the north loop a better place to photograph most of the wildlife at Bosque. The feeding areas seem more adequate, and this upper portion of the refuge has more room for the birds to spread out. After all it does take some room to accommodate 40,000 or more snow geese. Fairly soon after passing the cross road, the tour drive makes a small dog leg to the left and then to the right. This is one of the few places where there is no ditch alongside the road. It is also a preferred spot for shooting.

After the dog leg you come upon major feeding areas for snow geese and sandhill cranes. These birds are often right on the side of the road and within easy 200mm-lens range. This area is also a great place for shooting scenics because the Chupadera Mountains lie just across from the refuge to the west.

As you continue north along the upper east side of the north loop, you come upon a small building on your right, which is the only restroom facility on the tour route. After you pass the restrooms, the tour road bends sharply to the left and heads roughly southwest. This is one of my favorite areas for photographing sandhills and snow geese. The extensive food crops planted along here attract the birds, especially late in the afternoon. There is an irrigation ditch to your right, however, so a separation does exist between you and the fields. The second observation tower is located at this end of the tour loop. I like this tower best because it has a powerful, mounted binocular and provides a good view out over the feeding areas. Just past the tower is the parking lot; you can leave your car there and hike a short distance, thereby getting off the road for a bit.

Continuing on the tour loop I generally find the next half mile or so not very productive photographically, although on one trip to the refuge I did get my best shot of a buck mule deer here. Finally the road swings due south and takes you past a large flooded area (on your left). I find this a good spot to shoot from at sunrise because you can get silhouettes of any birds that are there. A short distance beyond this flooded area is the exit from the tour loop road.

Red-tailed hawk perched in a tree.

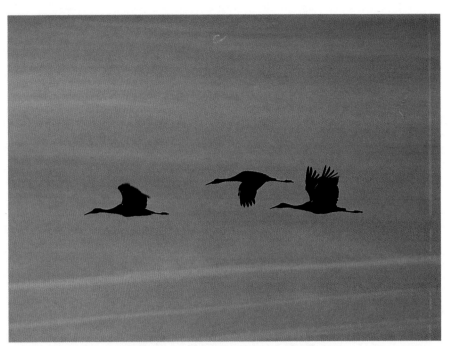

Sandhill cranes flying over the tour road at dusk.

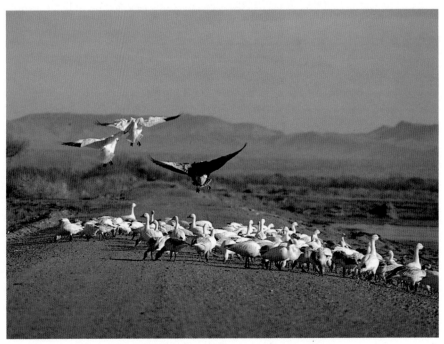

Snow geese landing on the tour road one morning.

HOW TO PHOTOGRAPH THE WILDLIFE

As you might suspect, the photography at Bosque is superb. Not only are there plenty of wildlife subjects but they are also easily photographed. One noticeable feature that makes the refuge such a great place to photograph wildlife is a system of inner roads and water-filled ditches that parallel the tour road. These are used for maintenance and irrigation. So even if you get out of your car to shoot, there is still a double set of barriers for much of the tour loop. Their presence makes the wildlife feel safer, and your subjects are more willing to stay put while you shoot. This leads to successful photography.

I find the following daily routine to be useful at Bosque. Before sunrise I get into position on the south end of the north tour loop (just before the exit gate). This area is usually flooded, and sandhill cranes that have come into the refuge for the night are often here. In the morning the sun rises behind them, silhouetting them against the sun. If the sunrise has some sky color to it, those colors will be reflected in the water. If conditions are just right, morning mists will add to the beauty of your pictures.

As soon as the sun is fully risen, the magic light of the sunrise is gone. I then head for the eastern side of the north tour loop. To save time, I skip the south loop and scoot across on the two-way cross road. I like to get to the feeding and resting places just north of the dog leg. This puts the sun behind the camera and provides frontlighting for the subjects, usually sandhill cranes and snow geese. The Chupadera Mountains don't usually photograph well in the morning because of this very flat lighting, so this is the perfect time to try for frame-filling shots of sandhill cranes and snow geese.

Be aware of backgrounds in your compositions on the east side of the refuge. Literally thousands of birds are there during the night. If a particular area is partially flooded, the birds will have turned it into a muddy mess. I try to find subjects along this area that are on firmer, more natural ground.

An hour or two after sunrise, I like to head for the feeding fields at the north end of the refuge. Because the sun is now high enough, you can increase the shutter speed in order to get some action shots. The regular routine for sandhill cranes and snow geese is to fly out of the inner refuge areas. The lighting at this time of the day is usually ideal for in-flight pictures as the birds head for the adjacent fields. The north tower is a good place to shoot from, but you can even shoot from the road because the birds are often right overhead.

In addition to sandhill cranes the endangered whooping crane is found at Bosque, generally at the north end of the refuge. Whooping cranes are usually present in very small numbers, from just half a dozen to a dozen. These cranes are taller than their sandhill cousins and stand out even more because they are mostly white. Check at the refuge headquarters to see if any whooping cranes are around. I've never found them very close to the refuge tour road, but I've been told that they are sometimes right alongside. Maybe your luck will be better than mine.

After shooting a few rolls of film I like to take a tour around the entire refuge around midmorning. This is a good time to look for some ducks, check out the prairie dogs, and see what other subjects are worth photographing. You might also use this time to explore the area around the Rio Grande. Park in the lot to the east of the two-way cross road. Then walk farther east, crossing the bridge over the irrigation canal. Ahead of you is a prominent levee with two angled access roads to the top. Take the left-hand one, and walk about 100 yards north along the top of the levee. Look for an opening in the trees and a road that takes you down to the river. The Rio Grande is visible from the levee at this point, as is a large sign that warns you that beyond where you're standing is a missile carryover area; this is part of the White Sands missile test site off to the southeast. It might be wise, as the sign suggests, to check with the headquarters staff when you plan your trip, to avoid the possibility of something unexpected dropping from the sky. There is a great deal of silt along the edge of the river, so walk carefully. I'm told that coming upon quicksand is also a possibility, but I've never come across any.

If Bosque is quiet from mid- to late morning, this is a good time to leave the refuge and to explore the nearby countryside. But don't go too far. I like to get back to Bosque by mid- to late afternoon and usually head directly for the east side of the north tour loop. At this time of day the sun has moved to the point where the Chupaderas are sidelighted; this illumination gives them appealing definition and texture. As such the mountains now make a better backdrop for the wildlife at Bosque. This is the time of day I like to concentrate on shooting scenics. As the afternoon wears on, sandhill cranes and snow geese mill around a lot. While they are airborne, they photograph well against the mountains. I tend to position myself at the southern end of the north loop in order to get these shots. A truly wonderful shooting spot is a place just south of the dog leg, where there is no ditch.

Late in the afternoon, I usually head back to the north end of the north loop. The sun is behind me now as the sandhill cranes and snow geese head back into the refuge for the night. This is a great place to be to record bird-in-flight shots. Many times these cranes feed in the adjacent fields and rise up, still slow in flight, right into the camera lens—an absolutely ideal shooting situation!

When the light levels drop so much that these action shots are impossible, I like to drive around to the east side of the tour loop (still on the northern end of the lamb chop) and wait for the sunset over the mountains. If the conditions are right, spectacular sunset colors will add to silhouettes of flying cranes and geese.

So far I've pretty much discussed only the birds at the refuge, especially sandhill cranes and snow geese, because these are the primary forms of wildlife found at Bosque; however, other types of wildlife live there, too. For example, the mule deer, with their huge ears, are quite photogenic. They are most active in the early morning, and I've generally found them at the north end of the

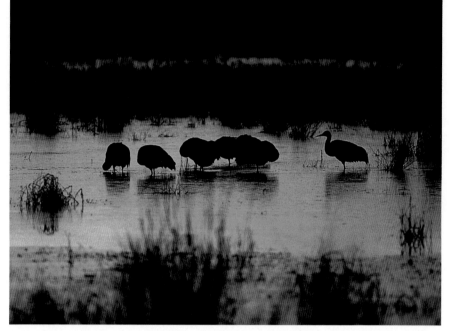

Sandhill cranes silhouetted at sunrise.

north loop. A good place to look for coyotes is in the bushy field just north of the dog leg on the lower east side of the north loop. This field is on the left as you drive along the loop and has a string of telephone poles across it. I've had the best luck with prairie dogs from the early part of the day to midmorning, especially at the south end of the refuge. If none of these small animals are present, position yourself and wait. Finally, wild turkeys seem to favor the fields at the north end of the north loop. As with most wildlife, they are most active early in the day and late in the afternoon.

PHOTOGRAPHIC EQUIPMENT AND FILM

If you're interested in photographing sandhill cranes and snow geese, which are fairly large birds, especially the sandhills, you might be able to get by with only a 200mm lens or a zoom lens that extends to 200mm at Bosque. But you might have to exercise some patience and catch these birds on film when they are close to the road or when there is no ditch or inner road to keep them at a distance from you. I think that you'd be better off shooting with a 300mm or 400mm lens in order to enable you to visually reach out over these physical barriers.

Because of the scenic possibilities at the refuge, using a standard or 100mm lens enables you to include the mountains in your images and to interject some

variety into your pictures. Although I carry wide-angle lenses, I've rarely found the need for them at Bosque.

If you plan to fly in to Albuquerque when you visit Bosque, you can save some baggage weight by leaving your tripod behind and bringing a beanbag instead. Your car can serve as a mobile blind, and placing the beanbag on the window ledge will provide more-than-adequate support. Another shooting technique I employ, especially with long lenses, is to slowly get out of my car and lay my camera and lens on the beanbag across the roof. This is much easier than trying to balance everything on the window ledge and is a steadier platform because more surface area of the lens is supported. If you don't have a beanbag, even a folded jacket will suffice.

Keep in mind that strong winds roar up and down the Rio Grande valley. In fact I find Bosque to be a very dusty place! I strongly urge you to carry plenty of lens-cleaning tissue, as well as something that you can use to effectively and safely blow dust off your cameras and lenses. I either use a large ear syringe or just forcefully blow the dust off. To save on the expense of lens tissue I always carry a large supply of clean, well-washed cotton handkerchiefs.

Sunset over the Chupadera Mountains.

PHOTOGRAPHIC SUPPLIES AND REPAIRS

Some types of film are available in Socorro. Look for a parking-lot photo-processing hut; Kodachrome 25 is actually for sale there. You can also try some of the stores. The nearest photo-supply places are in Albuquerque. There are several listed in the *Yellow Pages* as well as three repair facilities. So if something jams up—it might be clogged with dust—you can seek help. But since these facilities are 90 minutes away, they aren't very convenient.

There is a post office in Socorro, but it is closed on Saturday. All isn't lost, however, if you want to mail your film for processing. The Food Basket at the north end of town has post-office services and is open seven days a week.

THE BEST TIME TO VISIT

 The main reason for visiting the Bosque refuge is to photograph the sandhill cranes and snow geese, so it makes sense to go when they are there. On average, the birds start arriving the first week in November and stay until early February. However, you want to be at Bosque when the numbers are at their peak. The best time to visit then is the period from the end of November to mid-December. The highest number of human visitors arrive during Thanksgiving weekend; try to avoid coming then.

Although Bosque's prime responsibility as a wildlife refuge is to the sandhill cranes, vast numbers of snow geese also find the refuge suitable. In an attempt to keep the geese from decimating certain feeding areas, the refuge sponsors eight hunting days each autumn, usually in late October and through November. These generally fall on Mondays and Thursdays. During only the morning, parts of the refuge are closed to the public (the north end remains open). If you feel this might be of concern during a planned trip, call the refuge headquarters and ask about scheduled hunts. There is some talk about discontinuing them, so they might not be a problem. But it is a good idea to check anyway.

If I had to choose only one time to visit Bosque, it would be the first full week in December. Peak numbers of birds are there, and the very cold winter is still a way off. Although New Mexican weather at this time of year is typically cold at night, possibly getting down into the teens, the days are sunny and somewhat warm: temperatures can rise into the sixties. Nevertheless I suggest bringing along gloves for any early-morning shooting until the sun heats up the air. I bring a down parka with me, too, and warm footwear is also a smart idea.

HOW LONG TO STAY

 Shooting at Bosque del Apache for three to five days during the middle of the week is ideal. The number of visitors goes up drastically on weekends, but the refuge is almost empty the rest of the week. And while the dust problem is manageable on weekdays, the extra weekend traffic can easily make these conditions intolerable.

You should plan to spend several days shooting at Bosque for other reasons, too. I find that sunrises in the western part of the nation tend to happen quite quickly, so it is very easy to miss a good one. And to record exceptionally beautiful sunsets, you'll want to shoot on a breezy day because the wind blowing the dust around will enhance the colors of the sky. Finally, you might also have to wait for the particular animals you want to photograph to appear; they might not always be present when you are ready to shoot.

LODGING AND DINING

 There are no accommodations very near Bosque. You'll probably stay in Socorro, which is 10 miles north of the refuge. This is the closest community to Bosque, as well as the largest in terms of lodging and dining. There are several motels; plenty of grocery stores; 22 gas stations, some of which sell diesel fuel; and many restaurants. Write or call the Chamber of Commerce for a list of places to stay (see page 184), or have your travel agent book a place for you.

There are really only two campgrounds in the area that are convenient to Bosque. One is located at the south end of Socorro, and the other is just 5 miles north of the refuge. The Chamber of Commerce probably lists both of them; if not, simply call the refuge headquarters and ask them about camping. Both campgrounds have electrical and waste hookups along with shower facilities. The one in Socorro is an old KOA campground with many campsites, while the one on the refuge road is quite small with only about 10 sites.

You can also camp in Water Canyon, which is about a 40-minute drive from Bosque and 10 miles west of Socorro off Route 60. There is no sign; you just turn left (south) immediately before the historical marker and follow that road for a mile or so. Water Canyon is part of Cibola National Forest and offers a few free campsites that are scattered among the pines. But there are no hookups of any kind, only a toilet. Water Canyon is really set up for tents or small, self-contained campers but it is a lovely place.

If you like Mexican food, you'll be glad to learn that three or four restaurants in town specialize in this style of cooking. If you plan on having lunch outside the refuge, try the world-famous green-chile cheeseburgers at the Owl Bar & Cafe in San Antonio, which is 8 miles north of the refuge. Rumor has it that the bar came from the original Hilton Hotel.

NEARBY PLACES OF INTEREST

 Although the state's highway system is great, there is so much distance to travel in between destinations that there aren't many other places of interest near Bosque del Apache. But a couple of places are worth exploring. As you enter the town of Magdalena, which is 27 miles west of Socorro, look for the ranger station on your left. Turn there for the old ghost

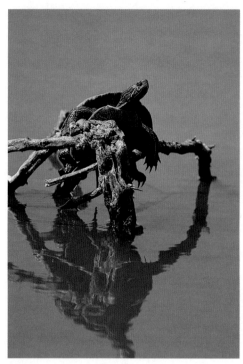

town of **Kelly**; now you're heading south on Route 114. When the pavement ends at a fork in the road, turn left and head uphill for Kelly. The total distance from Magdalena to Kelly is 3½ miles. At one time Kelly was the most prosperous mining town in Central New Mexico and was known primarily for its silver and zinc carbonate (used in the manufacture of paint). Today, however, there isn't much left in Kelly besides the church, some foundations, and two prominent mines. The short path into the upper mine is closed off, but there are a lot of footprints leading to and fro. The lower mine is still used by the New Mexico Institute of Mining and Technology. If you want to see where the stuff that makes film work used to come from,

Western painted turtle enjoying the afternoon sun at the edge of a pond.

going to Kelly will give you an understanding of some of the effort involved.

The site of the world's largest radio telescope is 24 miles west of Magdalena. The telescope consists of 27 dish antennas with 90-foot diameters spread out over miles of flat country. The site, which is called the VLA (for "Very Large Array"), has a visitor center. You can even walk out to some of the antennas. The VLA is worth visiting if you're interested in this type of technology.

Socorro has a self-guided walking tour that features 26 places. Check with the Chamber of Commerce for more information. On the **New Mexico Institute of Mining & Technology** campus, on the west side of town, you'll find a mineral museum and a first-class golf course that is open to the public.

Another enjoyable side trip involves heading east on Route 380 out of San Antonio. You'll pass through the old mining town of Carthage on the way to Bingham. Turn left at Bingham to the **Salinas National Monument** where you'll find two seventeenth-century churches, old Indian pueblos, and a museum. And about 35 miles east of Bingham, also on Route 380, you'll come across the lava beds at **Valley of Fires State Park**. This area of old lava flows has about 20 campsites and a hiking trail that leads you into the strange formations themselves.

Coyotes camouflaged in a field.

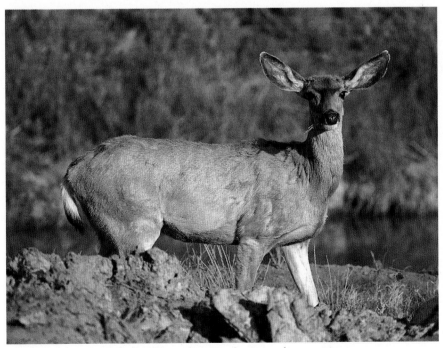

Mule deer doe standing near the tour road one morning.

BRIGANTINE NATIONAL WILDLIFE REFUGE

A REALLY GREAT AREA for wildlife photography is the Brigantine National Wildlife Refuge, located in Oceanville in southern New Jersey. This refuge is a major stopover for waterfowl migrating along the eastern seaboard. As the Atlantic coastline continues to lose wetlands and salt marshes to development, migrating waterfowl tend to congregate in the areas that are left. Because of this, phenomenally large groups of birds are found in Brigantine. In reality this small part of the New Jersey shoreline is literally a refuge, providing the necessary water, food, and shelter that are so vital to these migrating species. ❧ The refuge was established as Brigantine in 1939 and was renamed the Edwin B. Forsythe National Wildlife Refuge in 1984 to honor that New Jersey Congressman's environmental efforts. Later that same year this refuge and another one located in Barnegat, New Jersey, were combined under the same name. Brigantine is now referred to as the Brigantine Division of the Edwin B. Forsythe National Wildlife Refuge. But since the area has been known for many years as just plain Brigantine and so many people call it that, I'll refer to it in the same way. ❧ Brigantine contains a little more than 20,000 acres of prime salt marsh, tidal bays, and channels. During the 1950s a rectangular section of the salt marsh was enclosed by dikes to create two large impoundments. These two freshwater and brackish-water pools provide 1,600 acres of habitats. The auto tour route is laid out on top of the dike so visitors can drive out into the salt marsh and observe saltwater waterfowl on one side and freshwater birds on the other (see page 80). There is a lot of switching back and forth between the salt marsh and the impoundments. ❧ Brigantine attracts tens of thousands of migrating geese, ducks, wading birds, and shorebirds that pass through the area during both the spring and fall. In addition several species of waterfowl now make Brigantine their summer nesting area and raise their young on the refuge. Brigantine is also a major wintering spot for Atlantic brant and black ducks.

PURSUING MIGRATING WATERFOWL

GETTING THERE

 Incongruously Brigantine sits only a few miles across the water and salt marshes from Atlantic City. The refuge is located about a mile east of the town of Oceanville on Route 9. The main routes leading to Brigantine are the Garden State Parkway from the north and the Atlantic City Expressway from the west. Coming south on the Garden State, turn off at Exit 48 onto New Jersey Route 9 South. Drive past Smithville, which is about 7 miles from the parkway, and continue about 3 more miles south to Oceanville. If you're coming in on the Atlantic City Expressway, continue past the Garden State Parkway exit for about 3 miles, turn left onto Route 9 North, and stay on that road for about 9 miles to Oceanville. Then turn right onto Great Creek Road. (There is a small "National Wildlife" sign on Route 9, but it is easy to drive by it without seeing it. Look for a combination convenience store/post office on the east side of Route 9 at Great Creek Road.)

As you approach Brigantine you see the parking lot to your left and the refuge headquarters to the right. Take the time to visit the headquarters building, which houses an information office and various wildlife displays. You can also request to see a short film on Brigantine. The building is open on weekdays from 8 A.M. to 4 P.M. all year long. Located next to the parking lot are

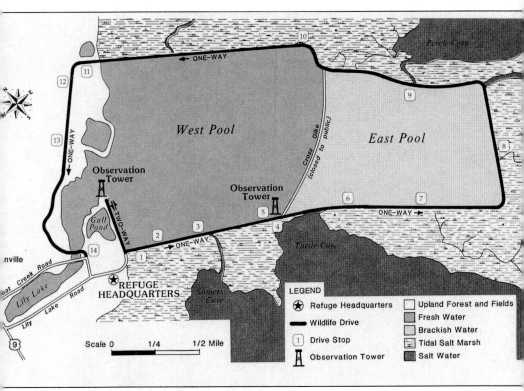

Courtesy of the Fish & Wildlife Service, Department of the Interior.

restrooms and an information booth. There is an entrance fee at Brigantine. Federal "Duck Stamps," and "Golden Eagle" and "Golden Age Passport" passes are also accepted for admission to the refuge. Duck stamps cost $15 dollars and are good for a year, starting in July. Golden Eagle passes entitle the bearer to free entrance to any federal fee areas, such as national parks and national wildlife refuges, cost $25 dollars, and are good during the calendar year starting January 1. Golden Age Passports are issued free of charge to persons 62 and over, and can be obtained at any federal recreation area. These passes also entitle bearers to a 50-percent reduction in fees at federal camping areas.

Perhaps a few words about these fees are in order here. For a long time there were no entrance fees to any of the national wildlife refuges. Land acquisition and refuge maintenance were paid for from taxes on hunting supplies and the Migratory Bird Hunting Stamp Program. This program, which was started in 1934, requires all hunters over the age of 16 to purchase and carry a duck stamp. To date the program has netted more than $350 million dollars and financed the purchase of more than 4 million acres of prime wetlands for migrating waterfowl. Many of the national wildlife refuges were originally acquired through duck-stamp monies.

Saltmarsh hay, a common grass with a fallen-over, cowlick appearance.

Snow geese flying over the north side of the West Pool.

Some people argue that since hunting is the main reason for maintaining these wetlands, hunters alone should carry the financial burden for them. However, much of the refuge land also provides habitats for songbirds, butterflies, mammals, amphibians, reptiles, other wildlife, and wildflowers—all of which are perfect subjects for photography. We photographers have been enjoying a free ride for a long time. So it seems to me only fair that since as photographers we also use these refuges, we should share the responsibility of maintaining the areas. For this reason, I always buy a duck stamp when I visit and urge you to do so, too. The attractive stamp is a pleasure to look at—the result of very stiff artists' competitions—and I feel that in a small way I'm helping some of the world's wildlife. A larger version of the duck stamp is also available and makes a nice gift.

NEAREST AIRPORT
Atlantic City International Airport is located about 10 miles west of Oceanville at Pomona. Three or four major airlines provide service from Boston, Washington, Philadelphia, and Newark.

CAR RENTALS
Avis and Budget car-rental agencies are located at the airport, and other national agencies can be found in Atlantic City.

EXPLORING THE REFUGE

 Brigantine is basically a salt marsh. You can gain access via an automobile tour road that has been built on top of the dikes that form two impoundments; this tour route is about 8 miles long. You can also reach the marsh via two walking trails that are considerably shorter than the car road, perhaps half a mile or so long.

DRIVING ALONG THE TOUR ROAD

Before you enter the refuge proper, pick up the *Self-Guiding Wildlife Drive* pamphlet; you can get one in the parking lot or the headquarters building. The drive has 14 numbered stops along the way, and the pamphlet explains each. It also suggests that you allow 1½ hours for the trip. In actuality, I find that I can't complete the circuit in fewer than several hours. There is just too much to see and photograph.

The tour road is two-way only at the very beginning, and the remainder of the route is one-way. Make sure that you have plenty of gas. An 8-mile-long road might not sound like much, but this is a dirt road with a 15 MPH speed limit and the going is slow. In addition you'll be making plenty of stops to look around and shoot. All of this will adversely affect your car's fuel efficiency. Also, I usually complete the loop and go right back out on it. If you aren't fully prepared and careful, you'll find that the car's fuel gauge seems to be dropping at an alarming rate.

After you pass the pay booth, you'll see a tiny parking lot for the Leeds Eco Trail on your right. Before you set out on this short trail, which is only half a mile long, be sure to pick up a copy of the pamphlet describing it. This brochure provides information on a self-guided tour of the trail and explains the various habitats. The Leeds Eco Trail winds along the edge of the salt marsh in a series of paths, little bridges, and boardwalks, and provides you with your only opportunity to get onto the marsh itself. The path then leads to the adjacent forest and back to the small parking lot. The trail is well worth the time you spend there. Even though I've had little success photographing birds because they are quite wary here, I always enjoy the walk.

The two dominant salt-marsh grasses seen along the way on the Leeds Eco Trail are very apparent. The taller one is cordgrass; this especially tough plant is found along the edges of creeks and channels only. The shorter and more abundant grass that often flattens out to form large cowlicks is saltmarsh hay. Although this grass once had great commercial value for use in agriculture as a mulch for strawberries, it isn't used as widely as it once was. Both of these grasses are unique in that they are able to survive the harsh saltwater environment.

Once you complete your walking tour on the Leeds Eco Trail, resume driving on the wildlife tour road. You'll immediately be faced with the choice of going straight or turning right. Continuing straight will take you to one of Brigantine's

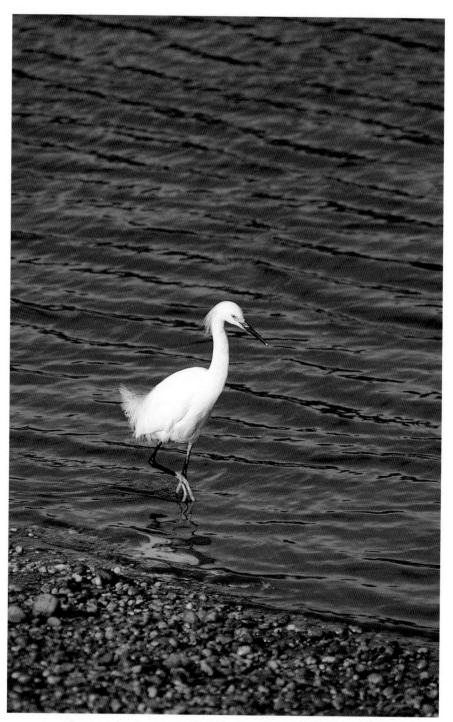

Snowy egret, *a frequent visitor to the refuge, on the edge of the tour road.*

two observation towers. This tower provides you with a view out over the mostly freshwater West Pool. This 900-acre impoundment is a great place to see a variety of ducks and other waterfowl. If you sit quietly in your car and exercise a little patience, you'll be able to shoot good pictures here. As you return from the tower, you see Gull Pond on your right. The pond was created by the removal of gravel to build the dikes out onto the marsh.

The short spur road to the first tower and the wildlife drive past Leeds Eco Trail are the only parts of the tour route where you encounter two-way traffic. The remainder of the dike road is all one-way, and you drive on it in a counterclockwise direction around the impoundments. This always keeps the fresh water on your left and the salt water on your right. The road itself is well graded, as well as wide enough for you to pull over and let other cars pass.

Next, as you head back out onto the wildlife drive proper, you can't miss a tall, reed-like grass called fragmites. This nonnative plant proliferates on disturbed soil, such as the dikes around the impoundments, and is a constant problem at Brigantine. Despite repeated burning, bulldozing, pulling, mowing, and other removal attempts, the fragmites seems to be winning and is quite a nuisance.

Shortly afterward you arrive at another observation tower called South Tower. Just beyond it is a 3/4-mile-long cross dike that separates the two impoundments. This dike was once open to the public but is now closed off because that area is part of a peregrine-falcon reintroduction program at Brigantine. The tower visible on the cross dike is used for the rearing and release of these spectacular birds, which you might see occasionally at the refuge.

The East Pool lies beyond the cross dike and consists of 700 acres of brackish water. This impoundment has more islands, sandbars, and mud bars than the West Pool does, and it also provides a better nesting habitat for resident ducks and geese. (Although the West Pool contains some islands, it is mostly open water.) The East Pool is also a vital feeding area for migrating waterfowl. As you start to drive along this pool, you pass a small beach on your right. Then as you continue along the wildlife drive, the road runs very straight (with the East Pool on your left and the salt marshes on your right). Eventually the road bends at a right angle. This is one of my favorite places to stop. You can park at the corner and enjoy a great view out over the marshes looking toward Atlantic City.

Then the road continues along the east side of the East Pool, takes another right-angle bend, and then turns to the left to direct you back toward land. This section of the road along the north side of both impoundments provides new views out over the pools and marshes.

Passing the last part of the West Pool, the road now leaves the dikes and gently climbs to meadows, fields, and hardwoods. Occasionally you can see deer here, possibly a raccoon or turtle, and lots of wildflowers in the spring. The tower in the field on the left is also involved with the peregrine-falcon reintro-

duction program. The road eventually brings you over a tiny bridge at Doughty Creek, a major source of fresh water for the impoundment pools. Just beyond the creek is the end of the wildlife drive. Here at the one-way gate, you can turn right and leave the area or, as I usually do, turn left and drive through again.

HOW TO PHOTOGRAPH THE WILDLIFE

 There is excellent public access to Brigantine. The automobile tour road runs right through the refuge, so birds have grown used to the presence of cars and people. As a result if you stay in or near your car (which acts as a photo blind by concealing your presence from the wildlife), you can get quite close to some of these waterfowl. Since many of the birds are in the process of migrating and have been flying long distances, they can be tired and hungry. This also tends to keep them around and makes them willing subjects. Sometimes you can park along the auto route and be within 20 or 30 feet of snow geese. If you were to try to photograph these birds somewhere other than a wildlife refuge, you'd be lucky to get within 200 yards of them. When you combine these various features, you have the opportunity for some great wildlife photography at Brigantine.

An important variable to consider when shooting at Brigantine is the wind direction. Birds tend to land and take off into the wind. So I always check where the wind is coming from first. Then I drive along the tour road on the dike and look for a good spot to photograph birds in flight. What I want is a place where both the sun and wind are to my back. This is an ideal situation because the wind slows down the birds, thereby enabling me to use slower shutter speeds, and the subjects are frontlighted. Years ago when I first started going to Brigantine, I stood or sat on the roof of my car and handholding a 200mm lens, shot away at snow geese coming into the impoundments for the night. Because the birds were gliding down into the sun, their heads and fronts were properly illuminated and there was almost no wing movement to slow down. The pictures from these visits remain in my files—and are still some of my best.

In addition to knowing the wind direction, it is also important, perhaps even more so, for you to be aware of the tides. This information is available at both the parking-lot information booth or the headquarters building. The tides greatly influence where the birds will be at Brigantine. When the tide is low, the outer marsh areas are available for feeding and your subjects are often too far away for you to be able to get any decent shots. Conversely, when the tide is high, the outer marsh areas are mostly submerged. This, in turn, forces the waterfowl to move in closer to the impoundments.

One day I was at Brigantine when the tide was low and discovered that the snow geese were all too far out in the salt marshes to photograph. So the next day I came back at high tide and found tens of thousands of snow geese right next to the dike road. The only thing separating me from the birds was a 100-

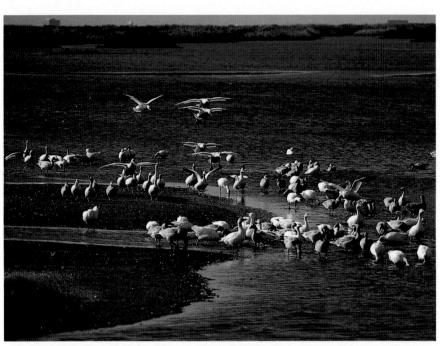

Snow geese landing at the water's edge on a West Pool sandbar.

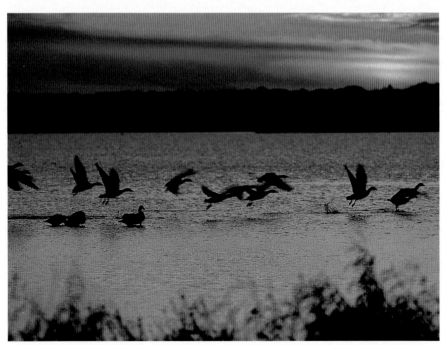

Snow geese photographed against the setting sun from the eastern section of the tour road.

foot mud flat. The wildlife felt secure because of this barrier, so they stayed there, eating, preening, and casually strolling around. All this produced good photographs, whereas the day before I was able to get only very few.

One area to keep in mind when planning to shoot at Brigantine is the south road in the vicinity of the observation tower. If atmospheric conditions are right—when dust or other particles in the air give the sky some color—you should be able to get some great shots of migrating geese against the setting sun. As suggested earlier, try some shooting from the tower itself. The pictures you shoot from this higher level offer a different perspective than those you shoot while standing on the tour road.

WHERE TO SHOOT

The Leeds Eco Trail is a good place for shooting scenics of the marsh, and you can even photograph fiddler crabs from the first little bridge at low tide. (The crabs with one huge claw are the males.) Gull Pond is another spot you might want to consider shooting from because it's occasionally used by migrating and resident waterfowl. But I've never had much luck shooting there because most of the wildlife seem to prefer other parts of the refuge. Fragmites, which can grow well over 6 feet tall, can easily obscure views from otherwise good vantage points throughout Brigantine. Nevertheless, you still might want to try shooting at Gull Pond; you can get a clear view out into the impoundments from one of the many breaks along the road.

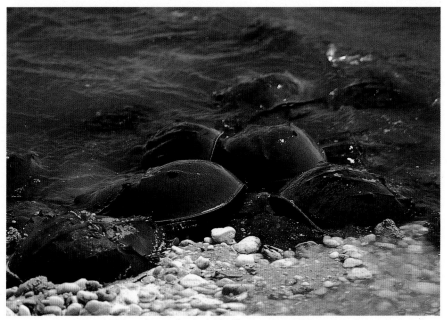

Horseshoe crabs on the beach, preparing to spawn.

And by all means climb the South Tower, and be sure to take your photo equipment along. This elevated platform gives you the best overall view of Brigantine, the impoundments, the surrounding salt marshes, and the open bays beyond. The tower also offers a great vantage point for sunset pictures.

The small beach on the right as you drive along the East Pool used to be an outstanding place to photograph horseshoe crabs during the early summer. They come to the beach by the thousands to lay eggs, which in turn attract various gulls and shorebirds. Even though the beach is now off-limits to visitors, you can still shoot some good photographs from the road when the birds feed on the horseshoe crabs. In addition the stretch of the wildlife drive along the north side of the impoundments is an excellent place for capturing images of snow geese flying into the impoundments or out to the salt marshes.

PHOTOGRAPHIC EQUIPMENT AND FILM

You can easily run the gamut of lens focal lengths at Brigantine. To photograph the amazing sight of several hundred snow geese coming in for a landing right over your head, you might decide on a standard lens. I also find that handholding either a 100mm or 200mm lens works well, even for shots of individual birds. For shooting situations where the birds are at a greater distance, perhaps sitting on a nest or feeding, you might need a 400mm or longer lens. Then again sometimes there are so many birds of one species in the same place that I've used a standard lens in order to include both the birds and their habitat.

The majority of my photographic endeavors at Brigantine involve an automobile blind. I find that a beanbag placed on the window ledge of my car provides the best support, even for long lenses. If the wind doesn't shake the car, this arrangement is exceptionally stable, convenient, and easy to work with. If, however, you don't have a beanbag but do have a tripod, bring it with you to Brigantine. I use my tripod when I shoot from outside my car, usually alongside it on the tour road. If I get out of my car very slowly, most of the birds stay around. I also like to shoot using a beanbag placed on top of my car, keeping the vehicle between my subject and me. My choice of a camera-and-lens support depends on where the birds are, how tolerant they seem to be, and what direction I'm shooting in.

In terms of film, I suggest bringing whatever film you usually shoot because the subjects don't require special considerations. I've been able to successfully photograph geese coming in for a landing with Kodachrome 25.

PHOTOGRAPHIC SUPPLIES AND REPAIRS

Although there are several photography stores in the Pleasantville and Mays Landing areas, both to the south of Brigantine, you might not find just what you need beyond the basics in film and supplies. Atlantic City is only about 30

minutes from the refuge and has about half a dozen camera shops. The largest is The Camera Shop (another franchise is located in Mays Landing). The repair shop closest to Brigantine is Young Photographic, located in Cardiff about 7 miles west of Pleasantville off Routes 40/322. This store offers authorized Canon and Minolta service, and can handle many other brands of equipment as well.

One-hour processing of prints is available in the Brigantine area. Also, there is a post office in the convenience store on the corner of Route 9 and Great Creek Road, which is right outside Brigantine. So local mailing of any film is no problem. This combination store/post office is open Monday through Friday, and Saturday mornings (see page 185).

THE BEST TIME TO VISIT

 Brigantine is open all year, but the spring and fall are the best times to visit. I prefer fall because migrating birds are more plentiful then and are apt to linger at the refuge. Although the same birds pass through in the spring, they are in a hurry to reach their more northern breeding grounds. Before you go, be sure to contact the refuge headquarters and ask for a copy of the *Calendar of Wildlife Events* pamphlet (see page 185). This one-page flyer is a valuable tool for planning purposes; it lists which birds are at Brigantine during the year and their primary activities, such as nesting and migrating. The calendar also provides the average times that peak numbers of birds are at the refuge. Here are some of the more important events in terms of photography.

I think that the fall migration of snow geese is the most spectacular display. It isn't unusual to see between 50,000 and 60,000 of these large white birds at one time, and their flights into the refuge for the night can be spellbinding! Although snow geese begin arriving at Brigantine in late October, their numbers peak between mid-November and mid-December. This is also the time when you might see bald eagles around the refuge.

On a recent November trip to Brigantine, I saw the following birds at the refuge: about 30,000 snow geese, several hundred Canada geese, several thousand brant (these were too far away to photograph but easily recognizable with binoculars), lots of shoveller ducks, gadwalls, pintails, blue-winged teals, buffleheads, great blue herons, great egrets, a northern harrier, several other species of shorebirds, and what I believed to be a peregrine falcon (this distant sighting was the result of a brief binocular glimpse). But the snow geese are the most breathtaking of all the birds because of their color and numbers.

The peak of northbound waterfowl migration during the spring usually occurs from the end of March to mid-April. Shorebirds and wading birds start arriving during the end of April. Canada geese hatch early, and goslings begin feeding on the dikes by mid-May. Ducklings are found on the refuge from mid-June to mid-July.

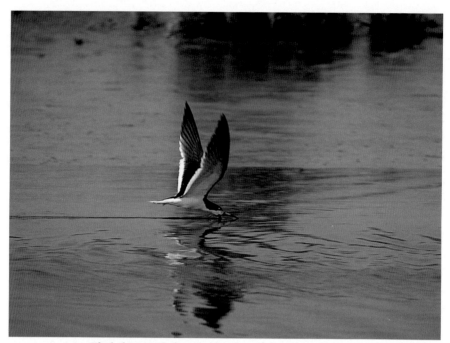

Black skimmer feeding along a narrow band of marsh channel.

Mosquito cloud at sunset.

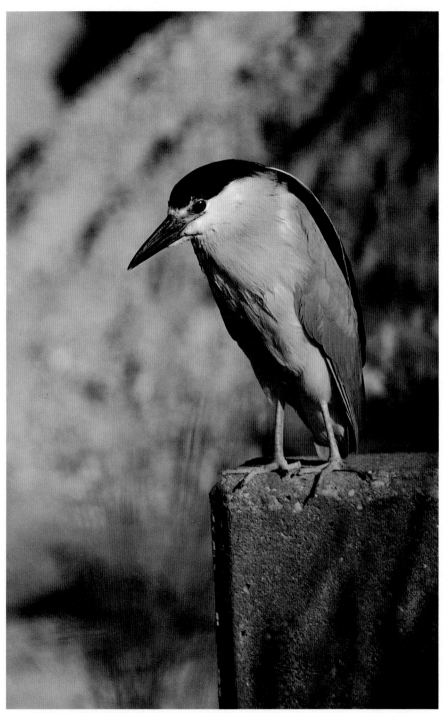

Black-crowned night heron, a surprise visitor to the refuge, on a concrete water gate.

When planning a spring or summer trip to Brigantine, you need to give some serious thought to biting insects. The area is prime salt marsh and a perfect habitat for mosquitoes. Their numbers can be frightening when conditions are right, so I try to go to the refuge in late April up through the latter part of May. Unfortunately I also like to visit Brigantine in early June when the horseshoe crabs are spawning on the beach just beyond the South Tower. Depending on the temperatures and mosquito hatches, being at Brigantine can be a brutal experience. I usually don't like to use insect repellent, but I make an exception when I go to Brigantine. Another nasty insect at the refuge is the greenhead. This pest is quite common during the summer months, and I find it to be the most annoying insect. If you are lucky and a good wind is blowing, you might be able to sit in your car and shoot from a window; you'll encounter few insects because the wind will keep them away from you.

HOW LONG TO STAY

I always find plenty of things to see and do in this part of New Jersey. In order to be assured of having at least one day of good weather, I usually plan on spending a minimum of two or three days at Brigantine. This time frame also gives me a chance to figure out the tides so that I can plan what times to be at certain places on the refuge. I find that the best time of day for good shooting at Brigantine is from about midafternoon to sunset. The light is still strong, and many birds are coming in to the pools for the night. Early morning is also a good time to be out on the wildlife drive. If the nights are cool, mist and fog are possible in the morning. The light can be excellent then, and fewer people are around. My usual routine is to be on the dikes at or shortly after sunrise and shoot until around 9 A.M. Then I leave Brigantine and head somewhere else of interest, where I stay until midafternoon. Then I return to the refuge and shoot until sunset. I also like to factor in extra time for trips into the nearby Pine Barrens or perhaps a run down to Cape May, which is about an hour south of Brigantine (see page 93). Plan on an entire day for each of these side trips.

LODGING AND DINING

The area surrounding Brigantine has been built up considerably in the last decade because of the attractions at Atlantic City. For this reason there are plenty of places to stay, especially along Route 30 through nearby Absecon. Write to the local Chamber of Commerce or check with national motel chains (see page 185). Only motels that are members of the Chamber of Commerce are listed, but there are other local motels. You can also try asking the staff at the refuge headquarters for a reference.

There are a few New Jersey state campgrounds in the general area around the refuge, including Wharton State Forest, Lebanon State Forest, and Bass River

State Park. Just a 20-minute drive from Brigantine, Bass is the closest. A heavily wooded area in the Pine Barrens of New Jersey, the park has a total of 178 campsites, but only 85 are available from the end of October through May. The lean-tos and cottages in the park are closed from the end of October through May. Because Bass River has no drive-through sites or electrical, water, or waste hookups, you have to rely on local private campgrounds for those services. However, the park does have a heated restroom facility with showers. I stress the heated part because the temperature was 25°F two of the autumn mornings I stayed there. The heat was most welcome! You can make reservations, although in the fall the place is pretty empty, even on weekends. Contact the Bass River State Park headquarters (see page 185). To get to Bass River, follow the signs westward from Exit 52 off the Garden State Parkway.

A number of local private campgrounds have plenty of sites available during the late fall when the Brigantine migrations are at their peak. For a listing contact the New Jersey Division of Travel & Tourism in Clifton (see page 185), and ask for the latest New Jersey campground directory.

There are restaurants and fast food places in this area as well. The nearby towns of Absecon and Pleasantville, which are both to the south on Route 9, are home to plenty of banks, gas stations (diesel is available), and grocery stores. Whatever might be lacking in these two towns can surely be found in Atlantic City, which is about a 30-minute drive from Brigantine.

NEARBY PLACES OF INTEREST

Some of the attractions of Brigantine, outside of the waterfowl, are the nearby areas of interest. The refuge sits just outside the eastern edge of the famous New Jersey Pinelands (also referred to as the **Pine Barrens**). This million-acre piece of land comprises about 20 percent of the total land area of New Jersey and is the largest tract of open space on the mid-Atlantic coast. The Pinelands are mostly pitch pine, cedar, and oak on a very sandy soil base. The area also has the largest unspoiled water source in the entire Northeast. Much of the water is in rivers and swamps. This unique habitat was recently designated a national reserve; it is also a biosphere reserve. The Pinelands are famous for cranberries, blueberries, hiking, camping, canoeing, and assorted flora and fauna, including the rare Curly Grass fern and the Pine Barrens tree frog.

In the center of the Pinelands lies **Wharton State Forest**. It offers canoeing, a multitude of hiking trails, and several campgrounds that are accessible by car and some that are accessible only by foot or canoe. The headquarters for Wharton State Forest is located in the historic village of **Batsto**, about 20 miles northwest of Brigantine on New Jersey State Road 542. Batsto village is the site of **Batsto Furnace** where cannonballs were cast for the Revolutionary Army. The village has been restored and comprises more than 30 buildings. These include

Tree frog photographed
with flash at
the Pine Barrens.

the furnace itself, gristmill, sawmill, glassworks, brickyard, and barns, which house some livestock. During the summer months many of the buildings are staffed with volunteers who wear period costumes and operate some of the exhibits. I always like to drive to Batsto and enjoy walking around the village.

About 30 miles south of Brigantine is the little village of **Stone Harbor**. As you approach the traffic light in town, turn right and then head south for several blocks. Here you'll find a two-block area of trees that has been set aside as a heron rookery. Although the edges have grown up over the years, if you search around, you can still find good views into the rookery and photograph various herons. Spring is the best time to visit because the birds nest then. There are some spectacular salt marshes in this area, and I try to spend some time out on them. Also when I make the trip down to Stone Harbor I usually continue to **Cape May**, which is just a few more miles south. One of the oldest seaside resorts in America, the town has more than 600 authentically restored Victorian houses. South Cape May Meadow and the Cape May Point State Park are premier birding areas, especially during the fall when hawks migrate southward.

Canada gosling resting on the tour road.

CHINCOTEAGUE NATIONAL WILDLIFE REFUGE

THE CHINCOTEAGUE National Wildlife Refuge is another all-important refuge for migrating waterfowl. It attracts thousands of snow geese, Canada geese, a variety of ducks, shorebirds, and wading birds. Established in 1934, the refuge is located on the eastern shore of Virginia, on the Delmarva Peninsula. This large body of land forms the eastern shore of the Chesapeake Bay, and Chincoteague is situated toward the bottom of the peninsula just below the Maryland-Virginia border. ✍ This particular refuge is unique in that it shares land with the National Park Service. This common ground is Assateague Island, a 32-mile-long, exceptionally skinny barrier beach. Only 3 miles wide at the widest point and less than a mile wide for most of its length, the island provides storm protection for Virginia's east coast. A devastating storm in 1962 required additional funding for the restoration of the area, which is how the National Park Service got involved. In return for the park service's financial assistance, the majority of Assateague Island was designated a national seashore. ✍ Long considered one of the best places on the East Coast of the United States for birders to add to their "life lists" (the checklists serious bird-watchers keep), Chincoteague is also home to diminutive Sika deer, white-tailed deer, endangered Delmarva fox squirrels, and the famous Chincoteague wild ponies. One of the most popular attractions at the refuge, the ponies live year round on Assateague Island. There are actually two separate herds. The National Park Service owns the ponies at the north end of the island, and these are kept separate by a cross-island fence. The ponies found at the south end of Assateague are owned by the local volunteer fire department. Its members keep the herd size under control by holding an annual auction on the last Wednesday and Thursday of July. After the ponies are rounded up on the island, they're made to swim across Assateague Channel into town for the auction. The event is quite popular, so this isn't a good time to visit

> ## CHASING WILD PONIES ON THE ISLAND

the area unless you want to join the throng. The town's population of 4,000 swells to more than 25,000 for the two days of the auction and stays that high through the following weekend. If you really want to be in Chincoteague then, you have to make your reservations early! ☙ The exact origin of the ponies is somewhat clouded and ranges from pirate castoffs to escapees from early settlers. Made famous by Marguerite Henry's book, *Misty*, these animals are truly wild. And despite their domestic look, once in a while they do bite or kick visitors to the refuge. Although this possibility exists, everybody seems to love the ponies at Chincoteague. Nothing stops traffic so much as these colorful animals, and you can photograph them easily when they are around. Often seen along the side of the road and sometimes right on it, the ponies occasionally seem to disappear entirely from the refuge. During my visits to Chincoteague, I've discovered that the beach-access road is one of the best places to find the ponies.

GETTING THERE

The Chincoteague refuge is located 3 miles east of the town of Chincoteague, Virginia. Head east on Virginia Route 175 from Highway 13, and soon you come to the Wallops Island NASA facility (see page

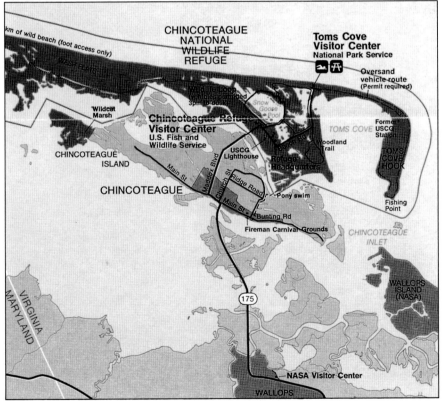

Courtesy of the Fish & Wildlife Service, Department of the Interior.

105). With all the antennae, rockets, and other equipment, you can't miss it. After you pass Wallops, you cross over little Mosquito Creek and end up out on a large salt marsh. A 4-mile-long causeway then brings you over the marsh to the drawbridge at Chincoteague. Continue on to the traffic light, turn left, go about three blocks, and turn right at the sign for Assateague Island. The refuge is about 3 miles straight ahead. There is an entry fee to the refuge at the entrance booth.

NEAREST AIRPORT

The nearest airport is Salisbury Wicomico County Regional Airport, located about 50 miles north of Chincoteague in Salisbury, Maryland. US Air is the only airline that serves Salisbury with connecting flights from Baltimore, Washington, and Philadelphia. It takes about an hour to get from the airport to Chincoteague via Maryland Route 13.

CAR RENTALS

Avis, Hertz, and National are the only car-rental agencies at the airport.

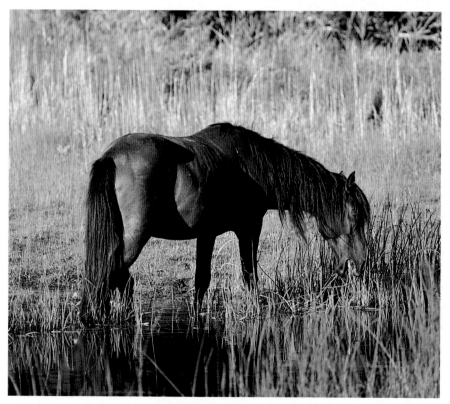

Wild pony feeding in the grass.

EXPLORING THE REFUGE

 The Chincoteague refuge occupies most of the southern tip of Assateague Island. The refuge has a headquarters building, a visitor center, an auditorium, a 3-mile-long paved Wildlife Loop, a 2-mile-long paved beach-access road, and several hiking trails. One of the most popular walking trails is the Woodland Trail, a 1.6-mile-long loop that brings you through pines to a viewing area for the ponies. (I've actually seen the ponies there only once or twice, but I still enjoyed the walk.) This paved trail is also open to bicycles. The area is the most likely place to see a Delmarva fox squirrel.

In addition visitors can hike and bicycle on several dirt maintenance roads that are open to foot traffic most of the time. They are sometimes closed in the spring because of nesting birds, trail maintenance, and for other reasons. The refuge terrain is very flat, so getting around isn't a problem. It is composed of salt marshes, beaches, two large freshwater impoundments, ponds, salt creeks, and channels. The two impoundments contain lots of islands and brush and make ideal nesting areas. The refuge also has a number of stands of loblolly pine and mixed hardwoods.

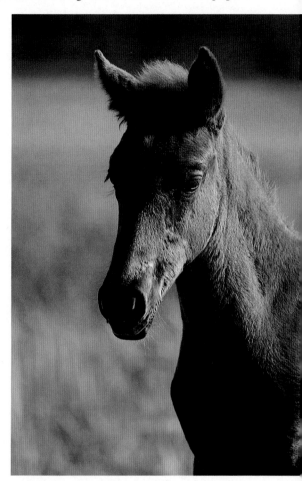

Wild pony close up, photographed without incident.

DRIVING ALONG THE TOUR ROADS

There are three automobile roads on the refuge: the beach-access road, Wildlife Loop, and Wash Flats. The roads are very different. The paved access road is always open during refuge hours and connects the entrance of the refuge to the beach. This two-way road takes you past Black Duck Marsh and Swan Cove, which are both on your left as you head toward the beach. This road also goes past the popular Woodland Trail (no cars are permitted on this path). The

beach area has several large parking lots, a National Seashore Visitor Center, and walking trails. It can be quite crowded, especially on summer weekends.

Wildlife Loop is open to vehicles from 3 P.M. until dusk and has a counter-clockwise traffic pattern. This road takes you around Snow Goose Pond, a large and popular spot for a variety of migrating and resident birds. There are two low observation platforms on the Loop and three or four hiking trails, one of which joins up with the beach-access road. Since automobiles are allowed on the Loop only in the afternoon, visitors travel on it via bicycle or foot the rest of the time. Cycling is a popular activity at Chincoteague, and many people bring their own bikes. If you want to ride a bicycle around the refuge but don't want to bring one with you, you can rent one in town.

At the north end of Wildlife Loop is the third car road, Wash Flats. This route is open to vehicles in November only, during Chincoteague's Waterfowl Week (see page 102). Between 4 and 5 miles long, this dirt maintenance road takes you past freshwater and saltwater marshes and a couple of ponds. You may walk on Wash Flats any time, but bicycles aren't allowed on it. Several short hiking trails lead from this road out to the beach.

HOW TO PHOTOGRAPH THE WILDLIFE

 The beach on the Atlantic side of Assateague Island is very popular for swimming, sunbathing, fishing, and bird-watching. Between this part of Assateague and the perennially popular Chincoteague, more than 1 million people visit the area annually. With this huge number of people driving, hiking, running, and bicycling around the refuge, the wildlife has grown pretty used to the presence of humans and therefore are easy to photograph.

Some spots, however, are better than others. The wild ponies can be found almost anywhere on the refuge, but they are mainly at the southern end to the right of the beach-access road as you head toward the ocean. Other good places to look for the ponies are in the marshes at the end of the beach road, along the beach road itself, and at the end of the Woodland Trail. You can also sometimes find the ponies along the Wildlife Loop. As you prepare to photograph them, keep in mind that they aren't cared for in any way by humans. As a consequence their manes and tails are generally covered with burdock and other bits of plant matter. I don't recommend spending a lot of time shooting closeups of the ponies because all of this will show up in your pictures.

Other popular animals at Chincoteague are the small Sika deer. Originally from Japan, the Sika are actually oriental elk that were initially released on the Chincoteague refuge in 1923. Like the wild ponies the Sika can be found practically anywhere on the refuge, but they are more likely to be at some spots more than at others. Check around the vicinity of the refuge headquarters early in the morning and late in the day. This seems to be the most likely place to find them. Another good location is at the beginning of the Wildlife Loop. The Sika deer

are very people-tolerant, especially if you move slowly. I've even seen people with point-and-shoot cameras get quite close to the Sika. There are no legal limits governing how close you're allowed to get to any of the animals at Chincoteague; you simply must observe the regulations about feeding and petting.

On the other hand I've tried unsuccessfully to get a decent photograph of the elusive Delmarva fox squirrel at the refuge. The best place to look for these squirrels is along the Woodland Trail, right off the beach-access road. Park your vehicle and hike the 1.6-mile trail. The large, numbered boxes on the trees are the squirrels' homes. Because the squirrels are mostly ground feeders, you should look low for them. They are much larger than gray squirrels, so you can't miss them once you spot them. Unfortunately, because the Woodland Trail runs through large pines and hardwoods, a sunny day produces many shadows—more than most films can successfully handle. The best weather conditions for photographing fox squirrels are hazy or overcast skies.

Many people go to Chincoteague to see and photograph the various types of birds that pass through the refuge. Spring and fall migrations bring tens of thousands of geese and ducks to the area. Two great places to photograph birds are Swan Cove, which is located along the beach road, and Snow Goose Pool on the Wildlife Loop. The beach itself is the best place to look for migrating shorebirds.

One of my favorite places to shoot from when I visit Chincoteague is along the ditch just past the entrance to the Woodland Trail parking lot. The area runs parallel to the beach-access road and is a good spot for cormorants, egrets, great blue herons, and night herons. The light here is good both early in the morning and late in the day, and there are places to pull off the beach road so you don't block traffic when you shoot. Another advantage is that the birds in this part of the refuge are very tolerant of people, a result of all the traffic. Crab fishing is allowed here, so people get out of their cars all the time. This activity doesn't seem to bother the birds either.

When the Wildlife Loop is open, it is a superb place to shoot at Chincoteague. Since there isn't any beach traffic then, the pace is a little slower. I like the first part of the loop best because the ditch alongside the road here attracts waterfowl. Late in the day, the light is better and more wildlife are around. Again, because of the high number of people driving, hiking, and bicycling on the Loop, most of the wildlife seem to tolerate humans well and stay put even if you leave your car. You don't often witness this remarkable behavior elsewhere. In fact, most photographers have experienced the frustration of easing out of a car only to have the subject run or fly away.

SPECIAL PRECAUTIONS

Signs scattered around the refuge warn visitors about the danger of the wild ponies kicking and biting, but people persist in touching and even feeding them. Although the ponies are pretty hard to resist, you must always remember that

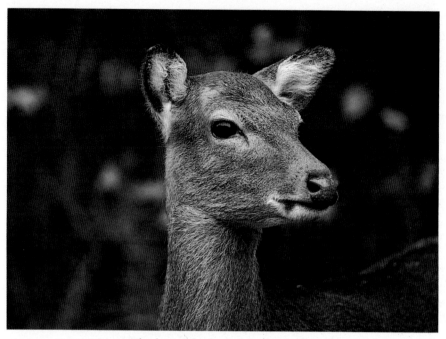

Sika deer at attention early in the morning.

they can switch from docility to aggression in an instant. Twice I've seen people kicked by these seemingly innocent animals, so be very careful around them.

PHOTOGRAPHIC EQUIPMENT AND FILM

 To photograph the ponies, Sika deer, large groups of birds, or scenics at Chincoteague, you can use a 50mm standard lens. A 200mm or 300mm lens is sufficient for good "portraits" of some of the larger birds, but lenses with even longer focal lengths can make shooting easier. Finally, since you can shoot outside your car without scaring the subjects away, you should bring and use the appropriate tripod for your cameras and lenses. The use of filters is a personal choice that depends on your own preferences and photographic goals.

In terms of film requirements, most of the wildlife at the refuge are used to people. As a result, you don't have to buy any specific film; simply bring the type you ordinarily shoot.

PHOTOGRAPHIC SUPPLIES AND REPAIRS

Food 'n Foto, a little food store on Main Street in Chincoteague, has a small photo-supply business and offers one-hour print processing. The store sells Kodachrome 25, 64, and 200; Ektachrome 100 and 200; various Kodacolor films; a limited supply of batteries and filters; and a small tripod or two. Chin-

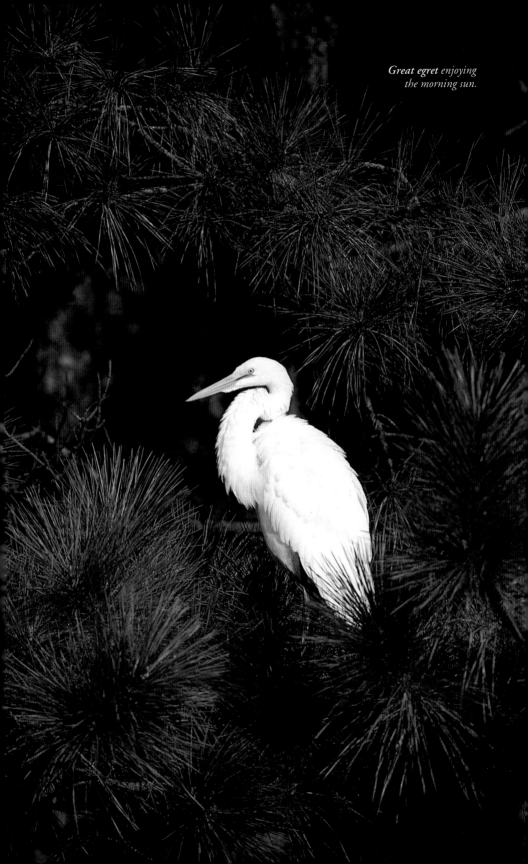

Great egret enjoying the morning sun.

coteague has a post office right in town, so that you can mail your film for processing, but there are no repair facilities anywhere near Chincoteague.

THE BEST TIME TO VISIT

 Although you may visit Chincoteague any time of the year, I prefer the spring and the month of May in particular. The winter chill is finally gone, and the refuge is lush with new green plant growth that can provide appealing backgrounds for your photographs of the wildlife. Also, the refuge has fewer human visitors during the spring, and there is less traffic on both the Wildlife Loop and the beach road. Be aware, though, that good weather draws people to the beach on spring weekends.

I try to stay away from the Chincoteague area during the busy summer months, but I do visit in the fall, which is the best time for bird-watching. There are great concentrations of migrating waterfowl then, and the foliage can be beautiful. If you decide to plan an autumn trip, you should work around three distinct time periods. Between the end of September and early October, shorebirds are at their peak number as they move southward. The end of October sees the arrival of snow geese and Canada geese, and the leaves still have some color left.

The peak of the fall migration is at the end of November. Chincoteague holds a special event called "Waterfowl Week" then, so you might consider this a good time to visit the refuge. The event always takes place Thanksgiving week, running from the Saturday before the holiday until the Sunday after it. During the week the Wash Flats road is open to automobile traffic; this is the only time during the year that you can drive on it. Another advantage of visiting the refuge during Waterfowl Week is that the Wildlife Loop opens at 9 A.M. instead of 3 P.M. Also, the visitor center sponsors a variety of guided walks, and a wildlife art exhibit is held at the lighthouse. In addition to the activities at Chincoteague, the town sponsors a variety of art shows. So not only are migrating birds at their peak during Waterfowl Week, but there are lots of associated activities at the refuge and in the town itself. All of this makes the last week in November a great time to visit Chincoteague.

However, if you decide to visit Chincoteague then, bear in mind that one of the biggest crowds of the year descends on the refuge between Thursday and Sunday of Waterfowl Week. Traffic can literally be bumper to bumper on both the Wildlife Loop and the Wash Flats Road. So a much better time to visit is earlier that week.

In terms of what time of day to visit the refuge, getting there very early in the morning is advantageous. In fact, I like to get to the refuge as soon as it opens, which is at 5 A.M. from May through September and 6 A.M. the rest of the year. Many times, I've practically had the place to myself for at least an hour. Because it is quiet then, it is a good time to photograph some of the birds while

they're feeding, especially herons. Then around midmorning, I usually leave the refuge to get something to eat in town, to explore the town, or perhaps to take a nap. I return to the refuge at 3 P.M. when the Wildlife Loop opens and stay there, or at another spot, until a little after sunset.

HOW LONG TO STAY

 Plan on spending, ideally, between three and five days at Chincoteague. Try to visit mid-week in order to avoid the weekend beach and refuge crowds. I find it difficult to concentrate on picture-taking when too many people are around. Because the wildlife move around, it may take a day or so for something worth photographing to materialize, such as the ponies. I've driven around the refuge for an entire day and seen only a few ponies way off in the distant sections of the refuge. Then just a day or two later the ponies were all over the roads, easy to photograph. Also, the weather can be a little unsettled during both the spring and fall, so you need to include a "bad-weather day." In addition because of the refuge's close proximity to the ocean, the weather at Chincoteague can be very different from that inland. Early-morning fogs are quite common.

LODGING AND DINING

 The inns and motels in the town of Chincoteague are able to accommodate the influx of visitors during the summer, when its population swells to around 25,000. Cottage rentals seem to be very popular in Chincoteague: there are about 20 complexes. You can also stay at one of at least two dozen motels and bed-and-breakfasts. If you plan to be at Chincoteague during the pony auction, make reservations well ahead of time! The Chamber of Commerce has a lodging directory that includes campgrounds and other services (see page 185). There are several large campgrounds in the town of Chincoteague, and they accept all manner of recreation vehicles as well as tents. On the drive into and through town, you'll see many billboards and signs advertising a variety of campgrounds.

While wandering around town, I counted 14 restaurants. Various kinds of seafood—especially oysters—appear on every menu because Chincoteague is a fishing town. I had a very good breakfast at Bill's Seafood Restaurant (try the sausage). And be sure to get some homemade ice cream at the Island Creamery.

NEARBY PLACES OF INTEREST

An unusual aspect of the Chincoteague refuge is that it shares Assateague Island with the Assateague National Seashore. In addition Maryland operates a state park at the north end of Assateague Island, complete with campsites and beach access. The National Park Service runs two visitor centers in the area. The **Barrier Island Visitor Center** is located at the

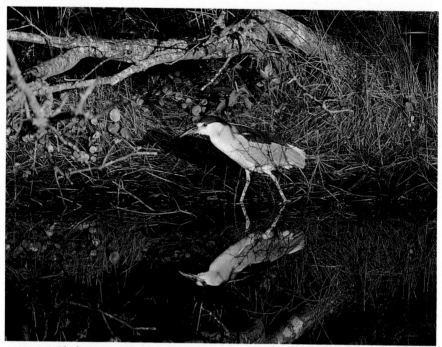

Black-crowned night heron in the ditch alongside the road to the beach area.

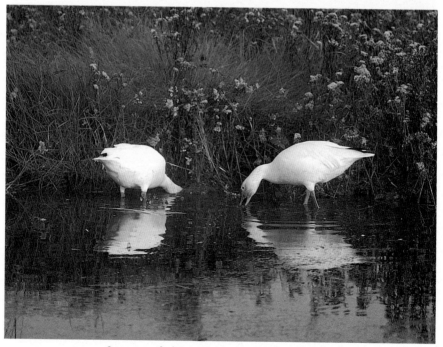

Snow geese feeding in the ditch on the Wildlife Loop.

north end of Assateague and features three nature trails, exhibits, an aquarium, various activities, a campground, and beach access. However, it takes about an hour to drive to that end of the island from Chincoteague, and the wildlife photography is nowhere near as good as that at Chincoteague.

The **Toms Cove Visitor Center** is to the left at the end of the Chincoteague beach road. The rangers there sponsor beach walks, marsh walks, bird walks, evening programs, and other activities. The center also has exhibits and a small aquarium. Contact the center for up-to-date information.

If you're interested in marine life the **Island Museum of Chincoteague**, which is in town, has exhibits on oysters and clams, as well as other aspects of the ocean. The museum is located on the left just before the causeway to Assateague Island.

The **Wallops Island NASA Facility** has a visitor center that you might be interested in. Various exhibits deal with early rocket and space exploration; these incorporate films and video displays. You can even see a moon rock here. The facility is open from 10 A.M. to 4 P.M. seven days a week between July 4th and Labor Day, and from 10 A.M. to 4 P.M. Thursday through Monday during the rest of the year.

Great blue heron standing in the soft marsh grasses.

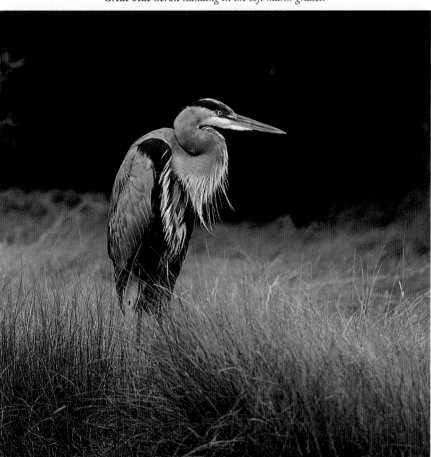

DENALI NATIONAL PARK AND PRESERVE

ENALI NATIONAL PARK and Preserve in Alaska is certainly one of the best places to photograph wildlife, but it might require some effort on your part. The animals here are truly wild, and the park service does all it can to keep them that way. With few exceptions no vehicle traffic is allowed in the park, and visitors get around on shuttle buses. You are, however, free to get off the bus at any time. Denali definitely isn't like Yellowstone or some of the other wildlife areas in this book where you can drive up to an animal, stick a lens out of your car window, and shoot away. But this doesn't mean that you can't accomplish this at Denali; in fact, some of the best photographs are often taken from shuttle-bus windows. Of course, if a large grizzly bear is close to the park road, you'd want the security of being inside a bus! 🐾 Obviously Denali is different, and some people find this type of photography appealing. In addition there aren't many places left where you can go to photograph caribou, grizzly bears, moose, and Dall sheep in the wild. There is no animal management at Denali, and in reality people are the ones who are managed. So if you want a challenge and perhaps to shoot some of the most rewarding wildlife photographs of your life, a trip to Denali is a must. 🐾 Denali is located roughly in the middle of the southern third of Alaska. The park encompasses more than 6 million acres of wilderness and includes a good chunk of the Alaska Range and Mount McKinley, which is the highest peak in North America. (In fact, the word "Denali" comes from an Athabascan word meaning "the high one," for McKinley.) 🐾 The scenery here is simply spectacular. The Alaska Range has permanent snowcaps and produces glaciers that wind down into the valley below. A multitude of rivers crosses the park road. Cold and clear, these glacial runoffs take on a braided appearance as they meander around the stream beds. The valley is composed of spruce forests known as tiaga and tundra. "Tiaga" is a Russian word meaning "land of little sticks" and refers to the sparse, stunted spruce trees

STALKING
TRULY
WILD
WILDLIFE

that dot the landscape. The tundra is made up of low subarctic plants and shrubs that are generally found above the tree line. At different times of the year the tundra includes blueberry bushes, willows, grasses, sedges, lichens, mosses, and wildflowers. And this rich flora is one of the main attractions that draw wildlife to Denali. ❧ At an elevation of 20,320 feet, Mount McKinley dominates the park. Its vertical relief of 18,000 feet from the 2,000-foot-high lowlands presents one of the most impressive mountain views in the world—when it can be seen. McKinley sticks up so far from the surrounding land that it creates its own weather and is obscured by clouds about 75 percent of the time. Even when the mountain is visible, part of it can still be cloudbound. It is a rare day that all of McKinley can be seen.

GETTING THERE

 Some people elect to drive to Alaska. The 3,000-mile-long highway originates at Vancouver on the United States-Canada border and is open year round. The drive takes about a week. If you're making the trip for the first time, I suggest that you get one of the Alaskan highway guides available at bookstores.

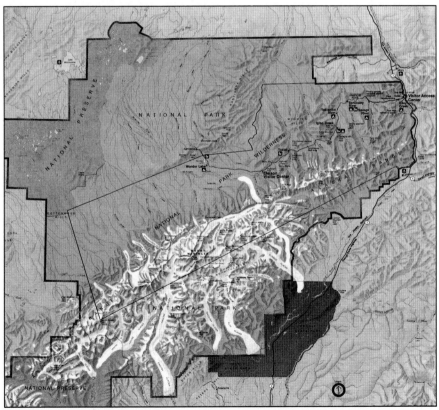

Courtesy of the National Park Service.

Tiaga in autumn.

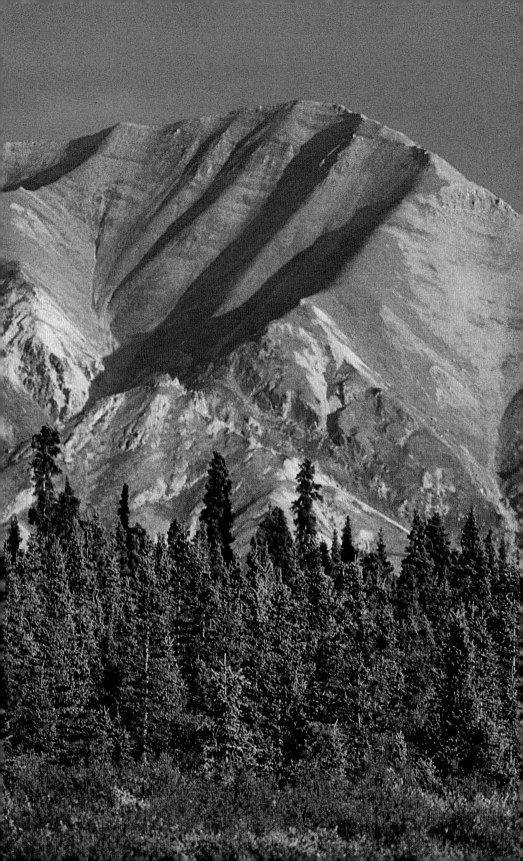

Other options include riding the Alaskan ferry or taking a cruise ship from Seattle. Both connect with buses and/or the Alaskan railroad, which take you directly to Denali. The railroad makes a stop on the park road across from the Denali Park Hotel. (You can also walk from the railroad station to a nearby campground.) You can, of course, also fly to Alaska (see below). Check with your travel agent to see what form of transportation appeals to you and your wallet.

The entrance to Denali National Park lies 250 miles north of Anchorage, and 100 miles south of Fairbanks. From the entrance an access road runs 90 miles into the park in an east-west direction. This road parallels both a broad valley between the Alaska Range to the south and much smaller but still impressive mountains to the north.

NEAREST AIRPORTS

Another travel option is to fly into Alaska. The two major airports serving Denali are Fairbanks and Anchorage. Although Anchorage Airport is farther away, at 250 miles from Denali, it seems to have better airline services and the airlines offer less expensive fares.

CAR RENTALS

Although rental cars are available at both airports, Anchorage, which is a larger city than Fairbanks, has a higher number. Six major car-rental agencies are found at Anchorage Airport, while Fairbanks Airport has only two or three. You can get camping supplies and just about anything else you might need in either Anchorage or Fairbanks.

EXPLORING THE PARK

The vast majority of visitors to Denali gain access to the park via free shuttle buses from the Visitor Access Center (VAC), which is located just inside the park entrance (see page 112). The Park Service limits vehicles for two reasons. First, much of the access road, which is made up of loose gravel, is narrow and winding; furthermore, the road is only one-lane wide at some of the most dangerous sections, so vehicle restrictions are partly for public safety. The second reason for the "buses-only" rule is to keep vehicle traffic to a minimum for the animals' sake. The park road crosses several important animal routes, and the Park Service wants to minimize the number of vehicles moving around. Since a full bus carries about 40 passengers, this translates into at least 20 fewer automobiles traveling the same route.

You'll see some cars on the road but their presence is strictly regulated. If you have advance reservations at one of the Wonder Lake Lodges beyond the western end of the park road, you may be issued a special pass that permits you to drive to that lodge and back out of the park. You may take your time going in and out, but you aren't allowed to use your vehicle once you arrive at your desti-

nation. You also may not back up or turn around to retrace any part of the road. Similarly, visitors who stay at the Teklanika Campground, which is about 29 miles into the park, are issued vehicle passes. Again, these passes allow you to drive in to and out of the campground only. Your vehicle must remain at your campsite for the duration of your stay.

Other vehicles allowed on the park road are those driven by professional wildlife photographers. To secure one of these special permits, only 10 of which are issued per day, photographers must apply at the beginning of the year and supply ample proof of their professional credentials. To qualify, photographers must have published at least 24 natural-history-type images the previous year, and 5 of these must have appeared in publications with circulations of more than 250,000. Tearsheets or other proof of publication must accompany the application. Because the permits are in such demand—photographers from all over the world apply—a lottery is then held for competing dates for them, which are good for a maximum of two weeks. At present professional photographers who are issued passes may drive in any direction. (If you qualify for one of these special permits, write to the Superintendent in care of Denali—see page 185.)

All vehicles must display a coded pass on the windshield so that park rangers can tell at a glance where the driver is staying and what he or she is doing. Violations range from fines to immediate expulsion from the park. Denali is one place where it doesn't pay to bend the rules!

Whichever method of transportation you choose, you must stop at the VAC, where everything begins before you start exploring Denali itself. The center is located about half a mile inside the park. In addition to paying the entrance fee, you can find general information, camping registration, shuttle-bus coupons, telephones, restrooms, and a bookstore. Be sure to notice the ranger-led trips and educational programs posted on the bulletin board, and pick up a copy of *The Denali Alpenglow,* a newspaper-style information package, as well as a park map.

DRIVING ALONG THE TOUR ROAD

Since you'll spend the majority of your time at Denali on the tour road, you need to give it special consideration in order to get the most out of it. Remember, this is the only means of access to the park. As mentioned earlier, the road runs in an east-west direction and is about 90 miles long. The maximum speed limit is 35 MPH throughout the park. For reference, brown mileage posts are located along the north edge of the road (the right side when you drive in). The first 15 miles are paved and take you past the hotel complex and the park headquarters. Early on the road climbs a bit and then is fairly flat as it crosses the tiaga and brings you to the Savage River. This is as far as private vehicles are allowed to go unless the drivers have a special pass. You can use the turnaround on the east side of the bridge and then park your car in the nearby lot if you want to hike around before

driving back to the VAC. There are a few good views of Mount McKinley from this first part of the road.

THE RULES OF THE ROAD

If you drive into Denali and go past the Savage River check station (in order to stay at the Teklanika Campground or one of the Wonder Lake Lodges), you'll be given a set of rules for driving. In brief these are as follows. Oncoming buses have the right of way, and all other vehicles must stop to allow them to pass. Headlights must be on at all times. Stop for all road work until signaled to pass. Beyond the Teklanika Campground, vehicles that are more than 22 feet long may be driven only after 10 P.M. and before 6 A.M. And remember, the speed limit is 35 MPH.

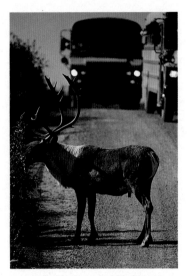

Caribou on road blocking the shuttle buses.

If you think these rules are restrictive, you are right: they are. The primary concerns of the Park Service are the safety and protection of the Denali wildlife. Be very cautious while driving on the road. Animals can and do suddenly appear. Parts of the road consist of only one lane, and there are no guardrails. When I drove to Wonder Lake I had no difficulty complying with the rules. As a matter of fact, I noticed that the majority of other people were driving even slower than 35 MPH most of the time. This is because you don't want to miss anything: there is so much to see, and you never know when a caribou or bear or moose or some other animal might cross the road.

RIDING THE SHUTTLE BUS

From the Savage River check station on, the tour road is made up of loose gravel. Access beyond this point is by shuttle bus only, with the exception of vehicles with special passes. The shuttle buses are, in fact, yellow Alaskan school buses, which the park uses during the summer months. The buses originate at the VAC. The first one leaves the VAC parking lot at 5 A.M., and the last bus departs from the Eielson Visitor Center (EVC) around 6:30 P.M. The departure times vary as mid-August approaches, so check with the shuttle-bus driver or at the VAC desk for exact times. The buses are free, but you need a coupon to board them; these coupons are available at the shuttle-bus desk and may be obtained up to two days in advance. Each of the buses has a seating capacity of 46 but only 42 passengers are allowed on. And although the buses leave the VAC every 30 minutes, you must sign up for specific departure times. Naturally the shuttle schedule is drastically reduced as soon as school starts and the buses

return to their regular winter use. The early shuttles allow you to spend more time in the park, especially if you plan to get off at Wonder Lake or continue on there after stopping off elsewhere (see page 118). Since no food or beverages are available within the park's boundaries, make sure that you pack a lunch because the round-trip to Eielson takes about eight hours (see page 116).

Here is what you can expect when you ride a shuttle bus. The drivers don't provide a regular narration, but they do point out scenic features and wildlife. They'll stop anytime there is a good sighting or when a passenger wants the bus to stop. You may get off the bus at almost any time (the bus continues on). Drivers don't let passengers off unless they intend to remain behind after the bus leaves. Drivers also won't let anyone off if there is any danger present, such as a grizzly bear close to the road. All of the bus windows can be opened, and their ledges make excellent camera platforms. Using a tripod is impossible because the buses, particularly the early ones, are usually filled to capacity, so there simply isn't room. Other benefits are that the buses provide a good, high vantage point and that there are many pairs of eyes looking around for wildlife. Finally, the drivers are great: courteous, knowledgeable, and practiced. The shuttle experience can be worthwhile and enjoyable if you use the system properly.

One way to do this is to simply stay with your original bus for the entire trip, especially your first one through Denali. This method gives you a feel for the park and lets you know what to expect. Although you'll definitely see wildlife, the animals might not all be close to the bus for you to shoot any decent pictures. On the other hand the closest sightings of the day might occur during the bus ride. In fact, many of the best grizzly-bear photographs have been shot from shuttle buses.

A second approach to successfully using the shuttle-bus system is to get off when a good wildlife or scenic opportunity arises. Wait for the bus to leave, and then spend time shooting. You may, in many areas of the park, hike anywhere you want to reach a better vantage point or to get closer to the wildlife. Then when you want to continue the trip or to return to the VAC, just flag down the next bus you see (see below). The driver will always stop as long as there is room for you. A third technique for utilizing the shuttle system is to get off at locations known for their excellent wildlife sightings (see page 116).

Shooting from the shuttle buses can sometimes be difficult, but not always. I've been on buses that were practically empty, so I had no trouble gaining access to a window and shooting great pictures—without ever getting off the bus. Your success depends upon the circumstances of that particular trip. If you are disillusioned on one shuttle bus, get off and try the next one that comes along. I finally got so fed up with a group of noisy people on one trip that I got off the bus and started walking along the road. Around the next corner I came upon a wonderful bull moose and was able to photograph it for some time.

Besides the regular shuttle buses, the Park Service sends four empty buses into Denali daily to move people around within the park. These buses, for example, pick up people who get off a shuttle bus in order to spend an extended period of time shooting in a particular spot, as well as those staying at the campgrounds. In addition four special camper buses are used to transport campers and their gear into and out of the park. These vehicles carry a limited number of people, but they also pick up visitors who need a ride. So don't worry about getting off a bus and being stranded. There are always plenty of buses moving around. Outside tour bus companies that are allowed into the park won't pick you up, so don't bother flagging them down. You can recognize these buses by their square front end and cream color.

There are, however, some problems associated with the shuttle system that you should be aware of. The most serious one is that the buses are shaky and therefore unstable as camera platforms. Another disadvantage is that the buses can be noisy, difficult to work out of, and full to capacity. If the weather has been dry, the windows will be unbelievably dusty. And it seems that someone else is always at the very window you want to use. When the driver stops the bus for a wildlife sighting or a good scenic, everyone ends up moving around. People change seats so that others can use their window, and this activity causes a slight movement of the bus. A tip: use the fastest shutter speed you can to cancel out the tremors of the bus. If there is a great deal of motion, try handholding your camera instead of resting it on the window ledge. I also suggest getting the back seat if possible. On most of the buses one of the rear seats has been removed. This gives you access to both sides of the bus because no one can be on the other side.

The shuttle buses follow the road through Denali. After the Savage River check station the road, which is composed of loose gravel, runs fairly flat for the next 15 miles or so and then climbs up to almost 4,000 feet at Sable Pass, which is prime grizzly-bear country. Park visitors are allowed to get off the bus in the Sable Pass area, but they must remain on the road. Next, the road drops down to the East Fork of the Toklat River and then climbs back up to Polychrome Pass. If you want a thrill, sit in the rear of a shuttle bus for the return trip over Polychrome. In several places the back end of the buses hangs out over the curves, giving you a frightening view down. Remember, there are no guardrails anywhere along the park road. Don't be too concerned, though: shuttle-bus drivers are given many hours of special instruction on how to handle places like Polychrome Pass. The view, however, is worth any stomach problems you might have getting there. You can see Mount McKinley in the distance, and a perfect example of a braided river is visible below. There are restrooms at Polychrome but because parking is limited, private vehicles aren't allowed to stop.

The road then winds downward from Polychrome to the Toklat River; here there are restroom facilities, a ranger station, and housing for park employees.

Dall sheep at the top
of Primrose Ridge,
near the Savage River.

Everyone in the park uses these various rest areas for reference. People also refer to the mileage markers, but these are sometimes hard to locate. It is more common to hear such comments as "There was a grizzly walking down the edge of the Toklat River this morning."

Continuing westward, the road winds and climbs over Highway Pass to Stony Overlook. This is where you'll see one of the park's most dramatic views: Mount McKinley rising over the valley below. Of course, there is a large turnout at this very popular stopping place. The tour road continues along to the EVC, which is located 60 miles from the park entrance. The shuttle buses make a 40-minute stop there before returning to the VAC. The EVC has restrooms and exhibits, as well as a spectacular view of the large Muldrow Glacier, Mount McKinley, and much of the more impressive parts of the Alaska Range. The EVC is a great place to have a picnic lunch. And be sure to take a walk out onto the tundra and enjoy the view from the elevated deck. The road continues beyond the EVC, but you have to sign up for special shuttle buses that run only between Eielson and the end of the park road at Wonder Lake. Check inside at the ranger station for schedules.

HOW TO PHOTOGRAPH THE WILDLIFE

Wildlife, in general, prefer certain types of habitat. Knowing where animals are usually found makes it easier to find them. The largest protected population of Dall sheep in the world is located in Denali. Because these animals prefer to be above the tree line, you can't easily photograph them from the road. You certainly can see them—usually as little white dots against the mountaintops—but you won't get any good shots of them. This means that you might have to go to them. Choice locations are Igloo Mountain and Primrose. Check with the VAC or a Park Service ranger for trail information.

Getting up to and back from Igloo Mountain and Primrose takes several hours, not to mention shooting time, so allow most of the day to be on the safe side. I think that it is important for you to be in fairly good shape to take one of these trips. The terrain can be steep, and the altitude or bad weather might make the hike even more difficult. It is easy to stray off the "trail" as you climb because it can peter out. If this happens, the trip will take even longer because you have to find the trail again. In some areas the going is particularly difficult off the trail because of shrubs and other obstacles.

Because Denali is so primitive and natural, you can find all types of wildlife. There are 37 species of mammals and 139 kinds of birds. Much of the wildlife is small, so you have to search for it. One advantage to going on one of the park-sponsored hikes with a naturalist ranger is that you learn information that can help you locate the wildlife. As mentioned earlier Denali is different from other wildlife areas. Sometimes photographing the wildlife can be ridiculously

easy; at other times, however, you have to work at it. In either event, you are sure to come away with some spectacular photographs from Denali.

When attempting to photograph the caribou, keep in mind that they move around the park as they search for their favorite foods. The caribou are usually located in the vicinity of the Sanctuary River during the early summer, and they move slowly westward as fall approaches. However, they can be found almost anywhere along the park road. I've also been surprised to come upon a caribou well above the tree line. The herd averages around 3,200 animals, so visitors always manage to see some. I've even been able to photograph caribou from the road when they were no more than 75 feet away. Moose prefer the willows and shrubs of the tiaga at Denali. Good locations are around mile 6 or 7 at the beginning of the tour road. You can also check around the Sanctuary River and Horseshoe Lake. I've also seen moose on Sable Pass, so you really never know where they're going to be.

Everyone wants to see grizzly bears, and Denali is one of the best places to photograph them. Again, Sable Pass is grizzly country, so no one is allowed off the 5 miles of the park road that runs through this restricted area. If no bears are around, you may get off the shuttle bus but must remain on the road. Keep in mind that bears are primarily vegetarians and feed on a multitude of berries. In the fall berry patches show up as reds and yellows, so check around those areas. Bears often blend in with their surroundings and don't move around much when they feed. Look for fuzzy, golden-brown lumps as you ride along. Other predominant types of wildlife found at Denali are wolves, foxes, beaver, marmots, pika, ptarmigan, and golden eagles. You might not see all of these creatures in one visit, but you should see most of them. Check Horseshoe Lake for beaver, and poke around the large rock formation above the parking lot at Savage River for marmot and pika. You might also come across pika by the rock piles around Stony Overlook, while marmots can also be found at Polychrome. Ptarmigan can be seen almost anywhere; I found about eight or so all around the Savage River parking lot one morning.

THE BEST SCENIC VIEWS

There are so many scenic possibilities at Denali that it is difficult to list all of them. The view that everyone wants to see, Mount McKinley, is the most elusive. The mountain is shrouded in clouds 75 percent of the time. If you happen to be around when it is clearly visible, remember that several spots offer better views than others do. If you come from Anchorage and drive to or from the park on Highway 3, stop at the overlook at mile 135.2 (this indicates the number of miles from Anchorage and is posted on a green roadside marker). This popular spot provides a great view over the Chulitna River to the south side of the mountain. Although there are other views closer to the park entrance, you won't go wrong here at mile 170.6 or at mile 206.5.

Within the park itself, the views from Stony Overlook and the EVC are pretty spectacular. Another popular spot is the north end of Wonder Lake. Getting good pictures here takes some doing, especially when you ride the shuttle buses, because the mountain weather can easily change by the time you arrive. When staying at Wonder Lake for a couple of days, I was fortunate enough to see Mount McKinley pop out at sunset—an unforgettable sight!

THE ETHICS OF SHOOTING

Denali differs from other national parks and wildlife refuges in that its primary concern is the wildlife. For that reason visitors must follow some guidelines. On foot you aren't allowed to get closer than 50 yards to most of the wildlife. It is all right for them to approach you if you are stationary, but you mustn't move closer to them. The limit is 1/4 mile for grizzly bears. These limits are for your sake as well as theirs. If you happen to be in a shuttle bus or other vehicle, it is possible to photograph any animal, including grizzlies, right alongside the road.

Regardless of the distance rules, you may not take any action that disturbs the wildlife. If your approach (even if it is within the park's guidelines) causes an animal to stop feeding or to move away, your action will be looked upon as harassment and must cease. I worked within these rules and had no problem photographing Denali's wildlife. For example, I once sat on a rock to watch and photograph some Dall sheep. After an hour or so I happened to turn around and found four others feeding behind me about 20 feet from where I was sit-

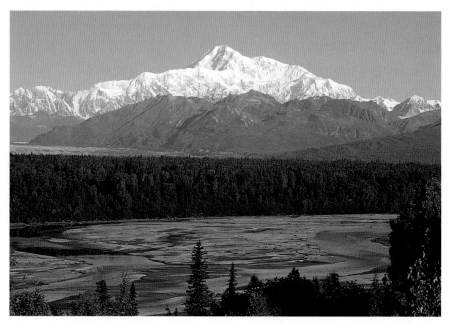

Mount McKinley photographed from Alaska Highway 3 at mileage marker 135.2.

Caribou feeding along the top of a ridge next to the rad leading to Wonder Lake.

ting. And on my last day at Denali a moose crossed the road right in front of me as I was shooting with a 50mm lens, and I had to back up to get all of it in the frame. In both cases I was much closer than 50 yards, but the animals approached me so there was no problem and certainly no harassment.

There are some other ethics to consider as well while shooting at Denali. Some of these are actually posted at various places in the park, but they bear repeating. If you get off a shuttle bus to photograph some wildlife, don't march out between the bus and your subjects and proceed to shoot. Wait until the bus has left. Many of the passengers remaining on the bus will have only point-and-shoot cameras, and the trip to Denali might be a once-in-a-lifetime experience. They want a picture of the animal or scenic, not one of you. So after the bus has left, work your way out to get your pictures. If another bus comes along, the suggested technique is to sit down until it has left in order to minimize your presence. Another option is to move behind a tree or other obstacle. Some people on the shuttle buses will resent your being off the road and will complain even if you are entirely within your rights to be where you are. To avoid this potential problem, try to be as inconspicuous as possible.

If you come upon someone photographing an animal, remember that the animal "belongs" to that individual because he or she was there first. This is merely photographic courtesy and applies everywhere. There is nothing more maddening than to carefully work your way closer to an animal for a better background or fuller frame and then have someone barge onto the scene and frighten away the animal. Wait until that person finishes and then move in. This might even be to your benefit since the longer the other person is there, the more accustomed the animal will get to having a human around. So it will be easier for you to work with the animal when it is your turn. If all park visitors cooperate in this regard, everyone can get all of their pictures with a minimum of trouble.

Finally, keep in mind how visible photographers are. They are, therefore, prone to criticism for any bad behavior. If you are an overly aggressive type of photographer who believes in doing anything to get the picture, you won't be very welcome at Denali—and might be better off going elsewhere.

SPECIAL PRECAUTIONS

There are no poisonous snakes at Denali, so you don't have to worry about them. But you definitely have to be concerned about encounters with grizzly bears. In fact, a whole page of the park information newspaper, *The Denali Alpenglow*, is devoted to avoiding grizzly bears. Read this carefully several times. People and grizzlies don't mix well! These bears are large, powerful animals that can easily outrun you, and they are on their home turf at Denali. If you're charged by a bear, don't try to run away. This will trigger its chase instincts. In addition the bears are extremely protective of their young and unpredictable in general.

The recommended technique for hiking around grizzly-bear country is to make your presence known immediately so that the bear can move away. I've encountered people singing, talking, and rattling empty cans to make noise. Keep in mind that the bears are sometimes hidden, resting or feeding out of sight, and you don't want to come upon one suddenly. Don't take any risks: be sure to get a copy of *The Denali Alpenglow* and carefully read the bear-warning section before you venture out into the park.

PHOTOGRAPHIC EQUIPMENT AND FILM

Considering the distance you have to travel to get to Alaska, your equipment load should be as light as possible, especially if you plan to do any hiking. During my visit I kept an eye out for what kinds of equipment others brought but came to no conclusions. There isn't any one method that works better than another. The decision depends upon the individual and what he or she expects to photograph and is capable of carrying. Backpacks seem to be popular, but they are hard to handle on buses. I spotted shoulder bags, but these aren't satisfactory for long hikes. This is true of hard cases, too.

I used a shoulder bag for my equipment because I thought it would be convenient to carry while dealing with airlines. I worked out of it from my car as well as out of the shuttle buses with no problem. And when going off to photograph Dall sheep I stuffed my pockets with film and an apple and took only my camera, a tripod, and a 300mm lens. I didn't feel like carrying too much on a climb to about 5,000 feet or so. And by the time I was halfway up, even these pieces of equipment seemed too heavy!

In order to pack wisely, I sent for lots of information and discussed the park with people I knew who had visited on a number of occasions. Then I decided to travel light. I brought two camera bodies and the following lenses: a 35mm, a 55mm, a 105mm, and a 300mm with a 1.4 teleconverter (420mm capability). With the exception of a heavier tripod (which wouldn't fit in a duffel bag for shipment), I really didn't miss any of my other equipment. You can travel with even less equipment by packing only a 70-210mm zoom lens and perhaps a standard or wide-angle lens.

It is difficult to say what you really need in terms of telephoto lenses at Denali. Often a subject is right by the side of the road, so using a 200mm lens enables you to get a head shot. At other times you might give anything for a 400mm or longer lens. I took my 300mm lens but used the 1.4 teleconverter on only a couple of occasions. I saw many 600mm lenses at Denali, but I hate to carry these big lenses and would prefer to try and get a little closer. I was lucky and hit a stretch of clear weather at Denali. The sky was deep blue. In fact, I used a polarizer on only a few occasions. As usual, I packed Kodachrome 25 and 64; because I was unsure of the availability of film in the area, I brought 15 rolls of each with me. This was sufficient for my needs.

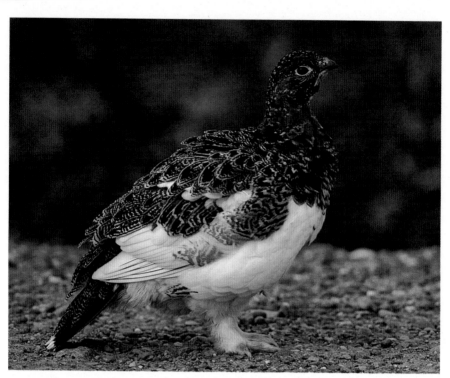

Willow ptarmigan walking along the edge of the Savage River parking lot one morning.

PHOTOGRAPHIC SUPPLIES AND REPAIRS

The gift shop in the Denali Park Hotel carries a good supply and a good variety of film: Kodachrome 64; Ektachrome 200 and 400; Ektar 125; and Kodacolor 100, 200, and 400. The shop also carries most standard camera batteries. There are no repair facilities at all anywhere near Denali, so be sure that your camera is in good shape before you leave. (Perhaps this trip will inspire you to arrange for a pre-departure cleaning and adjusting of your SLR.)

THE BEST TIME TO VISIT

Denali opens in early summer between mid-May and Memorial Day, depending on weather and road conditions, and closes down about mid-September. Early in the season, the park is still easing out of winter. Snow might keep sections of the road closed, and the animals don't look as good as they do later on. As the weather warms up, Denali turns green and the wildflowers bloom. Biting insects, mostly mosquitoes, are also around, but the park is quieter and not as crowded during the first part of the summer. By mid-August the larger animals' coats look much better and the mosquitoes aren't so bad. By the end of the month, the yellow and red fall foliage gives the landscape a totally different appearance. Because many people consider this the best time

to visit Denali, the park is more crowded, getting on some of the shuttle buses is harder, and the campgrounds tend to fill up.

Summer daytime temperatures average around 60°F, with nighttime lows in the thirties or forties. These are only guidelines. When I was at Denali during late August and early September, the temperature was 18°F one night! I was staying in a small tent, so I suffered. Three mornings in a row, the inside of the tent was covered with frozen condensation from my breath. So bringing a parka, gloves, and thermal underwear is wise. Traces of snow are common in the summer, any month. Remember that Denali is subarctic, and be prepared. Hiking in the tundra is surprisingly wet because the permafrost below it keeps any rain from soaking very far into the soil. Bring plenty of extra socks and a change of footwear. Also make sure to pack rain gear.

HOW LONG TO STAY

 Because of rapidly changing weather conditions and the amount of time it takes to get around the park, plan on spending at least five days at Denali. For example, it took me nearly an entire day just to get to where the Dall sheep were, photograph them, and then return to the park road. Staying for a week would be even better. The variety of activities, lectures, and hikes that the VAC offers can easily fill five to seven days. And I firmly believe that the more you know about an area, the better your pictures will be.

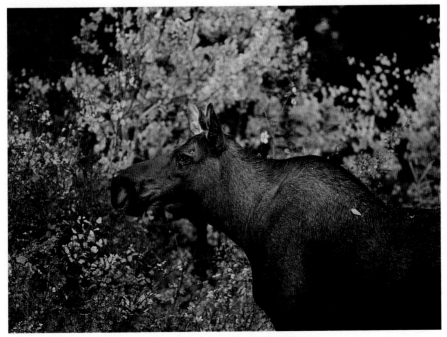

Moose against a backdrop of fall foliage.

LODGING AND DINING

The only hotel inside the park is the Denali Hotel, which is 1½ miles from the entrance. Contact the hotel for rates and information, or ask your travel agent to.

You'll also find accommodations where the park road ends 90 miles inside Denali. These lodges are just past Wonder Lake and offer various hiking trips, fishing, panning for gold, and other activities (access, however, is via the park road unless you fly into a small airstrip nearby). Some of the lodges transport you from the park entrance in their own buses (see pages 186-187).

Denali has seven campgrounds with a total of 288 sites. All campers must register at the VAC for campground space. There is a fee for staying at all of the campgrounds. Riley Creek is located just inside the entrance to the park from Highway 3, and its 102 sites are assigned at the VAC. This is the only campground with assigned sites. For the rest, VAC staff members keep track of only the number of campers. You claim whatever site is empty when you get to the campground. And you can drive your vehicle to only three campgrounds: Riley, Savage River, and Teklanika (with a special pass). You have to take a bus to the others. Four special camper buses leave daily from the VAC. Check the schedule when you register; you must sign up for these.

Only the Riley, Savage River, and Wonder Lake Campgrounds have flush toilets; the remaining campgrounds have pit toilets. All of the campgrounds, however, have potable water. Most of the sites are quite large and have tables and campfire grilles.

You may also backpack in Denali if you want to get away from it all and experience true wilderness camping. Backcountry permits are free and are available at the VAC. Because of potential bear encounters, backcountry campers are required to use bear-resistant food containers (these are given to you when you register). I highly recommend watching the excellent video on backpacking in Denali at the backcountry registration area.

With the possible exception of going back country, Wonder Lake is considered one of the best campgrounds. It lies on a low saddle between Wonder Lake and the valley below Mount McKinley. This campground offers some of the best views of McKinley from the park, but be aware that it takes almost an entire day to get there by shuttle bus. Despite this drawback, its 28 sites are popular and are often filled.

There are no telephones past the VAC and the hotel complex (there aren't even any at the Wonder Lake Lodges). If you must contact the outer world, do so before entering the park. There are no RV facilities in the park campgrounds: no electrical or waste hookups, and no drive-through sites. Generators are allowed only during certain times. There are no showers at any of the campgrounds, but for a small fee you can shower at the mercantile store next to the hotel complex.

About a mile past the VAC, this supply store carries propane, gas, diesel, beer, wine, and groceries. Just beyond the store, near the hotel, are the post office, tour-bus terminal, railroad station, and airstrip. The hotel has a snack bar, restaurant, and gift shop, as well as an auditorium for interpretive programs and other activities.

There are limited lodging facilities and restaurants outside the park entrance as well as in the town of Healy, which is about 12 miles north of Denali. Contact the park, and ask for the *Healy Valley Lions Visitors' Information Guide*; you can also get this from the Healy Chamber of Commerce. In addition to lodging, the guide lists area restaurants, flying services, raft trips, and other information. For example, Denali Raft Adventures and ERA Helicopters are located just outside the park entrance.

NEARBY PLACES OF INTEREST

Although the number of nearby places of interest is limited, there are some additional park attractions that you might find appealing. The park service hosts a number of activities throughout the summer. Check the "Discovery Hike" schedule posted in the VAC for the daily ranger-led trips in the park. These hikes vary in difficulty, so read the guidelines carefully before signing up. Rain gear is required on all trips. Also check the VAC bulletin board for evening programs offered at the various campgrounds and other locations in the park. In addition afternoon and evening programs are held in the Denali Hotel auditorium.

Sled dogs played an important part in Alaskan history and the Park Service rangers still use them to get around Denali during the winter. Be sure to catch the demonstrations given daily. Again, check *The Denali Alpenglow* for times and locations of the various park activities (I must have read this a dozen times and still missed things I would've liked to see or do!).

To fully appreciate the size of Denali and the majesty of Mount McKinley and the Alaskan Range, try a "flightseeing" trip by Denali Air. The airstrip is located adjacent to the railroad station across from the Denali Hotel. The charter service has been winging passengers over the park for more than 25 years. The aircraft hold only five or six passengers, which means that everyone gets a window seat. So make sure that you bring your camera with you on the plane! A standard lens works well; simply set the lens at infinity, use a fast shutter speed, and keep your camera from touching the vibrating windows.

Mount McKinley photographed during a sightseeing flight.

EVERGLADES NATIONAL PARK

Everglades National Park is one of my favorite places to shoot, and I've visited there every winter for the past 12 years. The park is located in southern Florida and occupies most of the tip of that huge peninsula. It is the second largest national park in the lower 48 states and attracts about 1 million visitors a year. ❧ The big draws are the birds. The Everglades is a major breeding and wintering area for a multitude of herons, egrets, ibises, ducks, and pelicans. The variety of these birds and their tolerance of humans make the park one of the very best places to photograph wildlife in North America. The Everglades is also the only subtropical region in the United States, and it is unique geologically. Porous limestone forms the land under most of Florida. Rainfall over central Florida, which averages around 50 inches per year, saturates the limestone and flows slowly southward in a thin sheet. The word "Everglades" comes from an Indian word meaning "river of grass." This "river," which is about 6 inches deep and 50 miles wide, ambles its way southward to Florida Bay and the Gulf of Mexico. The combination of this water and the climate makes Everglades so unusual that the park is both an International Biosphere Reserve and a World Heritage Site. ❧ There are only two seasons in southern Florida. The rainy season runs from May through October, and the dry season from November through April; this cycle is another reason why the park is such an excellent place for wildlife photography. During the dry season the "river" dries up, and food (primarily fish) becomes concentrated in the ponds and sloughs of the region. This is where the wildlife come to feed; their hunger overcomes their fear of humans. Even photographers pose no threat, so you can get fairly close to birds that would ordinarily fly away or otherwise quickly disappear beyond the reach of our lenses. Because the Everglades is so diverse, you should be familiar with the area in general as well as the different habitats within the park.

SEEKING OUT
WADING BIRDS
AND HUNGRY
ALLIGATORS

GETTING THERE

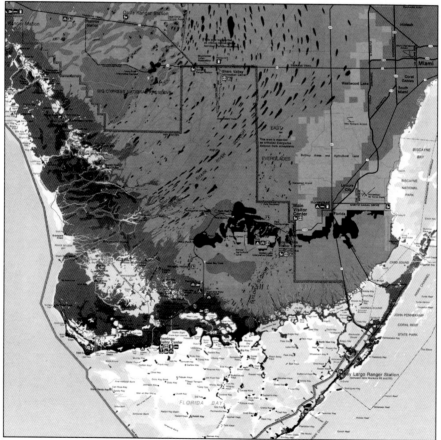

On my trips to the Everglades, I've either driven south from my home in New England or flown to Miami and then rented a car. If you're planning to rent a car, make sure that you head west and take the Florida Turnpike South to Homestead, the last exit. The only other choice is Route 1, but this is a gruesome road of stoplights and shopping-mall traffic. Whether you fly or drive, you end up going first to Homestead, the nearest city to the park. At the southern end of Homestead, look for Route 27, which leads right into the park. The park road is 38 miles long and is often referred to as "the road through nothing to nowhere." There is an entrance fee at the main gate. If you plan on leaving the park, save the small receipt because you can use it to reenter for seven days.

NEAREST AIRPORT

The nearest major airport is Miami International Airport; it is about an hour from the main entrance to the park.

Courtesy of the National Park Service.

CAR RENTALS

All of the major car-rental agencies are located at the airport, including Alamo, Avis, Budget, Dollar, and Hertz. Also, Miami—in fact, southern Florida in general—offers the lowest car-rental prices I've ever come across. It isn't unusual to be able to rent a compact car for about $70 dollars a week.

EXPLORING THE PARK

 The public has access to three areas of the Everglades. The headquarters and main entrance are on the east side of the park, 11 miles southwest of Homestead. Shark Valley is located at the middle of the northern boundary and is about 45 minutes by car from Homestead. Everglades City is located at the northwest corner of the park, almost on Florida's west coast. All three areas have a visitor center and offer various ranger-led activities. The wildlife is more accessible and easier to photograph on the east side (near the main entrance) and in Shark Valley.

I find the drive from Homestead to the main entrance of Everglades frightening. The road takes you through part of a large winter food-growing region. You have your own idea of what a national park looks like and you anticipate wilderness, but instead you're confronted with artificial agriculture at its highest level. Fertilizers, pesticides, insecticides, and herbicides seem to be a way of life, and the area reeks of chemicals. I roll up my car windows and drive through the area as quickly as I can.

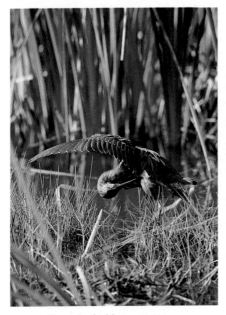

Green-backed heron preening.

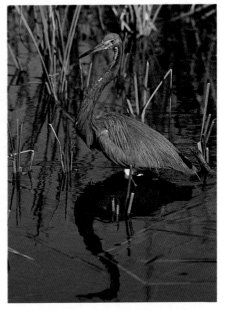

Tricolored heron standing among the cattails in Eco Pond.

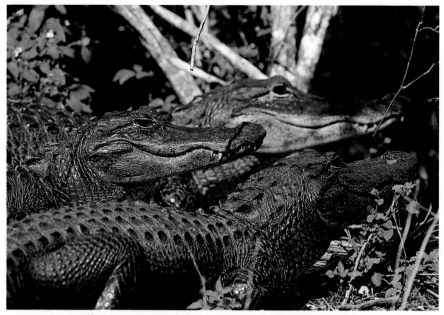

Alligators, a common but unsettling sight, in their natural habitat.

Once I get past the park boundary, the change in the landscape is so dramatic that I usually have to stop and get my bearings. A good place to do this is at the visitor center, which is immediately on your right after you pass the entrance sign. The center boasts some excellent exhibits, an information desk, field guides and books, a film about the park, restrooms, and public telephones. Pick up a copy of the *Visitors' Guide to South Florida's National Parks*, the excellent park newspaper that lists all activities and the various hours of operation; it is full of other valuable information. Make sure that you get the excellent park map that also lists nearby areas of interest and things to do.

Everglades National Park is unique and has diverse habitats. It is a vast, open, flat place, which stretches as far as the eye can see. The area isn't at all like the dark, snake-infested jungle depicted in the movies. Upon entering the park, you'll immediately be struck by its flat appearance. The predominant vegetation is sawgrass, a tough, saw-toothed sedge. In a way the Everglades resemble the midwest with their flatness and waving "grasses."

About a mile south from the entrance is a small bridge and some willows. This area is Taylor Slough, a very shallow channel cutting through the otherwise flat limestone. Much of the water flows only through the sloughs during the dry season. There are two major ones in the park, Taylor Slough and the much larger Shark Valley Slough, which runs through the center of the park.

Continuing south, you'll find one of the most popular areas in the park, Royal Palm, about 1½ miles south of the main entrance. There are two areas

worth exploring there: the Anhinga and Gumbo Limbo Trails. The Anhinga Trail is located on the edge of Taylor Slough, and a paved walkway and board-walk bring you out into part of the slough. The water around the banks of the trail is clear, and you can watch the fish swimming below as you stroll around the boardwalk.

The Gumbo Limbo Trail is a hardwood hammock next to the Anhinga Trail and is cool and lush with ferns, gumbo limbo trees (which are recognized by their thin, peeling bark), strangler figs, palm trees, and aerial plants. One area that I especially like is the old tropical gardens. Enter the Gumbo Limbo Trail from the exit end, which is to your right as you stand in the parking lot, and face the trail. Follow the paved trail for about 100 yards past the small bridge and pond on your right.

At this point you can look for a grassy road on your right. It is very straight and leads to the old gardens. A short walk (several hundred yards) along this road brings you to an enormous tree covered with ferns, air plants, and vines. Old trails veer off to the right, taking you directly into the gardens. Here you see giant philodendrons, exotic fruit trees (don't eat the oranges—they are unbe-lievably sour), and tropical vines. The old stone building in the garden was once used as a deer feeding station, and you might come across old underground water-storage areas. At one time there was even a small hotel where visitors could spend the night.

South of Royal Palm is the last significant stand of Dade County Slash Pine in Florida; the rest were turned into timber years ago. These pinelands are home to deer, raccoons, owls, bobcats, snakes, wildflowers, and ferns. I always try to spend some time in the pinelands, especially if I've recently arrived in the park with my pale winter skin. There is a parking area and a paved walk. I suggest taking the walk to orient yourself and then get off this path and out into the pines. This is a great area for the small Everglades morning glories, ladder ferns, and various palmettos.

Keep your eyes open for poisonous plants whenever you are off any of the beaten paths in the Everglades. If you aren't familiar with poison ivy, poison-wood, and machineel, check with a field guide or ranger naturalist or consult one of the bulletin boards; they usually have a display identifying and describing these plants.

As you continue south, the pineland area suddenly gives way to another habi-tat, cypress. These strange-looking trees are coniferous (needle-bearing) and drop their needles during the winter dry season. This section of the park resembles a forest of dead trees, all short and gnarled; however, the cypress are very much alive and with a little rain might start to grow leaves in March. Every so often you'll come across a stand of cypress that is shaped like the familiar bell curve used in statistical work. These stands are called "cypress domes" and are formed around small pons in the limestone. Be sure to keep your eyes open for them.

Cypress trees are very specific as to where they can grow, depending on water depths. If the water is too deep, the tree "knees" will be submerged and the tree will die because it is choked off from the oxygen the knees usually provide. Conversely if the water is too shallow, the tree growth will be stunted. If you were to fly over a typical cypress dome, it would look like a doughnut with no trees in the center where the water was too deep. You would see the largest trees around the edge of the pond under ideal conditions, and trees of decreasing height out to where none grow at all. Cypress stands are great places to explore but if you haven't done so before, I urge you to check the activity schedule and take a "wet walk" with a ranger. When going to a cypress dome, wear sneakers or other footwear that you don't mind getting wet and mucky. Thongs and sandals have a nasty habit of coming off and can be difficult to retrieve.

South of the cypress are noticeable clumps of hardwood trees. These "islands," which are called "hammocks," are areas of slightly higher land where such hardwoods as mahogany and gumbo limbo can live. Deer, bobcats, raccoons, owls, and Florida tree snails are found in the hammocks. Orchids and aerial ferns live on the branches of the hardwoods. The hammocks are the areas of the park that most closely resemble jungle habitats. At first glance, they seem impenetrable because of the denser vegetation around their edges. After you struggle through this boundary, however, you can get around the inside of the hammock more easily because it opens up.

As you approach the southern end of the park, you notice that the land gently merges with Florida Bay. The transition zone is prime habitat for red mangrove trees. These shrub-like trees with their tangle of prop roots form an important habitat for developing fish and shrimp. Roughly equivalent to northern salt marshes and so keenly eyed by developers, the mangrove swamps are not only crucial nursery and spawning grounds for a host of marine life but also critical buffers from storms and hurricanes.

One of the best Everglades "hot spots," if conditions are right, is Mrazek Pond. It is about 5 miles north of the flamingo complex (see page 136). Many people like to shoot at Mrazek late in the afternoon but it can be very good in the morning, too.

If you have the time, I suggest a day trip to the Shark Valley section of the park; it is about a 45-minute drive from Homestead. Shark Valley lies in the huge Shark Valley Slough, which runs roughly through the middle of the park. Shark Valley has seen a great deal of renovation recently. There is a new visitor center, the parking lot has been enlarged, and the tram road has been raised somewhat. This road used to routinely flood and was consequently closed; this problem should be solved now. The tram road takes visitors 8 miles out into the sawgrass where there is a tall observation tower. Some of the best wildlife viewing is in the ditch alongside the tram road. There is almost always water here, and the wildlife know it. For example, alligators and birds flock to the area. This is a

good place for limpkins, yellow-crowned night herons, and the rare and endangered Everglades kites, too.

The trip into the sawgrass is long, especially since the round-trip is 16 miles. Automobiles aren't allowed on this road, so your choices are limited to the tram (there is a fee for the trip) or to a bicycle (if you don't have your own with you, you can rent one). I usually walk part of the way, and I find the exit end, which is behind the visitor center, to be especially more interesting. I've seen dozens of yellow-crowned night herons sitting in the willows, and once I even saw a limpkin feeding an apple snail to its young about 40 feet away from me. I've always liked Shark Valley, and I feel that it is worth the time it takes to get there.

HOW TO PHOTOGRAPH THE WILDLIFE

 The wildlife photography in Everglades National Park is superb. As discussed earlier the water levels in the park are critical for birds and animals. During the dry season the little water available is concentrated in only a few areas. So these, of course, become crowded with hungry alligators and a variety of wading birds. The wildlife are so intent on feeding that the birds and animals seem to ignore people. As a result photographing the animals and birds is much easier. These are truly wild creatures, but they seem to know they are in a safe place and are far more tolerant of the presence of humans.

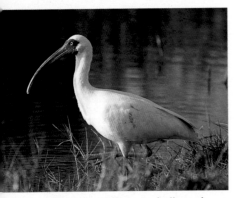

Cattle egret in the bright sunshine at Eco Pond.

White ibis displaying its brilliant plumage during breeding season at Eco Pond.

Some of the birds that I've seen and been able to photograph on the Anhinga Trail in the Royal Palm area include great blue herons, little blue herons, green-backed herons, wood storks, white ibises, pied-billed grebes, anhingas, American egrets, American bitterns, and the popular purple gallinules. Alligators sun themselves along the banks, and you can see a variety of turtles and fish, too.

The first part of the Anhinga Trail is elevated slightly above the water, so the way you set up your equipment is critical. Since the birds and alligators are in the water below you, adjust your tripod legs to their lowest setting. This will produce a more natural angle to your subjects than fully extending the legs will. And because the

majority of your subjects are fairly large and very tolerant—sometimes they are on the railing right next to you—you don't need terribly long lenses here. On many occasions I've seen people using long lenses be unable to fit their subjects into the frame. I've consistently been able to do good work with a 300mm or 400mm lens and rarely felt the need for any of the longer focal lengths.

The best time to hit the Anhinga Trail is as early as possible after sunrise. Get here first thing in the morning. The trail gets more popular as the day wears on, but the real crowds don't start arriving until around 9:30 A.M. So an early arrival will give you plenty of shooting time. The trail gets a bit risky after the masses arrive, especially on the elevated boardwalk out over the water. Even with only a few people walking around, the boardwalk can sway enough to adversely affect your pictures. After the crowds arrive the vibration becomes impossible to deal with. This situation is particularly problematic when you use any kind of telephoto lens.

The grassy road off the Gumbo Limbo Trail is a good place to look for zebra butterflies. With some patience, you can photograph them. Another good spot is the Long Pine Key Campground, which is located just south of the Royal Palm area. Barred owls make their home among the pines and are often visible. Large pileated woodpeckers and red-shouldered hawks are also seen in the area.

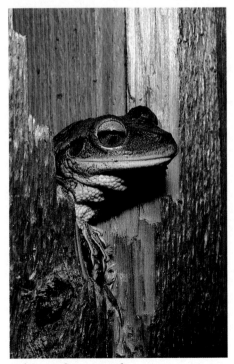

Cuban tree frog waiting for insects in a wooden light pole.

Very rare sightings of the endangered Florida panthers occur here, but don't plan on seeing any because these animals are severely threatened and quite elusive.

One of the reasons I enjoy cypress domes is that I usually have the place to myself. Here you can see and shoot air plants and an occasional orchid. White ibises and barred owls like cypress domes and are sometimes within camera range. Depending upon the time of year it is, you can often walk into a dome and stay dry all the way in. At certain times you can easily find yourself in water up to your knees or even higher. If this happens, you'll really feel like part of the Everglades: alone, up to your waist in water, and worrying about cottonmouth snakes! If you decide to shoot at a cypress dome, be aware that there often is

no dry place where you can put your equipment. So this is a good time to think about getting a photographer's vest. It will keep equipment handy and out of the water. In addition, I usually bring a tripod with me and worry about drying it out later. When I shoot in a cypress dome, I also carry a small flash unit because subjects can be in deep shadow. And remember to wear socks that you don't care about because they'll get unbelievably dirty.

Wading birds, as well as an occasional roseate spoonbill, go on feeding frenzies at Mrazek Pond, ignoring all the clicking and whirring of photographers' assorted equipment. Plan on arriving early, choose a good spot near the edge of the water (which is practically anywhere), and wait. The crowds will arrive soon, so if you are late you might find it difficult to get a clear shot because of all the other people around.

Patience sometimes really pays off in many spots in the Everglades. Several years ago I was at the edge of Mrazek Pond just after dawn. Some roseate spoonbills were there but were too far out for me to photograph. Suddenly about 100 feet away from me, a bobcat leapt out of the bushes and grabbed a spoonbill. Unfortunately they were in too much shadow to photograph and I was only able to stand around and watch the cat carry off its prize. Other people had arrived by then, and all of us were mumbling about the event when right in front of us an alligator grabbed an American egret. This time everything happened in full light, and the motor drives whirred. Of course, there have also been times when I've sat at Mrazek Pond and gotten nothing but cramps in my legs.

Another good place for photography right at Flamingo is Eco Pond, which is a few hundred feet short of the campground area. Although the pond is badly overgrown with fragmites, I still find it worth a slow tour around the edge. Stand on the new observation platform to see out over the fragmites; the sun is better from this shooting position. I've had a lot of success here, making good shots of baby alligators, a rail, a coot, green-backed herons, a very curious mockingbird, and a smooth-billed ani.

You might also want to check around the parking lots at Flamingo. Several years ago I found an osprey nest with young in it in one of the trees there! And after storms, black skimmers and terns rest in the parking lots by the marina and at the campground. The pilings at the marina docks are often perches for pelicans, and they sit there for hours.

One of my favorite places at Flamingo is the sandpit in front of the motel complex. If the tide is out the sand will be exposed and covered with all kinds of shorebirds, as well as white and brown pelicans, terns, and black skimmers (check with the ranger station at Flamingo about tide times). I think that the best time to shoot here is during the afternoon because the light is better. I rent a canoe from the marina and work my way toward the sandpit until I am as close as I can get without scaring away the birds. I put the tripod legs over the bow to support the camera; this also serves to anchor the canoe. If you sit still,

even the birds that first moved away will eventually return and be close enough to photograph. One year a reddish egret pranced by right in front of me. This was a great experience and resulted in great pictures!

Finally, I like to take a trip along the research road even though it isn't very scenic. This road leads off to your right just before the parking lot at Royal Palm. I've shot some good pictures of pines, Brazilian pepper (a nasty, nonnative plant taking over south Florida), and baby alligators in the little pond on the west side. About a mile or so along the road, there is an open ditch on the right side. This is worth a picture because it offers a cutaway view of the underlying limestone that is the very foundation of the Everglades.

THE BEST SCENIC VIEWS

Some areas of the Everglades are particularly good for shooting scenics. During the winter, when sunrises seem to be consistently better than sunsets—I think the warm days and cool nights create the early mists necessary for spectacular sunrises—my favorite area is practically anywhere among the cypress trees. The Pa-hay-okee lookout tower provides a great vantage point for looking out into the sawgrass plain. Looking west from the parking area, I've been able to shoot some wonderful sunsets over Paurotis Pond. Another place to shoot sunsets is Pine Glades Lake. Take the first dirt road on the east side of the highway just south of the Pinelands.

SPECIAL PRECAUTIONS

If you plan to photograph wildlife, you need to know a few things about snakes. They are found in most wilderness areas but they really don't want anything to do with humans. In fact, snakes take every measure possible to avoid contact. If you walk purposefully through an area and move fairly slowly you would probably never see a snake your entire life.

There are four kinds of poisonous snakes in the Everglades that you should be aware of: the diamondback and pygmy rattlesnakes, and the coral and cottonmouth (also known as water moccasin) snakes. It took me seven years to find my first poisonous snake in the park—and I was looking. In contrast when I was with a ranger-led group, a woman who was deathly afraid of snakes and spent every minute looking for them discovered a large diamondback rattlesnake. Her shrieking brought us on the run to see the snake! It was her first visit to the Everglades and because of that sighting, perhaps her last.

The point is that while there are poisonous snakes in the park, they actually pose no threat. I don't know of any instance when a visitor was bitten by a snake. My feeling is that people are intruders into the snakes' territory and that we are safe unless we make some effort to harass them. I've photographed both diamondback and cottonmouth snakes from about 5 feet away and while I don't particularly like snakes, I didn't feel threatened or in any danger. In both

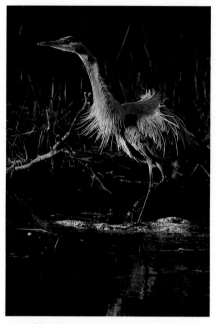

cases, I moved in very slowly and made no intimidating gestures. The snakes seemed to realize that I wasn't a threat and simply lay where they were.

However, if you have occasion to sit or lay on the ground, you should be aware of nasty creatures known as chiggers. These mites are tiny beasts that bite, leaving an itchy welt that can persist for weeks. Chiggers always seem to favor my belt line and the area around my socks. An effective way to prevent bites is to liberally spray your pants and shoe area with the appropriate insecticide. But the hazard that many people consider the greatest is the mosquito. The Everglades mosquito is especially vicious and aggressive (and I can understand why the famous British fighter airplane of World War II was named after this insect). You can even buy a colorful decal at Flamingo that states that you've given blood in the Everglades. After having made many small donations, I bought one and display it proudly on the side of one of my camera cases. Although the peak season for this insect is from about mid-May through November, mosquitoes can be present at other times. As a local saying goes, the Everglades is the only place in the world where a gallon of mosquitoes can come out of a quart jar.

Great blue heron pruning its feathers in a shaft of afternoon light.

PHOTOGRAPHIC EQUIPMENT AND FILM

 You don't need really long lenses to get great pictures in the park. I've done some good work with a 200mm lens, but I prefer a 300mm or 400mm lens. Much of the wildlife is so used to having people around that you can do very well with the shorter focal lengths. If you have a shorter lens but feel more comfortable with something longer, try using a teleconverter. Teleconverters are lightweight and take up very little space in your camera bag. Get a converter made by the same manufacturer as your telephoto lens; the optical quality will be much better than that of a generic converter.

I also suggest bringing a wide-angle lens with you because a great deal of the Everglades is open. A 28mm or 24mm lens is fine. I always bring a macro lens to shoot the many small subjects in the park, including the butterflies and wildflowers.

I am a proponent of using a sturdy tripod and recommend that you bring one into the park. If you use any kind of telephoto lens, you'll get better results

with a tripod. You'll also come away with better wildlife pictures. Finally, in addition to my usual supply of Kodachrome 25 and 64 film, I bring a polarizer with me.

PHOTOGRAPHIC SUPPLIES AND REPAIRS

Homestead has only one small photography store that I know of, Don Rhodes Camera and Studio. Although the supplies are pretty basic, the shop does carry Canon, Nikon, and Pentax equipment. There are several repair facilities in Miami for Canon, Minolta, Nikon, Olympus, and Pentax equipment. The largest repair facility is Southern Photo Technical Service; others include Habersin and Phil's Camera Sales and Service (see page 186). Fortunately, I haven't had any problems with my equipment while visiting the Everglades.

THE BEST TIME TO VISIT

Winter is usually the dry season. Water levels are down, and the birds must concentrate on what is available. December, January, and February tend to be the best months although I also like early March. The weather is a bit warmer, and the camping availability is better.

Although the summer can be very hot and humid, the sawgrass turns green, the apparently dead cypress come to life in delicate greens, and great afternoon thunderstorms roar through the park. Because the warmer part of the year, May

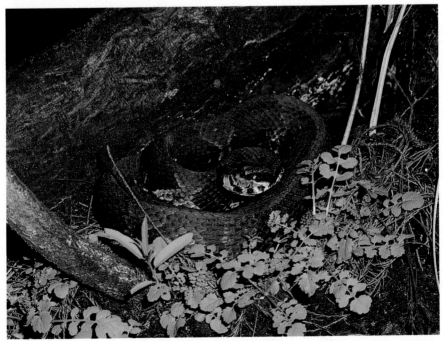

Cottonmouth snake curled up in a fallen tree trunk.

through August, is considered off-season, motel rates are lower and more rooms are available.

HOW LONG TO STAY

The Everglades is a large and subtle place—subtle in the sense that there aren't any sweeping vistas or grand geologic formations. I feel that a week is adequate to get a true sense of the park. Take every ranger-led trip you can fit into your schedule in order to learn more about the park and its wildlife. The more you learn about the park inhabitants, the better your pictures will be. If you can spend only a day in the Everglades, I suggest that you spend it at Royal Palm. Walk the Anhinga Trail in the morning, eat a picnic lunch at the visitor center, and then spend the afternoon on the Gumbo Limbo Trail. Be sure to hike down to the old tropical park.

LODGING AND DINING

Located at the southern end of the park is the Flamingo complex. A motel, restaurant, gift shop, visitor center, marina and marina store, and campground are all located here. The marina store sells limited camping supplies, packaged sandwiches, beer, and wine. The small visitor center has restrooms and public telephones, as well as its own gift shop where you can purchase those forgotten field guides.

Homestead is the best place to buy groceries, hardware, gasoline, diesel, and other items. Fill your tank before entering the park; the only gas station is at Flamingo and its prices are higher than those you'll find outside the park. Unfortunately, Homestead is noted for thieves, so guard your car while shopping, especially if you leave any camera gear in it. A couple of years ago I had an unfortunate experience in Homestead, and I know of several other park visitors with similar tales.

There are a number of restaurants in Homestead, including the major fast-food places, as well as restaurants featuring Chinese, Italian, and Mexican fare. One of my favorites is the Capri, an Italian restaurant across the road from Coral Rock Motel on Krome Avenue. Because the restaurant is divided into two distinct sections, you can either dine casually or dress formally. I also enjoy Sonny's BBQ.

The two campgrounds within the park are both at the main entrance side. The northern one, Long Pine Key, has 108 large sites, restrooms (but no showers), a trailer pumpout station, and a small amphitheater. I strongly recommend the evening programs—check the schedule at the bulletin board next to the telephones. Long Pine Key is pleasantly laid out among the pines and has several interesting trails for bicycling or walking.

The Flamingo campground has a larger camping area than Long Pine Key and is separated into four loops. Loop A is the best because it has more and

larger trees in addition to the only shower in the park. The shower has only cold water though, so go around midafternoon when it is less crowded and the water seems warmer. Loop A has 55 campsites, which fill up quickly. Despite 12 trips to the Everglades, I've managed to get into Loop A only twice. Loops B and C are very open and have a total of 105 campsites. Finally, the T Loop has 65 drive-through trailer sites, as well as a pumpout station.

Flamingo also has a walk-in area for tents; this section of the campground is situated right on the edge of Florida Bay. At one end is an amphitheater and again, I urge you to attend the evening lectures. The backcountry campsites available in the park are accessible by foot or canoe. There is no fee for them, but you do need to get a permit at any ranger station. There is a 14-day limit for all camping during the winter months, and all of the campsites are on a "first come, first serve" basis. No reservations are accepted. None of the sites has electrical or water hookups, and electrical generators are allowed only between the hours of 6 A.M. and 10 P.M.

There are many private and national-chain motels in Homestead both along Krome Avenue (the main street) and Route 1, which parallels it. In addition to the Coral Rock Motel, where I've stayed, you'll find three other motels: Budget, Days Inn, and Howard Johnson's. Some motels are more popular than others, and reservations are advised. It appears that Homestead has only trailer parks, but several of these do have campsites.

If you want to stay in the park but don't want to camp, try the Flamingo Inn at the Flamingo complex. The inn offers duplex cottages with kitchens and standard-type motel rooms, as well as a restaurant. For information on accommodations, trailer parks, and restaurants in Homestead, contact the Chamber of Commerce (see page 186).

NEARBY PLACES OF INTEREST

Although you'll probably want to avoid the several tourist traps in the Homestead area, I do recommend one. I've always enjoyed the **Orchid Jungle**, which is located on S.W. 157th Avenue in Homestead itself. The Orchid Jungle is laid out in a large hardwood hammock, and the path winds among huge trees festooned with all kinds of orchids. The buildings house rare orchids and research and propagation facilities. There is a small entrance fee but you are under no obligation to buy anything; however, the temptation to do just that is great. Yes, you are free to take pictures!

If you have the time and interest, I also recommend making the trip to **Biscayne National Park** in Homestead. Simply follow the signs to the visitor center. There really isn't much to see at the center itself; the essence of the park is the underwater scene. Take a snorkeling or diving trip to see the beautiful reefs. They've been protected and therefore spared some of the exploitation of the Florida Keys. You might even want to rent an underwater camera from a local

dive shop. This generally costs between $25 and $35 dollars and includes an underwater flash unit. The rental period covers the dive or snorkeling trip, which usually lasts half a day. If you don't want to get wet, take a ride on the glass-bottomed boat that makes reef trips. Contact Biscayne National Park for times and reservations of the various boat trips (see page 187).

As long as you are in southern Florida—and assuming that you have the time—I definitely recommend visiting **Corkscrew Swamp**, which is an Audubon sanctuary, and the **Ding Darling National Wildlife Refuge**. Both are on Florida's west coast (see page 168).

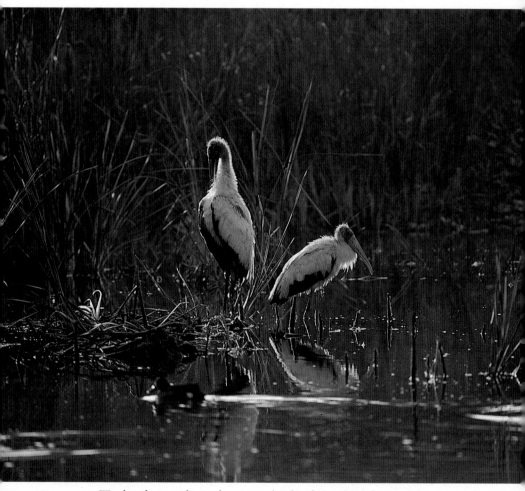

Wood storks, *an endangered species, at the edge of Mrazek Pond one morning.*

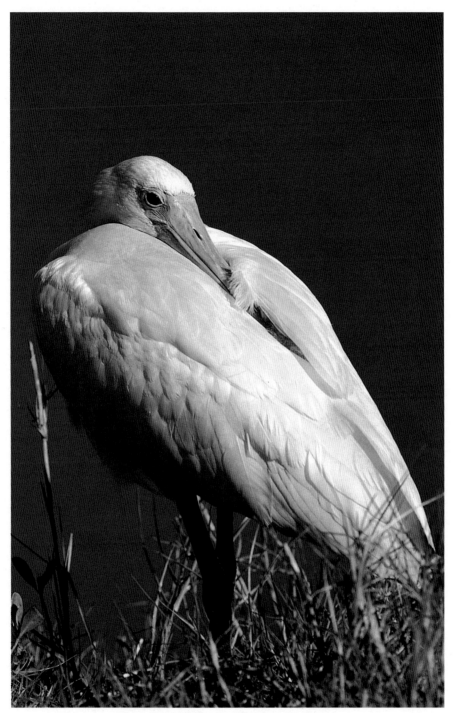

Roseate spoonbill showing off its first-year plumage.

YELLOWSTONE NATIONAL PARK

Y ELLOWSTONE NATIONAL PARK is certainly one of the very best places to photograph wildlife in North America, not only because of the diversity and approachability of the wildlife but also because of its scenic beauty. With its unique features, Yellowstone is both an International Biosphere Reserve and a World Heritage Site. Yellowstone became the world's first national park in 1872, and most of the animal species that were present in the 1800s are still found here. I particularly like the fact that these animals aren't managed by humans; the laws of nature govern populations and survival. To me, these are wilder and more "natural" animals than those in manipulated herds found elsewhere. ❧ To appreciate the physical size and diversity of Yellowstone, you should explore it section by section. Located primarily in the northwest corner of Wyoming, with slivers of land in Idaho and Montana, Yellowstone contains about 3,500 square miles. Put another way, the park comprises 2½ million acres. To give you a better understanding of just how massive this park is, Yellowstone is roughly half the size of New Jersey or about the size of Delaware and Rhode Island combined. This amount of acreage makes Yellowstone the largest national park in the lower 48 states. Only the Alaskan national parks are bigger. Square in shape, Yellowstone is mostly mountainous with several large plateaus and valleys. The Continental Divide winds through the southwest section, and Yellowstone Lake, North America's largest mountain lake, is located in the southeast corner. ❧ Yellowstone's present-day features are the result of geologic events that took place millions of years ago. About 500 million years ago this part of the Rocky Mountains was covered by a shallow ocean. Then about 75 million years ago the area was uplifted to a mountain plateau that eventually was folded into the Rocky Mountains. This explains why there are so many sedimentary rocks and marine fossils in the park. Yellowstone might have remained a large mountain plateau,

> # PHOTOGRAPHING BISON AGAINST A VAST BACKDROP

144

but the area underwent three violent volcanic eruptions within the last 2 million years. The last eruption, which occurred about 600,000 years ago, created an enormous caldera, or basin, of 1,000 square miles. For the sake of comparison, the Mount St. Helens explosion formed a caldera of less than 1 square mile. ❧ There is little evidence of Yellowstone's caldera today because of subsequent lava flows and erosion; however, the area is by no means volcanically dead. In fact, Yellowstone is one of the most thermally active areas in the world. There are about 10,000 geysers, hot springs, mud pots, and fumaroles. Mud pots, or paint pots, are small areas of bubbling mud; this mud is very liquid and has gases bubbling up through it. Fumaroles are steam vents, which are cracks in the surface through which steam billows out. Old Faithful, the most famous geyser in the world, is located in Yellowstone. Early on cool mornings, parts of Yellowstone still appear to be smoking from the 1988 fires but this smoke is actually only steam from active geothermal features.

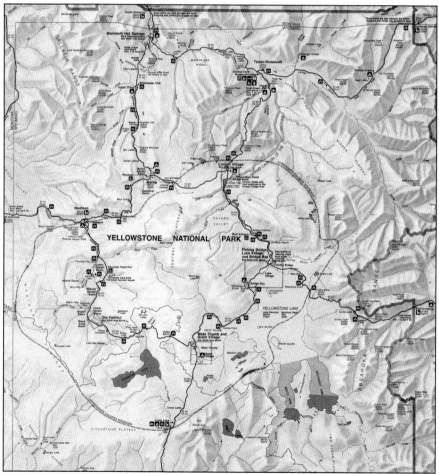

Courtesy of the National Park Service.

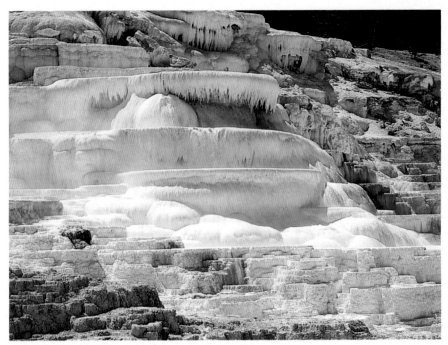

Minerva Terrace, with its extensive travertine terraces.

GETTING THERE

Since Yellowstone is situated out west in the Rocky Mountains, getting there can be a problem for most visitors. East-coast drivers heading west can use Interstates 80, 90, and 94, while drivers coming from the west and driving east can take Interstates 80, 84, and 90. None of these highways leads directly to the park, so you must then travel on various state routes in order to gain access to the several park entrances. If, however, you don't have the time to drive to Yellowstone or don't want to spend the time on the road, you can, of course, fly.

NEAREST AIRPORTS

Although some people use the Salt Lake City Airport as the gateway to Yellowstone, it is much easier to fly into the airports that are closer to Yellowstone; these are at Bozeman, Montana, and Jackson Hole, Wyoming. Both airports are served by most of the major airlines or fed from Salt Lake City. During the summer months, additional flight service is available to Cody, Wyoming, and West Yellowstone, Montana.

CAR RENTALS

While Salt Lake City Airport has the most car-rental agencies, Jackson Hole Airport has at least six of the major companies represented as well as a few local

companies. Bozeman Airport has three or four major car-rental companies, as well as one or two local rental agencies.

EXPLORING THE PARK

 I can't stress enough the importance of getting information at the visitor centers in Yellowstone. The park makes so much available in terms of trips, ranger activities, and valuable information that it seems foolish not to take advantage of it. The centers are staffed by enthusiastic and knowledgeable personnel. Many offer educational programs and films. The more informed you are, the more you'll get out of a trip to Yellowstone and the better your pictures will be. Also make sure to get a copy of the *Yellowstone Map and Visitor Guide* and *Yellowstone Today*, the official newspaper of the park. The newspaper lists things to do, park regulations, and hazards; it also suggests ways to take full advantage of your visit to Yellowstone. I also urge you to get a copy of *Hamilton's Guide to Yellowstone National Park* (see page 161).

Despite the size of the park, access to Yellowstone is excellent. There are five entrances, all designated by compass points: north, northeast, east, south, and west. All of the entrance roads lead into the interior of the park where there is a large double-loop road in the shape of a figure eight. Called the Grand Loop, this road connects most of the park's most popular attractions. You have to drive

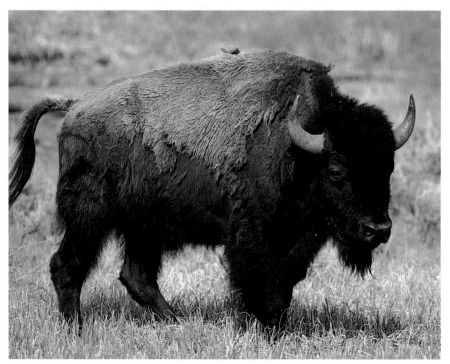

Bison in sagebrush at Lamar Valley.

142 miles to complete the Grand Loop, and most visitors spend the majority of their time exploring the park on it.

The harsh Rocky Mountain winters are hard on roads, and the 350 miles of roads in Yellowstone suffer considerably. Only the road from the northeast entrance through the northern section of Yellowstone to the north entrance is kept open year round. But even during the summer you can encounter potholes, washed-out sections, mud- and snowslides, and other obstructions. Several roads lead up over steep mountain passes, and although the speed limit is 45 MPH throughout the park, you should plan on going about half that speed. So, it might take you an hour to travel 20 miles. Combine these factors with delays caused by vehicles stopped for animals on the road, and you'll understand why visitors must be patient. Allow yourself plenty of time to get from one part of the park to another. When I was in Yellowstone one June, a mud- and snowslide closed the east entrance road for a full day or so. It can also snow quite heavily at Yellowstone in late July.

As you drive into the park, you'll come upon Mammoth Hot Springs 5 miles south of the north entrance, up a lovely, winding canyon road. The site of an old United States Army fort, which has been incorporated into the facilities at Mammoth Hot Springs, this area is famous for extensive travertine terraces, which are limestone deposits that resemble cake frosting. Water from hot, mineral-laden springs flows over these terraces, creating new deposits on a daily basis. A network of stairs and boardwalks provides access to such formations as Minerva and Jupiter Springs. There is also an automobile tour route, the Upper Terrace Drive. This 1½-mile-long loop takes you to the top of the terraces and provides access to several thermal hot springs.

Although thermal activity is scattered throughout Yellowstone, I consider two major concentrations to be superior. The first is the Norris Geyser Basin, located on the west side of the figure-eight loop where the two loops connect in the middle. This area has the most volatile thermal activity in North America. Steamboat, the world's tallest geyser, is here, too. It throws a column of mineral water 300 feet high, but it performs only a couple of times per year. The whole Norris Geyser Basin is literally a hotbed of bubbling and puffing and spraying.

All of this activity is the result of the junction of several faults under Norris's surface. These cracks are conduits that enable geothermal heat to come to the surface, where it mixes with water to form geysers and hot springs. Tremors in the earth and even earthquakes are common in the Norris Geyser Basin area. I like the early-morning hours at Norris, when the cool night air combines with the steam from the many cracks and vents to form an unearthly sight (see page 157). Walk along the boardwalks and trails—bring a camera, of course—and explore this unique area. The small but excellent museum just off the parking lot posts a schedule of eruptions of the more dependable geysers. You can easily spend half a day here.

The other geyser basin that I find remarkable is the Upper Geyser Basin. This area is thought to have the greatest concentration of geysers in the world and is home to Old Faithful. Grab a seat anywhere around the "bleachers," and then wait. Within an hour or so, Old Faithful will erupt. Check the posted eruption time. What is so "faithful" about this geyser is its consistency. It erupts 21 to 23 times every day and has done so for about the last 100 years. Old Faithful isn't the highest, largest, or most spectacular geyser, but it is the best known and draws hundreds of spectators for every "performance."

Miles of walking trails fan out from the Old Faithful area. I suggest taking the paved boardwalk trail to Morning Glory Pool. Leave your vehicle in the parking lot at the general store, and walk due north about 100 feet until you come upon the trail. Then turn left and head into the geyser area. The trail is approximately a mile long.

The Upper Geyser Basin is located at the southwest corner of the lower loop road. Between here and Madison Junction, which is on the western portion of the same loop, is the Midway Geyser Basin. This basin has paint pots, mud-posts, and geysers. You might find this area to be less commercial and crowded than the Old Faithful complex. Midway Geyser Basin lies along the Firehole River, which I consider one of the most scenic rivers in the park.

Another popular spot in Yellowstone is where the Yellowstone River formed a large canyon and two large waterfalls. This scenic area is known as the Grand Canyon of Yellowstone. Although the canyon is about 20 miles long, drives along the north and south rims are only a mile or so long. Of the several over-looks by the canyon, the most popular is Artist Point at the end of the south rim road. Here you can enjoy a spectacular view of the 300-foot-high Lower Falls down the 1,000-foot width on one side of the canyon. But don't miss the view in the other direction! The canyon walls there are layered with pastels, yet they're often overlooked in favor of the falls.

And although the Grand Canyon of Yellowstone has numerous hiking trails, you must keep your abilities in mind. The rim of the canyon is around 8,000 feet high, and the altitude can easily have an adverse effect on you. I consider myself to be in good condition, yet I was doing a bit of huffing coming up a short trail. A strategically placed bench was most welcome—just to set my pho-tography equipment down, of course.

Another scenic area in Yellowstone is the Firestone River. It winds along the western side of the lower loop road. The river itself is shallow, wide, and quite scenic as it meanders through a wide valley, meadows, and marshes. Mountains form the background, and geothermal activity is quite evident, especially on cool mornings. Immediately south of Madison Junction is a 2-mile-long, one-way loop road that parallels the river and goes past Firehole Falls. The many turnouts provide parking places, and there are occasional footpaths leading to the Firestone River.

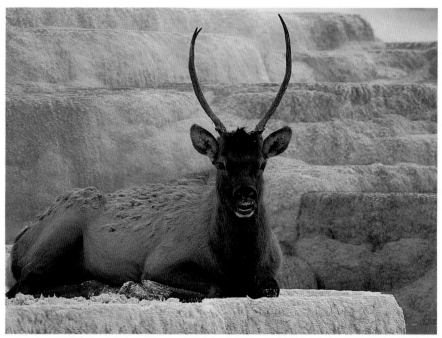

Single elk taking advantage of the warmth from a hot spring on a cool morning.

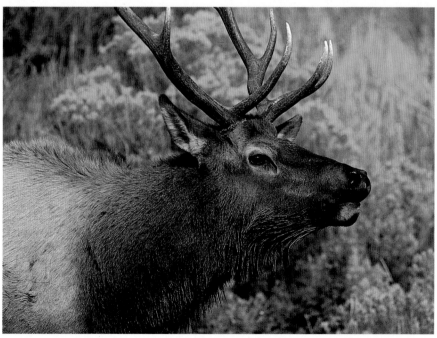

Bull elk bugling as it walked out of the woods near Mammoth Hot Springs.

HOW TO PHOTOGRAPH THE WILDLIFE

Along with 6 species each of amphibians and reptiles, there are about 60 species of mammals in Yellowstone. The ones visitors are most likely to see are bison, elks (or wapiti), pronghorn antelopes, and grizzly bears. In addition, Yellowstone has mule deer, bighorn sheep, moose, and black bears. Some of these animals are hard to miss and might even block the road in front of your car, while others require you to diligently search the area in order to see them. Because of the size and diversity of terrain in Yellowstone, knowing where each of the animals is apt to be found and photographed will make your task easier.

Marmot basking in the sun on the boardwalk.

Roughly 3,000 bison live in Yellowstone, which is just a fraction of the millions that once roamed America. Bison are frequently referred to as buffalo, but true buffalo are found only in Asia and Africa and are ox-like mammals with widespread horns. American bison are the largest land mammals in the United States and can weigh as much as 2,000 pounds. Both males and females have horns, but the male's are larger. The horns of the males, along with their distinctive anatomical features, make them easier to spot than the females. There are three major herds of bison in Yellowstone but individuals and small bands might wander away from the main groups.

Ground squirrel posing in the Lamar Valley area.

A good place for you to find bison is in the Lamar Valley at the northern end of the park. This is especially true during the spring and early summer. I prefer the Lamar Valley to the rest of Yellowstone because there are fewer people; the area is far away from the more popular attractions. The Lamar Valley is lovely in the spring, and you can find wildflowers there as well as bison, moose, and pronghorn antelopes. In addition, many of the bison have calves with them at this time of the year.

The road to the Lamar Valley starts from Tower Junction on the upper loop and winds for about 20 miles or so to the northeast entrance to the park. Only the first 10 miles or so are good for wildlife photography. Other places to locate bison are in the Hayden Valley between Canyon Village and Fishing Bridge, around Madison Junction, and along the Firehole River and Nez Perce Creek in the Lower Geyser area. You might also want to explore Fountain Flat Drive, which is about 5 miles south of Madison Junction off the road to Old Faithful.

You don't need a very long lens to photograph bison, but I recommend a focal length of at least 200mm for good full-frame images without having to get too close (see page 156). Bison are very dark in color and photograph best on overcast days; you can also wait for a cloud to partially block the sun. This will reduce the contrast between the almost black hides of the bison and the surrounding grass and background. As with most animal photography, early-morning or late-afternoon light is best. Bison are so much a part of the landscape at Yellowstone that you shouldn't concentrate on just individual animals. Get some shots of several animals together or some scenics with bison in them.

Some people claim that Yellowstone has the greatest concentration of elk in the world, so you shouldn't have difficulty finding any. Photographing them is easy, too. My daughter and I once spotted some distant bull elk across a meadow. We followed the proper procedures of moving slowly, keeping downwind, averting our eyes, and taking a zigzag route (I learned these techniques through trial and error and by reading various magazines and books on the subject.) We finally managed to get within decent shooting range for a 300mm lens and were surprised (and a little embarrassed) to find a large group of tourists about 75 feet from the elk! These people had been hidden behind a small ridge, so my daughter and I didn't see them. Intent on not spooking the elk, we were noticed by the other tourists immediately. They probably wondered what in the world we were up to.

Autumn is elk-rutting season at Yellowstone, and the park rings with their bugle-like calls. Elk look much better during the fall than they do in the spring. In addition they're engaged in mating rituals. These are the reasons why so many photographers congregate at Yellowstone in the fall. Since elk are grazers, look for them in the meadows along the Madison River beside the road into the park from the west entrance, along the Gibbon River between Madison and Norris. You can also check along both the Firehole River and Nez Perce Creek. Another good location for elk is at Mammoth Hot Springs. The animals like to hang around there on the lawns and among the buildings.

Pronghorn antelopes aren't quite as easy to photograph as bison and elk are. Look for the antelopes' branched horns—both males and females have them— and white rump patches. You can find pronghorn antelopes wherever there are sagebrush flats, especially in the Lamar Valley and the area by the north entrance. A technique I've found moderately successful is to locate antelopes

that are feeding and watch for their direction of travel and slowly make your way to a spot far ahead of them. Then sit quietly. Sometimes they'll pass fairly close to you. Of course, there seems to be an equal chance that they'll go off in another direction!

Another very popular animal at Yellowstone is the grizzly bear. Everyone wants to see and photograph these large bears. Encounters between humans and grizzlies were more frequent years ago, and unfortunately there were many instances of maulings and even deaths. The biggest problem was that bears associated people with food. Today an extensive public-awareness program about bear habits coupled with a program about keep food and garbage away from the bears have significantly reduced this serious problem (see below). Furthermore grizzly bears now stay in the wilder, less accessible sections of the park but you can still see them. Ask about the most recent sightings at a visitor center. Good locations for bear photography are in the meadows of Hayden Valley and just east of Fishing Bridge.

Mule deer, moose, and an occasional white-tailed deer are also common in Yellowstone. While you can find deer anywhere in the park, look along the edges of forests, especially in the northern sections. Bighorn sheep stick pretty much to the higher elevations. Your best bet is to inquire about recent sightings at the Mammoth Hot Springs visitor center. You might learn that you have to hike to Specimen Ridge or some other location. Moose prefer willow and waterlilies, so look along streams and marshes. I once found a cow and a calf right alongside the Lamar Valley road, well within the range of a 200mm lens.

Other accessible wildlife in Yellowstone varies, and successfully photographing these animals depends on how much luck and patience you have. Ground squirrels are plentiful in the picnic lawn in front of the visitor center at Mammoth Hot Springs. Elk are often seen here, too. Coyotes can be spotted in the meadows of the valley areas, usually early in the morning. Try the boardwalk trail between Castle Geyser and Grand Geyser in the Upper Geyser Basin for marmots. The creatures sun themselves early in the morning and are quite easy to get close to.

From a photographic standpoint, I like the Castle, Grand, Grotto, and Riverside Geysers as backdrops. These particular geysers attract fewer tourists than Old Faithful does, and they have more interesting formations. Check the bulletin board at the nearby visitor centers for eruption times, and plan your visit accordingly. I also like the Daisy Geyser, but it is difficult to shoot because the eruption fans out and seems to be heading for the photographer!

SPECIAL PRECAUTIONS

Yellowstone is a wild area and has been deliberately maintained as such. You should, therefore, be aware of some of the major hazards. Getting close to a grizzly bear is foolish and extremely dangerous. People have been badly mauled

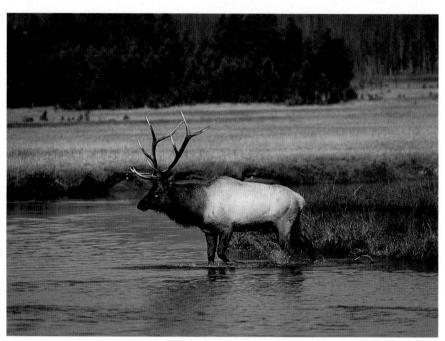

Bull elk on the park road between Madison and West Yellowstone,
a favorite spot especially in the fall.

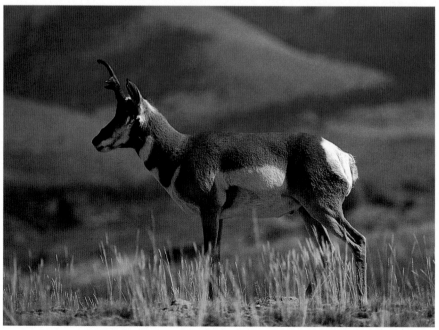

Pronghorn antelope in the hills near the north end of the park.

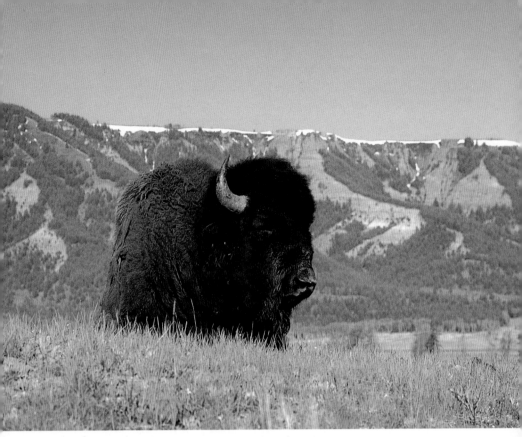

Bison snoozing in the sun.

and some even killed by these animals. Clearly, taking a chance by trying to get close for a better shot of a grizzly isn't worth it.

Bison are very unpredictable so while they appear to be tame and docile, like cows, you shouldn't get close to them. Nevertheless, you'll probably even see people standing right next to a bison to have their picture taken. So keep your camera handy—you might get a picture of someone being tossed through the air! Bison are by no means harmless. In fact, tourists are gored by bison every year. I once managed to get within 15 feet of a resting bison before I knew about the animals' disposition or the park's regulations. But when the bison started to show the whites of its eyes, I decided that I was close enough to the animal and beat a hasty retreat. When I was at Yellowstone one June, a woman had been gored two days before I arrived and another had been punctured two weeks earlier. Both women required hospitalization. In order to prevent such medical emergencies from happening, park regulations forbid visitors from getting within 25 yards of most animals; an understandable exception is the 100-yard limit for grizzlies.

Besides taking precautions when you approach the wildlife at Yellowstone, you need to be careful when you're simply walking around. The fires of 1988 left

many weakened trees standing. These may now be further damaged by decay, ice, and snow. And occasionally the trees fall, especially during high winds. So keep your senses on full alert when you walk through any of these areas.

In addition be sure to observe the signs around thermal areas. They tell you to stay on the boardwalks for good reason. The deceptively solid-looking ground off the paths can be very thin, and extremely hot water might be just below the surface. People have been seriously burned and even scalded to death in Yellowstone when they fell through the ground in what appeared to be safe areas. If you're tempted to swim in a thermal area, check to see if it is safe at a visitor center before you go. Swimming is prohibited in all pools and streams that flow directly from a thermal pool. These waters might contain organisms that can cause amoebic meningitis, which can be fatal.

PHOTOGRAPHIC EQUIPMENT AND FILM

Because Yellowstone gets so many visitors, much of the wildlife is used to having people around. As a result you can get good photographs easily, especially of the larger animals, with even a 200mm lens. A good lens to take to the park is a 70-210mm zoom lens. In addition I bring a wide-angle lens for scenics, as well as a standard lens. If you don't have a wide-angle lens, this might be a good time to try a disposable panoramic camera. And since a great deal of the wildlife is approachable—within safe limits—I carry a tripod, of course. For shooting situations when I remain in the car, a good window mount or beanbag serves to keep the camera steady. While a 200mm lens might be adequate in some circumstances, I carry at least a 300mm or 400mm lens of good quality for longer shots.

Whatever lenses you bring with you to Yellowstone, be very careful with them while shooting in any of the geyser areas. The spray contains minerals that can be impossible to remove from the outer surface of your lenses. The water portion of the spray quickly evaporates, leaving the harmful minerals deposited on the outer element. Be prepared to quickly cover the front element with something (even your hand in a pinch), or keep a skylight filter over it.

PHOTOGRAPHIC SUPPLIES AND REPAIRS

Since I am a devotee of Kodachrome 25, I was delighted to find that most of the photo shops in Yellowstone stock both Kodachrome 25 and Kodachrome 64; Ektar 125; Ektachrome 100, 200, and 400; and Kodacolor 100, 200, and 400. Most of the common camera batteries are also in stock. One-hour print processing is available at Old Faithful as well as at Grant Village, Mammoth Hot Springs, Canyon Valley, and Fishing Bridge.

While visiting the Grand Tetons, which are located immediately south of Yellowstone, I managed to knock over a tripod with my favorite Nikon F2 attached. You can imagine my dismay to find the camera's bottom plate badly

bent and attached by only one screw (the other screws had been yanked through the plate itself). I removed the plate and was able to straighten it out by carefully using a small hammer and screwdriver. The internal frame that holds the 1/4 x 20 tripod socket, however, was split and irreparably damaged. I had the option to call Nikon for assistance but I thought that it would be quicker to simply drive up to f11 Camera in Bozeman, Montana, which happened to have the exact part I needed. (This shop, which is open Monday through Saturday from 9 A.M. to 5 P.M., can repair almost any type of camera.) Back in Yellowstone that night, I installed the new frame and replaced the plate. The camera was then ready for business.

Finally, you'll be glad to know that even though Yellowstone is a national park, it has post-office facilities. The main office at Mammoth Hot Springs is open all year long. During the summer months, additional offices are located at Old Faithful, Grant Village, and Canyon Village.

THE BEST TIME TO VISIT

 More than 2 million people visit Yellowstone in the summer. Obviously this isn't a good time to try to get any decent photographs. Two possibilities remain: spring and fall. The first week in June is a wonderful time to visit. The meadows are green, the wildflowers are in bloom, the rivers are full, and the bison have their calves with them. Because there aren't that many visitors around, I had no difficulty getting into any of the campgrounds on a recent trip, even when I arrived late in the day. The more popular attractions, such as the geyser basins and the loop roads, were starting to get crowded but the Lamar Valley was practically empty.

Early fall is also an ideal time to visit Yellowstone. The green valleys have turned soft brown, and the aspen leaves have changed to brilliant yellows. While most of the animals' coats are a bit scruffy in the spring, they are sleek and have good color by the fall. And since autumn is elk-rutting season, you can get great shots of conflicts between the bulls. Keep in mind, however, that park roads are closed around November 1 (except in the northern section of the park). Furthermore, early snows aren't uncommon so the roads might close even sooner. I suggest the period from mid-September to early October as a good time to visit Yellowstone in the fall.

You might want to consider planning to go to Yellowstone in the winter. The land is covered with snow and clouded with thermal mists. Gaining access to much of the park is by snow coach, snowmobiles, snowshoes, and cross-country skis. Many of the animals that were up in the mountains during the summer have moved down into the valley. Mammoth Hot Springs is fully open, and accommodations in Old Faithful at the Snow Lodge are available from mid-December to mid-March. Transportation to the Snow Lodge is via snow coach from West Yellowstone, Montana.

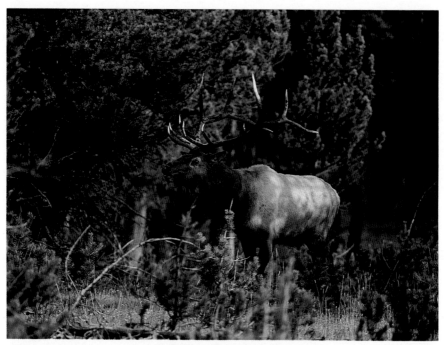

Bull elk standing in a clearing.

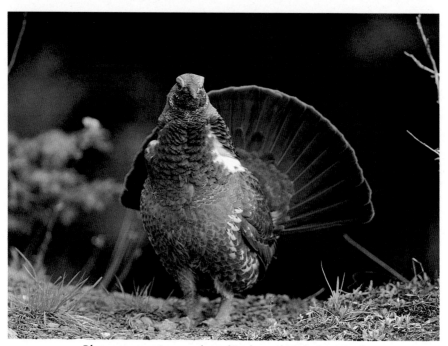

Blue grouse strutting near the parking lot on the Lake Butte Road.

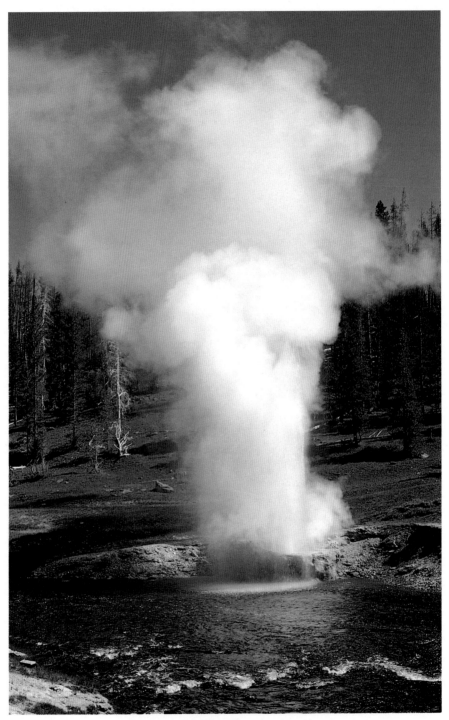

Riverside Geyser, located on the river's edge.

HOW LONG TO STAY

 Because of the size and diversity of Yellowstone, I suggest spending at least four days in the park. (A week-long stay is, of course, even better.) This gives you enough time to move around and concentrate on each major area. For example, consider spending one day in geyser country, one in the canyon, one at Mammoth Hot Springs, and one at Lamar Valley. Include a day or so for traveling from one place to another. The roads can be slow, especially if you get caught behind a sluggish camper, and some of the passes take awhile to get over. Dunraven Pass is more than 8,000 feet high, and the road has several switchbacks. So you can see that a week at Yellowstone really isn't that long.

LODGING AND DINING

 Because the Grand Canyon area of Yellowstone is such a well-visited spot, it has a visitor center, accommodations, a store, a service station, and a campground. In addition to the park's headquarters you'll find a visitor center, a hotel, cabins, a general store, a post office, restaurant, a service station, and a campground in Mammoth Hot Springs. This year-round "community" is the oldest one in the park.

Other lodging alternatives at Yellowstone include hotels or cabin-type accommodations at six areas: Mammoth Hot Springs, Roosevelt, Canyon Village, Lake Village, Grant Village, and Old Faithful Village. The home of the most famous geyser in the park, the Upper Geyser Basin area also supports a visitor center, the Old Faithful Inn, the Old Faithful Lodge, cabins, a post office, a service station, a cafeteria, and a general store. However, there is no campground in the Upper Geyser Basin. Opening and closing dates vary, so check about them at any of the visitor centers. In order to make your plans in advance—which I highly recommend, especially during the busy summer season—you can either write to the park and request the accommodation schedule or contact TW Recreational Services, Inc. (see page 189).

Immediately outside the west entrance to the park lies the town of West Yellowstone, Montana. This bustling community has all the services you could ask for from lodging, restaurants, and car rentals to tour guides, outfitters and even barbers. Write or call the Chamber of Commerce for its directory of services (see page 189).

There are 11 campgrounds in the park and all of them, with the exception of Bay Bridge, operate on a "first-come, first-serve" basis. Bay Bridge has a partial reservation system operated nationwide by Ticketron. In addition the Bay Bridge and Canyon Village Campgrounds are restricted to hard-sided camping vehicles because of frequent bear activity. This means no tents or even vehicles with canvas pop-tops.

At 10 of the campgrounds camping is limited to 14 days between July 1 and Labor Day, and 30 days during the rest of the year. Only the Mammoth Hot

Springs campground is open year round. The others open on varying dates between the first week in May to the end of June, and they close between early September and the end of October. Check at a visitor center for the exact dates or get a copy of *Yellowstone Today*, which contains the campground schedule.

The Grant Village, Canyon Village, Madison, and Fishing Bridge Campgrounds are the largest ones in the park. There are about 300 to 400 sites in each. The next largest campgrounds are Indian Creek, Lewis Lake, Mammoth Hot Springs, and Norris, with 85 to 100 sites each. The remaining campgrounds have only between 29 and 36 sites each. Public showers are available only at the Old Faithful Lodge, Grant Village Campground, Lake Lodge, Fishing Bridge Campground, and Canyon Village Campground. Fishing Bridge has the only real recreational-vehicle hookup facilities, and Slough Creek has no water supply.

Within the park, Hamilton Stores operates general stores, tackle shops, and photo shops at all of the five major villages. Here you can find camping supplies, groceries, liquor, and food service (except Roosevelt). In addition Yellowstone has more than 12 dining rooms, cafeterias, and snack bars. Keep in mind, however, that some of the dining rooms require reservations for dinner.

Supplies and groceries are also available at Gardiner, which is just outside the north entrance to the park; Cooke City, which is outside the northeast entrance; and West Yellowstone, which is by the west entrance. If you purchase nothing else at a Hamilton Store—and it is hard to resist one of the huge ice cream cones—at least get a copy of *Hamilton's Guide to Yellowstone National Park*. Priced very reasonably, the book is filled with valuable information on all aspects of the park.

NEARBY PLACES OF INTEREST

There is so much to see and to do at Yellowstone that it is hard to imagine going anywhere else in the area, but there are some places to consider. The **Grand Teton Mountains**, now a national park, lie just south of Yellowstone. To get to them, you simply take the highway out of Yellowstone's south entrance and then follow the signs to Jackson. These mountains are spectacular, especially when Jackson or Jenny Lake is in the foreground of the view. In addition Yellowstone is surrounded by five national forests: Custer, Gallatin, Shoshone, Targhee, and Teton. These offer grand scenery, overviews into the park itself, and some beautiful campgrounds. Keep in mind, however, that these forests are mostly mountainous, and the only areas that are accessible to the public are campgrounds, fishing ponds, and lakes.

OTHER PLACES OF INTEREST

I F YOU DECIDE to visit any of the following areas, write or call and request everything available in the form of maps, brochures, Chamber of Commerce information, accommodation listings, and resident wildlife. All of this information should make you familiar enough with the places and their wildlife—and enable you to take better photographs.

AÑO NUEVO STATE RESERVE, CALIFORNIA

The Año Nuevo State Reserve is located 55 miles south of San Francisco, immediately adjacent to California Route 1 near the Big Basin Redwoods State Park. This reserve is truly unique. Northern elephant seals come ashore here to breed

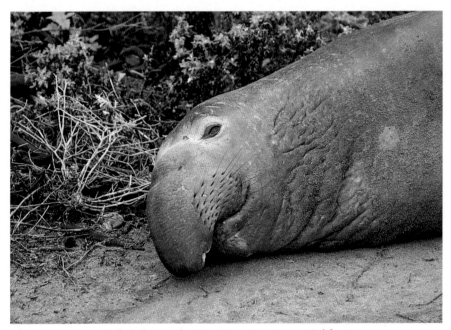

Bull elephant seal at Año Nuevo State Reserve, California.

and raise their young because the several hundred acres of sand dunes are one of the few undisturbed areas left on the California coast. This is critical for the raising of young seals.

Follow this procedure for photographing the seals. Upon arriving at the entrance booth, pay the parking-lot fee and sign up for a guided tour of the seal colony. You'll be given a plastic tag with the time of the tour. Park your vehicle, check in at the visitor center (where you turn in the tag), and pay a small fee for the tour. Plan on about three hours for the tour: it takes approximately half an hour to get to the colony and half an hour to get back, and, of course, you want to spend some time there.

There is a 20-foot minimum approach distance to the seals, but a 200mm lens can be sufficient considering their size. A 300mm lens would be even better for individual portraits. To photograph groups of the 300 or so seals in the colony, you can use a standard lens. Bright, sunny weather isn't ideal for shooting because the seals tend to be more active on cloudy or overcast days.

The best time to visit Año Nuevo is from mid-January to early February. The greatest number of seals, as well as newborns and bulls (who leave at the end of February) are there then. During this time period public access is strictly controlled, and you may go to the colony with a guided tour group only. Try to reserve a tour in advance because they are limited to 20 people per group; you don't want to get to the reserve and find the tours all booked up. After the tour restriction ends in March, visitors are allowed to go to the colony without

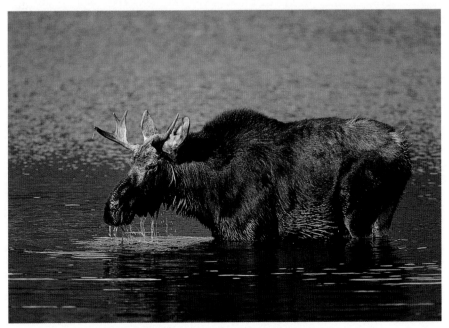

*Young **bull** moose at Baxter State Park, Maine.*

escort. Most of the males have already left, but you have unrestrained access to females and pups. The 20-foot approach limit, however, is still in effect.

If you find that the tours are booked up or don't want to be escorted, go to Cove Beach. It is only a few hundred feet past the visitor center, and male elephant seals are often there. My routine was to take a tour and then go down to Cove Beach. If you really want to get the most out of a day at Año Nuevo, sign up for both an early and a late tour. You can then spend the time in between the tours having lunch and visiting Cove Beach.

There are no accommodations in the immediate area around Año Nuevo, but a half-hour drive puts you in the vicinity of several towns and small cities, including Scotts Valley, Santa Cruz, and Felton.

BAXTER STATE PARK, MAINE

Established in 1931 as a result of efforts by then Governor Percival P. Baxter, Baxter State Park is an unusual wilderness area of 200,000 acres. Located roughly in the center of Maine, you can reach Baxter by taking Interstate 95 to Medway, which is Exit 56. Then follow Highways 11/157 west to Millinocket, where signs direct you to Baxter.

Baxter is a jewel of mountains, ponds, and valleys. The dominant peak is Mount Katahdin, the highest point in Maine. The park is also a naturalist's paradise, with a diversity of animal and plant life. But most people come to Baxter to photograph the moose. The many shallow ponds of this state park are especially attractive to these large animals, which are commonly seen and easily photographed here. Hunting isn't allowed in Baxter, so the moose aren't nervous around people. One of the most popular places to find moose is Sandy Stream Pond, about four tenths of a mile north of the Roaring Brook Campground. On one trip to Baxter, I hiked in and came upon six moose: two cows, three calves, and a young bull. Since Sandy Stream Pond is only a few hundred yards in length, you can easily get around it and find the most favorable light and background. Other good spots for seeing moose are Grassy, Abol, and Tracy Ponds, all of which are in the southern section of the park.

You don't need very long lenses at Baxter, but they do help when a moose happens to be on the other side of a pond. I've done nicely with a 300mm lens, and I could have managed with a 100mm lens. A little patience and luck can get you pretty close to one of these tall beasts. And you don't truly appreciate their size until one walks out of a pond right next to you!

Fall is one of the best times to visit Baxter because the moose are in rut and the foliage is quite colorful. Late September or very early October are considered ideal. The weather is generally clear and cool, and some early snow might dust Mount Katahdin, thereby enhancing any scenics. Spring and summer can be lovely times in the park, but you should be aware of black flies; these can be a real nuisance.

There are eight campgrounds in the park with a variety of walk- and drive-in sites, lean-tos, and bunkhouses. Two additional areas have only cabins. No recreational vehicles are allowed because of size restrictions (check at the park headquarters). The gravel park roads are rough, winding, and narrow with a 20 MPH speed limit. No pets are allowed at any time because Baxter is a designated wilderness area.

There are a couple of lodges outside the park entrance, and you can find motels and restaurants in nearby Millinocket.

BOMBAY HOOK NATIONAL WILDLIFE REFUGE, DELAWARE

The Bombay Hook National Wildlife Refuge is located on the eastern shore of Delaware. Route 13 serves this part of the state and is a heavily traveled road. I generally turn off onto Route 9, which parallels Route 13; it is a quiet, scenic two-lane road that winds among the salt marshes. If you come through Smyrna, look for the refuge sign at the south end of town.

Bombay Hook has a visitor center, observation towers, a photography blind, a boardwalk trail, and a 12-mile-long auto tour route through the marshes, impoundments, and adjacent lands. This dirt road is primarily one-way, counterclockwise, although some sections are two-way. The refuge's 15,000 acres are primarily salt- and freshwater marshes that are attractive to waterfowl migrating along the Atlantic Flyway. The refuge also features some other habitats: hardwoods, swamps, fields, and meadows. These provide habitats for wildlife other than waterfowl.

Huge numbers of migrating birds visit Bombay Hook every year. You can even use a standard lens to photograph concentrations of them. I've done fairly well photographing individual birds with a 300mm lens, but a longer lens would be better. If the water levels are right, the photo blind is a good place to be, especially late in the afternoon. Check at the visitor center as to the availability and effectiveness of the blind on that particular day. If the water levels happen to be down, the birds will be too far away for you to photograph them.

The best time period to photograph geese and ducks is between mid-October through November. In fact, it is common to find 100,000 or so birds on the ponds and impoundments. Typical birds are snow geese, Canada geese, pintails, shoveller ducks, herons, teals, and wigeons. Fall weather along the shore in Delaware can be lovely, with clear skies, warm days, and cool nights. Spring is also a good time to visit Bombay Hook. May sees the largest variety of wading birds, and shorebirds are at a peak then, too. In addition wildflowers are in bloom, and the heavy summer mosquito populations haven't hatched yet.

Most accommodations are located in nearby Smyrna and Dover. Check with the Kent County Tourism Corporation for lodgings and campgrounds. There are also a couple of Delaware State Park campgrounds within an hour's drive of Bombay Hook: Lums Pond State Park and Killens Pond State Park.

DEVIL'S TOWER NATIONAL MONUMENT, WYOMING

Located in the very northwest corner of Wyoming, Devil's Tower National Monument is one of the best places to photograph prairie dogs. Take Interstate 90 West, the major highway to Devil's Tower, for about 80 miles to Sundance, Wyoming, and then follow Route 14 North for 28 miles to the entrance to the tower. (The nearest city is Rapid City, South Dakota.) Devil's Tower is so named because of a spectacular volcanic plug that rises out of the Black Hills. The monument is a popular attraction for rock climbers, who can almost always be seen climbing it. There is a campground at the monument plus a visitor center and a couple of hiking trails.

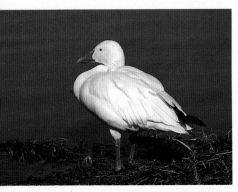

Snow goose at the Bombay Hook National Wildlife Refuge, Delaware.

The Prairie Dog Town is in the meadow between the campground and the tower. To get there, cross over the bridge just past the entrance booth, and then look for a parking lot on the left next to the meadow. Because this well-established colony is visited so often by humans, the prairie dogs aren't as skittish here as they are at other locations. Prairie dogs build an earthen mound around the entrances to their burrows. These serve as watchtowers and help keep rain out. One of the prairie dogs acts as sentinel and whistles of any danger. This signal sends the entire colony underground. While visiting the area, however, I found the prairie dogs fairly easy to work with. I walked out onto the meadow and, of course, all the prairie dogs disappeared underground! So I picked out a nice-looking burrow entrance and set up a tripod and camera nearby. I didn't have to wait more than five minutes or so before a prairie dog reappeared. My 300mm lens worked fine in this situation, and with a bit of patience I think I could have even used a 200mm lens.

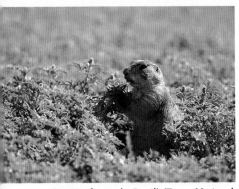

Prairie dog at the Devil's Tower National Monument, Wyoming.

The campground at Devil's Tower is open from the middle of May through the end of September. Its 51 sites can accommodate tents, trailers, and small recreational vehicles. But there are no hookups. Winters can be brutal in this part of the country, and the landscape bleak. Try to visit during the early spring or fall months. The campground is open then, and the weather, naturally, isn't as hot as it is during the summer.

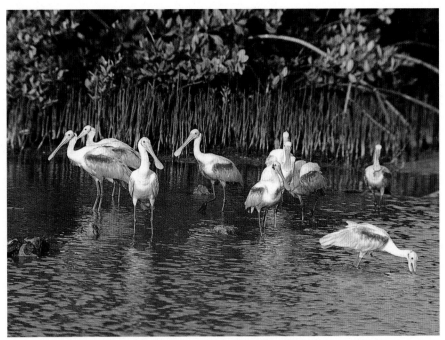

Roseate spoonbills at the Ding Darling National Wildlife Refuge, Florida.

Atlantic puffins at Machias Seal Island, Maine.

DING DARLING NATIONAL WILDLIFE REFUGE, FLORIDA

Located on the island of Sanibel, Florida, is another of my favorite areas, the J. N. "Ding" Darling National Wildlife Refuge. Named for a Pulitzer-Prize-winning cartoonist, the refuge has long been recognized as a premier wildlife-photography hot spot. Ding Darling is a great place to capture roseate spoonbills, wading birds, herons, and alligators on film. Take Florida State Road 867 West off Route 41, south of Fort Meyers. Follow the signs for Sanibel and Captiva Islands, cross over the causeway, and turn right down the main street in Sanibel. The refuge is clearly marked on your right.

The wildlife at Ding Darling are primarily interested in feeding on the mudflats and in the shallow waters alongside the 5-mile-long, one-way auto Wildlife Drive that winds through the refuge's 5,000 acres. In fact, the wildlife pretty much ignore human visitors to the refuge. This means that great opportunities exist for good photography. I've seen lenses of all focal lengths used successfully at Ding Darling, but this really depends upon the situation. I once watched a photographer, sitting quietly on the edge of the road, reach his peak frustration level as a night heron walked right in front of him, grabbed a crab, and proceeded to eat it—all within a few feet and too close for the photographer's 500mm lens! If the birds are feeding close to the drive, you'll even be able to shoot with a 100mm lens. The lens I use the most at Ding Darling, however, is my 300mm lens.

The birds feed mostly at low tide, so pick up the tide-table information available at the visitor center. Sunset and sunrise are, of course, excellent times to shoot regardless of the tides, but if they coincide, that is even better. My favorite time to visit Ding Darling is early March, when the roseate spoonbills have usually arrived and the weather tends to be more stable. Earlier in the year, winter storms are still possible, bringing with them plenty of rain and cloudy days. But by March, the weather patterns are more consistent, the days are warm, and there isn't much rain.

Sanibel is a popular winter community and while it may seem incongruous that a national wildlife refuge is located there, the two communities seem to coexist well. Be sure to visit the excellent Sanibel-Captiva Nature Center, which is within a block of the entrance to Ding Darling.

There is only one campground on Sanibel, and it tends to be crowded and very expensive; however, other lodging is available in Sanibel. Contact the Chamber of Commerce, and request its *Island Guide*. Accommodations are also available on the other side of the Sanibel causeway. Check with the Greater Fort Meyers Chamber of Commerce for recommendations (see page 186).

KLAMATH BASIN NATIONAL WILDLIFE REFUGES, CALIFORNIA AND OREGON

Six separate management areas make up the Klamath Basin National Wildlife Refuges: Bear Valley National Wildlife Refuge (NWR), Clear Valley NWR,

Klamath Forest NWR, Lower Klamath NWR, Tule Lake NWR, and Upper Klamath NWR. These are situated on the Oregon/California border. To reach them, take Oregon State Route 39 South across the border, where it becomes California State Road 139. Follow Route 139 for about 3 or 4 miles to the town of Tule Lake. Signs will then direct you to the refuge headquarters.

The Lower Klamath National Wildlife Refuge was established in 1908 and was the nation's first waterfowl refuge. An auto tour road provides access to the 47,000 acres of marshes, open water, and grasslands. The Tule Lake NWR is located about 8 miles east of Lower Klamath and consists of mostly open water and adjacent fields. There is a short auto tour route at Tule Lake. The Upper Klamath, Bear Valley, Klamath Forest, and Clear Lake refuges are all located in Oregon, just over the California border. Any access to these areas is limited.

If I had to choose between Lower Klamath and Tule Lake, I would go to the latter because it provides more access to waterfowl on open water. In addition birds at Tule Lake tend to be skittish. I've done fairly well shooting with a 300mm lens but a longer lens would be much better. Stay in your car: it makes a great blind. A beanbag on the window ledge (or a folded jacket) works very well. A window mount is good to have here.

Bear Valley has the highest concentration of wintering bald eagles in the lower United States. They roost in the valley but fly to the Lower Klamath and Tule Basin areas to feed on waterfowl. The largest numbers of eagles—upward of 500—arrive in January and February, and the birds are best seen and photographed from the auto tour routes, especially when otherwise open water areas are frozen over. March and early November are considered prime viewing times, with more than a million birds on the refuge. Write to the refuge headquarters for a list of local accommodations, trailer parks, and campgrounds (see page 187). The nearest campground is at the adjacent Lava Beds National Monument, an interesting place to visit.

MACHIAS SEAL ISLAND, MAINE

There are four puffin breeding areas in the Gulf of Maine, but people are allowed to land on Machias Seal Island only. This 15-acre rocky island lies about 10 miles southwest of Cutler, Maine. Access is by boat. Time spent on the island is under the auspices of the Canadian Wildlife Service, which keeps a resident warden there during the summer puffin breeding season. A maximum of 30 people is allowed ashore daily, and the visitors' time on the island is limited to three hours. There are four blinds, a lighthouse with a foghorn (take earplugs in case of fog!), and a couple of other buildings. Landings are made from rowboats onto slippery, seaweed-covered rocks, so if a slight sea is running, this part of the trip can be exciting.

People make the trip to Machias Seal Island primarily to see and photograph puffins. The 2,500 or so of these "sea parrots" are so used to people and the

Marbled godwits at Morro Bay, California.

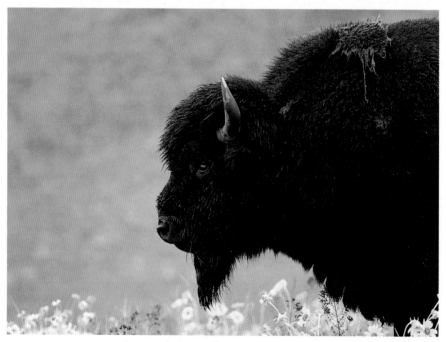

Bison at the National Bison Range, Montana.

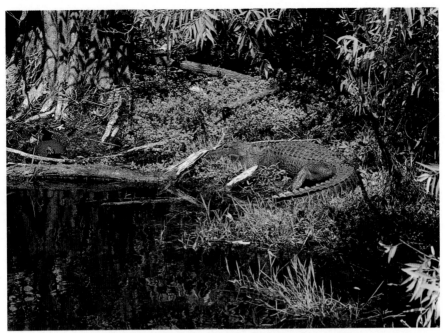

Alligators at the Okefenokee National Wildlife Refuge, Georgia.

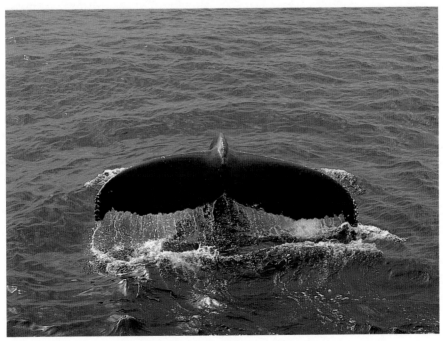

Humpback whale at Provincetown, Massachusetts.

blinds that photographing them is actually like shooting fish in a barrel. Here is the procedure. After the Canadian Wildlife warden assigns the blinds, you are then led through tern nesting grounds. Be sure to carry your camera gear over your head as protection and to wear a hat because terns are defensive and "dive-bomb" intruders. The blinds are wooden structures with viewing ports all around and at different levels. They are long but very narrow, which makes it difficult to use a tripod in them. So the best support is a beanbag, folded shirt, or sweater. The puffins are on the rocks right in front of the blinds and within the range of a 200mm lens. Longer lenses, obviously, reach out for more distant birds, and even a 100mm lens is fine for closer ones. People usually are allowed to stay 30 to 45 minutes in each blind (the warden moves you around so everyone can get different views). The best weather conditions for photographing puffins, which are very contrasty subjects with their black-and-white feathers, are hazy days or even fog.

The best time to visit Machias Seal Island is anytime the boats run, which is from the middle of May through the middle of August. The chicks generally hatch around the middle of June. Other subjects are razorbills, Arctic and common terns, and a few murres (these depart the island by July). Allow time for more than one trip because the weather may not be favorable. Advance reservations are advised.

Boat trips to Machias Seal Island leave from Jonesport, Cutler, and Grand Manan Island (see page 187). You can reach Jonesport via Maine State Road 187 South from Route 1; Cutler is on Route 191. This road winds along the shore below East Machias. Grand Manan Island can be reached by ferry from New Brunswick, Canada. There are motels in Jonesport, Machias, and Cutler. Lodging is also available on Grand Manan Island.

MORRO BAY, CALIFORNIA

Morro Bay lies about halfway between San Francisco and Los Angeles and is one of the few sheltered areas of the California coast. A huge volcanic plug, which is at the entrance to the bay, and a barrier beach form protection for the dunes and marshes that surround Morro Bay. The bay itself is about half a mile wide and is home to a number of birds, including loons, sea otters, harbor seals, marbled godwits, great blue herons, mergansers, cormorants, surf scoters, and a variety of shorebirds.

The only way to get among this smorgasbord of wildlife is by canoe or kayak. Although you can rent boats in town, I chose to accompany Richard Hansen, a skilled local photographer and guide who knows the area well. We set out by canoe early one morning, and in a three-hour period had photographed seals, loons (one so close that I couldn't focus the lens), surf scoters, and marbled godwits. We could have gone after more subjects, but a recent storm had left many of the bay's residents a little spooked and difficult to approach.

A 70-210mm zoom lens is ideal at Morro Bay. Canoes tend to tip, and longer lenses can be difficult to keep steady; however, a 400mm lens on a stock might work. Hansen paddles while you sit forward in the bottom of the canoe. This keeps the center of gravity low and leaves you free to shoot.

Anytime during the year can be a good time to visit Morro Bay, but wildlife does change from month to month. Spring and fall might be the best times to visit: you'll find migrating birds in addition to the resident wildlife. If you're planning a trip for a certain time, contact Hansen to find out what wildlife is there then.

The town of Morro Bay has plenty of motels and several restaurants, as well as a camera store. You'll find a campground at the southern end of town. Check with the Chamber of Commerce for information (see page 187).

NATIONAL BISON RANGE, MONTANA

If you want a compact area to photograph at you might want to consider a trip to the National Bison Range located about 35 miles north of Missoula, Montana, at Moiese. Take Route 93 North from Interstate 90 for about 27 miles, and then watch for the refuge sign at Moiese. Part of the National Wildlife Refuge system, the range is a small mountain that juts up from a large, flat valley. Its 19,000 acres of grasslands and valleys support bison, pronghorn antelope, elk, and even some Rocky Mountain Sheep.

Access to the range begins at the visitor center. There are two auto routes that lead out from the center. Towed vehicles, trailers, and large motor homes are prohibited from the longer route because of its steep grades and switchbacks. Known as the Red Sleep Mountain Auto Tour, this 19-mile-long dirt road winds upward from 2,700 feet to almost 5,000 feet. There are no guardrails, and some of the drop-offs are dramatic. There is a shorter tour road that avoids the hazards of Red Sleep, but it isn't nearly as spectacular as the longer route.

I've done well at this refuge with a 300mm lens and even a 200mm lens. There are times when you can use a standard lens to record several animals at once. You may get out of your vehicle, but you aren't allowed off the road. Exceptions to this are two short walking trails toward the top of the tour road.

Early June is a wonderful time to visit the Bison Range. The summer crowds haven't arrived yet, the hot summer weather hasn't settled in, the days are generally warm with cool nights, the grasses are all soft greens, and wildflowers are in bloom. Fall is another good time to visit: the animals' coats look better. There is a bison roundup and an auctioning off of surplus animals around the first week in October. Check with the refuge headquarters for exact times; you might want to attend or to stay away because parts of the refuge are closed then.

There are practically no accommodations near the refuge, but the visitor center has a list of campgrounds that are between 8 and 60 miles away. Many people stay in Missoula and commute to the refuge. I think visiting for a couple of

African elephants at the San Diego Wild Animal Park, California.

Texas longhorns at the Wichita Mountains National Wildlife Refuge, Oklahoma.

Flamingo at the
San Diego Zoo,
California.

days provides you with plenty of opportunities for some good shots, as well as some weather variations.

OKEFENOKEE NATIONAL WILDLIFE REFUGE, GEORGIA

The largest national wildlife refuge and the largest primitive swamp in America, Okefenokee National Wildlife Refuge lies in southeast Georgia. This huge wilderness of 400,000 acres is home to alligators, wood storks, and sandhill cranes, as well as a variety of other birds, mammals, and reptiles.

There are three entrances to Okefenokee Swamp. Folkston, on the east side, is considered the primary entry and has a visitor center, exhibits, boardwalk, tower, walking trails, a boat-rental concession, and the refuge headquarters. Take Georgia State Road 121 South from Folkston for about 8 miles. The 4-mile-long entrance road to the refuge will be on your right. To the north is the Okefenokee Swamp Park, a private, nonprofit development that has interpretive displays, a boardwalk, tower, boat rentals, and swamp tours. The third entrance is at the Stephen C. Foster State Park, on the west side of Okefenokee; here you'll find a small natural-history museum, marina, boat rentals, and a campground. Access is via Georgia State Road 177 North out of Fargo, Georgia. I prefer to spend my time at Okefenokee on the Folkston side because it is more open and there is more wildlife to see. The Foster side has larger cypress trees and is darker and more "swampy," like old horror movies.

Most of the swamp is pretty wet, and a boat or canoe is essential if you want to get anywhere. You can rent one, but if you are a first-time visitor, I recommend taking a guided boat tour in order to get a feel for the place before setting out on your own. I like to visit the Okefenokee refuge anywhere from mid-March through late April or early May. The weather isn't too hot yet, and the crowds aren't bad. I've found that the refuge can get quite crowded on weekends as summer approaches.

Okefenokee is a great place to photograph alligators and larger wading birds. I rent a skiff with an outboard and motor out into the swamp. A large canal runs through Okefenokee, but you'll see more by taking trips out of the canal. Long lenses are usually needed in Okefenokee. But even a 200mm lens is often too long for photographing alligators—depending on how close you really want to get to your subject!

Another warning: Be careful getting out of a skiff onto more "solid" land. Okefenokee is an Indian word meaning "land of trembling earth." What appears solid is actually a floating peat mat, and while it will usually hold you up, walking on the peat mat is very much like walking around on gelatin. I've found that the best technique is to pull the skiff onto land, get back into it, and then set up a tripod. This arrangement is quite stable and you don't have to worry about falling through the peat mat or having a tripod leg drop out from under the camera.

You can find accommodations, restaurants, and gas stations in Folkston and Waycross, which is about 30 miles to the north. There is a campground at the Stephen C. Foster State Park on the west side of Okefenokee. Two others are located at the Laura Walker State Park and Traders Hill Park, both near the east entrance to Okefenokee.

PROVINCETOWN, MASSACHUSETTS

The first whale-watching trips in the United States left from Provincetown at the tip of Cape Cod in the 1960s. The tip of Cape Cod is the closest point of land to Stellwagen Bank, the southern part of the Grand Banks. Whales migrate between rich fish-laden northern waters and the warmer-climate areas where they rear their young. Whales like to feed near Provincetown during their migrations, and a number of boats take people out to see and photograph them, not only from Provincetown but also from other New England ports. To get to Provincetown, follow Massachusetts Route 6 all the way to the tip of Cape Cod. The town itself isn't that large, and the town dock is easy to find.

The whale-watching season runs from April through October. You can see whales practically anytime, but many people feel that April and either September or October are the best months. The whales most often seen are humpbacks, but fins and minkes are also commonly spotted. The humpbacks approach the boat and even swim underneath and come up on the other side. Although whales can be seen anytime during the day, the early-morning trips generally provide the calmest water and the whales are easier to see. But sunset trips may provide you with the most spectacular photographs.

Whale-watching boats are large and make fairly stable camera platforms—unless the ocean is rough. Even so, there is little point in taking a tripod on a whale-watching boat. Your best bet is to handhold your camera and use the highest shutter speed you can to offset boat motion as well as that of the whales. A 70-210mm zoom lens is ideal for capturing whales on film. Experienced whale photographers usually carry two cameras, one with a zoom lens and the other with a fixed lens. This second lens might be a standard lens for photographing a whale that comes up alongside the boat. A motordrive or autowinder is quite useful when you photograph whales because the action can be quick at times.

A good place to stand on the boats is as far forward in the bow as you can get. Some boats even have a bow platform that extends out over the water. This is the premier viewing place because the boats generally keep their bows to the whales. Another good place is forward on the upper deck. You never know where a whale will appear, so just wait until one comes up on your side.

There are many motels and restaurants in Provincetown as well as elsewhere on the Cape. There are several campgrounds in the local area. The Chamber of Commerce guide lists all of this information (see page 188).

SAN DIEGO WILD ANIMAL PARK, CALIFORNIA

If you want the thrill of an African safari and don't want to travel far, the San Diego Wild Animal Park may be a good option. Established in 1972, the park is one of the largest wildlife preserves in the world. Run by the nonprofit Zoological Society of San Diego, the park's 1,800 acres are located in Escondido, California, about 30 miles north of San Diego. To get there, take the Via Rancho Parkway East, which is just south of Escondido, and follow the signs to the Wild Animal Park. Here, elephants, zebras, gazelles, giraffes, Cape buffalo, and other exotic wildlife roam free on African and Asian "plains."

An easy way to see the most wildlife is to take the 50-minute monorail through the plains areas. The rear seat of the last car offers one of the best vantage points. Try to shoot from the right side: the monorail travels clockwise, so you'll be on the inside. Tripods are difficult to use on the monorail, but a beanbag should work well on the railings. The first and last trips of the day are best as the animals are more active then. Especially good places for photography in the Wild Animal Park are the Kilimanjaro Trail, the African Marsh, and the Kupanda Falls Botanical Center. Like the animals at most zoos and other animal parks, those here aren't disturbed by people, so you really don't need long lenses. I carried only a 200mm lens with me when I was there and did very well with it. An excellent choice is a 70-210mm zoom lens.

The very best way to photograph the plains animals is to take a photo caravan. Operating from May through September, these special vehicles take a maximum of 10 people out onto the plains in open stake-bed trucks and get them close to the animals. No tripods are allowed, but monopods and beanbags are permitted. There are two caravan trips, one lasts 1¾ hours; the other, 3½ hours for only a little more money. I recommend the longer trip since it brings you to many more animals.

Because of the subtropical climate, you can visit the Wild Animal Park anytime during the year. The park can be crowded on weekends, so try to visit during the week. Also, the photo caravans can get booked up so make advance reservations. There are plenty of accommodations nearby.

SAN DIEGO ZOO, CALIFORNIA

The San Diego Zoo is consistently rated one of the best zoos in the world. To get to the park, you can fly to San Diego International Airport, which lies about 5 miles due west of Balboa Park. You can take your pick from the many car-rental agencies located at the terminal. After renting a car, take Interstate 5 South from the airport to California Route 163 North to the park, and then follow the signs for the zoo.

Operated by the nonprofit Zoological Society of San Diego, the zoo occupies 100 acres of land in Balboa Park, at the north end of the city. The climate is subtropical, and the majority of the zoo's animals are able to stay outdoors all

year around. The zoo is quite attractive, with lush exotic plants, shrubs, and trees. The San Diego Zoo is basically laid out on two levels. The entrance booths and parking lots are located on the upper level. The lower canyon level is accessible by paths, stairs, or escalator. Because of the up-and-down traveling involved, I recommend renting a baby stroller to haul heavy photographic equipment around. If you want an easy way to preview the zoo, there is a tram that will whisk you around both the upper and lower levels.

The majority of the zoo's inhabitants are in outside enclosures, which makes for easy photography: there are no bars or wire to shoot through. Many of the enclosures are heavily planted, which also helps you to shoot good pictures. I especially liked the Rain Forest Aviary, the new Gorilla Tropics, and the mercat and the Siamang monkey exhibits. A good all-around lens is a 70-210mm zoom lens, but longer focal-length lenses, such as a 300mm or 400mm lens, are necessary for head shots and some of the smaller animals. A standard lens is best for large enclosures or overall views of the zoo. And if you run out of slide film, you can buy Kodachrome 64 and Ektachrome 100, 200, and 400 at the Camera Den or the gift shop; Kodacolor Gold 100, 200, and 400 are also sold here.

Because of its subtropical climate, you can visit the San Diego Zoo anytime during the year. San Diego is the second-largest city in California and has plenty of motels, including practically every known chain. Restaurants also abound, with perhaps seafood and Mexican dishes the city specialties.

WICHITA MOUNTAINS NATIONAL WILDLIFE REFUGE, OKLAHOMA

Situated in southwest Oklahoma, the Wichita Mountains National Wildlife Refuge is a 60,000-acre refuge that is home to bison, Texas longhorn steer, elk, deer, and wild turkeys. Granite mountains rise 1,000 feet above the lakes and prairies of the refuge's central valley. The Will Rogers World Airport, which is the closest major airport, is in Oklahoma City, about 100 miles north of the refuge, and is served by 11 major airlines. A dozen national car-rental agencies and a few local ones are located at the airport. Public access to Wichita is via Oklahoma State Road 49, which runs the length of the refuge. A visitor center is open Friday through Sunday from March to December, and the refuge headquarters serves as a visitor-contact station during the week.

Because of the relatively small size of the refuge, you can readily photograph bison and longhorns. There are around 500 bison on the refuge. The longhorns are beautiful animals. Of Spanish origin, these many-colored cattle are the stuff of old Western movies. The highway runs through open range, and these large animals often block the road. You don't need long lenses here. In fact, a good choice would be either a 70-210 zoom lens or perhaps a 200mm lens. Standard and wide-angle lenses are useful for shooting scenics.

Surplus bison and longhorns are auctioned off each fall. These spirited auctions are open to the public. The bison auction is held on the first Thursday in

November, and the longhorn auction is the third Thursday in September. If you're interested in attending, contact the refuge headquarters for the exact dates (see page 188).

In addition to the animals, Wichita Mountains NWR has a multitude of lakes, streams, canyons, mountains, and grasslands—all of which readily lend themselves to good scenic photography. There are more than 15 miles of hiking trails, so you can get away from the high-public-use areas. The best time to visit Wichita is probably in the fall when the animals look much better than they do in spring. Also, fall foliage colors tend to peak around the first week in November. Spring is also a good time to visit the refuge as everything is green and lush. And early June is an ideal time for wildflowers. Keep in mind that the summer months are hot and humid.

There are 90 campsites at Doris Campground, the only campground in the refuge. For other accommodations, you'll find that the nearest town of any size is Lawton, about 25 miles to the southeast of the refuge. About 20 motels are there, including six national chains, as well as plenty of restaurants.

WIND CAVE NATIONAL PARK, SOUTH DAKOTA

Ordinarily you wouldn't think of visiting a national park designed to preserve a cave system if you want to photograph wildlife. Located in the Black Hills at the southwest corner of South Dakota, Wind Cave was established in 1903 to protect the cave itself, one of the world's oldest. The park's 29,000 acres of rolling grasslands are home to various animals, including bison, mule deer, pronghorn antelope, and prairie dogs. Several excellent cave tours are available if you like to explore underground.

To get to the park, you can first fly to Rapid City, which is considered the gateway to Wind Cave. Rapid City Regional Airport is served by three major airlines and has at least six car-rental agencies for you to choose from. Then take U.S. Route 385 and South Dakota Route 87, which wind through the western side of the park. Within a loop of Route 385 lies a 2-mile-long park road that provides access to a large visitor center, campground, and picnic area, as well as the cave entrance.

Although you can find the park's wildlife anywhere, one of the best places is along U.S. Route 385 just south of the park road. It is common to see bison on the prairie, and they can be easily photographed. There are prairie dogs in this area, too, but I found them skittish and difficult to photograph. A better location for shooting pictures of these little mammals is at the intersection of Routes 385 and 87, just north of the park facilities. There is a large turnout there, and the prairie dogs are more used to people.

Heading north on Route 87, you'll pass through another section of Wind Cave National Park. This area is good for bison and especially pronghorn antelope. There is a hiking trail and a fire lookout tower off Route 87; the tower is

open from 8 A.M. to 5 P.M. At the junction of the tower road and Route 87, look for another prairie dog town.

Continuing north on Route 87 takes you into Custer State Park, which has an entrance fee. Here, you'll find the scenic 14-mile-long Needles Highway, as well as an 18-mile-long Wildlife Loop with resident bison, antelope, deer, elk, and prairie dogs.

A 200mm and 300mm lens should suffice at Wind Cave. The animals are used to automobiles and people and will stay within medium-telephoto range. One evening a small group of mule deer was within 10 feet of my vehicle, and a pronghorn antelope was feeding alongside the road on the other side of the car. The gift shop carries Kodachrome 64 and Ektachrome 200 and 400; it also stocks Kodacolor Gold 100, 200, and 400, as well as Ektar 100 and 1000—perhaps for dimly illuminated cave shots.

Accommodations are available in the towns of Custer, Hot Springs, and Rapid City, as are grocery stores, restaurants, and gas stations. Campgrounds are located in Custer State Park, Wind Cave National Park (which has 100 sites), and Black Hills National Forest; there are private campgrounds outside the immediate area, too.

OTHER AREAS
The following is a list of areas that enjoy good reputations for wildlife photography.

British Columbia, Canada
Tourism British Columbia
1-800-663-6000
Humpback and killer whales are found at various locations from the southern coast of Alaska to the northern California border. The best months to visit are July and August.

Bronx Zoo, New York
Southern Boulevard
212-367-1010
This is the largest urban zoo in the United States, and one of the best. It is open all year, but the best time to go is from the spring through the fall.

Chilkat
Bald Eagle Preserve
Visitor's Bureau
Haines, Alaska
1-800-458-3579
This is one of the better places to photograph bald eagles: 3,000 of these birds visit Haines, Alaska, annually. The best month to visit is November.

Churchill, Manitoba
Chamber of Commerce
204-675-2022
This area has the largest concentration of polar bears in the world. The best time to go is from late October through November.

Katmai National Park
King Salmon, Alaska
907-246-3305
The viewing platform at Brooks River is famous for Alaskan brown bears. July is the best month.

Natural Bridges State Park
Department of Parks and Recreation
Santa Cruz, California
408-423-4609
Santa Cruz is one of the few monarch-butterfly wintering areas in the United States. The time period from October through February is best.

RESOURCES

AÑO NUEVO STATE RESERVE
c/o San Mateo Coast District
95 Kelly Avenue
Half Moon Bay, CA 94109
415-879-0595
Reservations: 1-800-444-PARK
Reserve hours: 8 A.M. to sunset
Parking fee: $5.00
Guided-walk fee: $2.00

**ARIZONA-SONORA
DESERT MUSEUM**
2021 North Kinney Road
Tucson, AZ 85743
602-883-1380
Museum hours: 7:30 A.M. to 6 P.M.
 March through September, 8:30 A.M.
 to 5 P.M. October through February
Entrance fee: $6.00

TUCSON CHAMBER OF COMMERCE
Metropolitan Tucson Convention and
 Visitors Bureau
130 South Scott Avenue
Tucson, AZ 85701
602-624-1817

GILBERT RAY CAMPGROUND
Pima County Parks and Recreation
 Department
1204 West Silverlake Road
Tucson, AZ 85713
602-883-4200

CATALINA PARK CAMPGROUND
Arizona State Parks
800 West Washington, Suite 415
Phoenix, AZ 85007
602-628-5798

SAGUARO NATIONAL MONUMENT
3693 South Old Spanish Trail
Tucson, AZ 85730
602-883-6366 (west)
602-296-8576 (east)

SABINO CANYON
5900 North Sabino Canyon Road
Tucson, AZ 85715
602-749-2327

MADERA CANYON
Santa Rita Lodge Nature Resort
Box 5444
Sahuarita, AZ 85629
602-625-8746

TUCSON CAMERA REPAIR
742 Limberlost Drive
Tucson, AZ 85719
602-887-1841

BAJA, MEXICO

SAN DIEGO INTERNATIONAL
VISITOR CENTER
11 Horton Plaza
San Diego, CA 92101
619-236-1212

TIJUANA CHAMBER OF COMMERCE
Tourism Department
Correo Federal Pacific, Apartment 1005
San Ysidro, CA 92073

BAJA EXPEDITIONS (OUTFITTERS)
2625 Garnet Avenue
San Diego, CA 92109
800-843-6967

OCEANIC SOCIETY EXPEDITIONS
(OUTFITTERS)
Fort Mason Center, Building E
San Francisco, CA 94123
415-441-1106

BAXTER STATE PARK HEADQUARTERS AND VISITOR CENTER
64 Balsam Drive
Millinocket, ME 04462
207-723-5140
Park hours: 6 A.M. to 10 P.M.
 May through October
Headquarters and Visitor Center hours:
 8 A.M. to 4:30 P.M. seven days a week
 May through October, 8 A.M. to 4:30
 P.M. Monday through Friday October
 through May
Entrance fee: $8.00
Camping fees: variable

MILLINOCKET CHAMBER OF COMMERCE
P. O. Box 5
Millinocket, ME 04462
207-723-4443

BOMBAY HOOK NATIONAL WILDLIFE REFUGE HEADQUARTERS
Refuge Manager
R. D. #1, Box 147
Smyrna, DE 19977
302-653-9345
Refuge hours: sunrise to sunset
Visitor Center hours: 7:30 A.M. to
 4 P.M. Tuesday through Friday,
 9 A.M. to 5 P.M. weekends (closed
 summer weekends)
Entrance fee: $3.00

KENT COUNTY TOURISM CORPORATION
P. O. Box 576
Dover, DE 19903
1-800-233-KENT

DELAWARE DIVISION OF PARKS AND
 RECREATION (STATE PARKS)
P. O. Box 1401
Dover, DE 19903
302-736-4702

BONAVENTURE ISLAND

TOURIST INFORMATION OFFICE OF PERCÉ
P. O. Box 99
Percé, Québec, Canada O0C 2L0
418-782-5448 (June through October)
418-782-2933 (off season)
Tour boat fare: $10.00

CAMPING BAIE DE PERCÉ (CAMPGROUND)
P. O. Box 86
Percé, Québec G0C 2L0
418-782-2846

TOURISME QUÉBEC (GASPÉSIE GUIDE)
Case Postale 20 000
Québec, Canada G1K 7X2
1-800-363-7777

FORILLON NATIONAL PARK
The Superintendent
P. O. Box 1220
Gaspé, Québec G0C 1R0
418-368-5505

PHOTO CASSIDY, INC.
Gaspé, Québec G0C 1R0
418-368-2011

BOSQUE DEL APACHE NATIONAL WILDLIFE REFUGE (HEADQUARTERS)
P. O. Box 1246
Socorro, NM 87801
505-835-1828
Refuge hours: sunrise to sunset
Visitor Center hours: 7:30 A.M. to 4:30
 P.M. daily in late fall and winter
 (closed weekends in summer)
Entrance fee: $2.00

SOCORRO COUNTY
CHAMBER OF COMMERCE
103 Francisco de Avondo
P. O. Box 743
Socorro, NM 87801
505-835-0424

BRIGANTINE NATIONAL WILDLIFE REFUGE (HEADQUARTERS)

Edwin B. Forsythe
National Wildlife Refuge
Great Creek Road
P. O. Box 72
Oceanville, NJ 08231
609-652-1665
Refuge hours: sunrise to sunset
Headquarters and Visitor Center hours:
8 A.M. to 4 P.M. weekdays in winter
and summer, weekends in spring
and fall
Entrance fee: $3.00 per vehicle

GREATER MAINLAND
CHAMBER OF COMMERCE
927 North Main Street
Pleasantville, NJ 08232
609-646-0777

BASS RIVER STATE FOREST
CAMPGROUND
P. O. Box 118
New Gretna, NJ 08224
609-296-1114

NEW JERSEY DIVISION OF TRAVEL AND
TOURISM (PRIVATE CAMPGROUNDS)
P. O. Box 5289
Clifton, NJ 07012
1-800-JERSEY-7

WHARTON STATE FOREST
Batsto R. D. #4
Hammonton, NJ 08037
609-561-3262

BATSTO VILLAGE
Batsto Historic Site
R. D. #4, Hammonton, NJ 08037
609-561-0024

THE CAMERA SHOP
609-344-4994 (Atlantic City)
609-641-6633 (Mays Landing)

YOUNG PHOTOGRAPHIC
609-645-3505

CHINCOTEAGUE NATIONAL WILDLIFE REFUGE (HEADQUARTERS)

Refuge Manager
P. O. Box 62
Chincoteague, VA 23336
804-336-6122
Visitor Center hours: 9 A.M. to 4 P.M.
Wildlife Loop hours: 3 P.M. to dusk
Entrance fee: $3.00

CHINCOTEAGUE
CHAMBER OF COMMERCE
P. O. Box 258
Chincoteague, VA 23336
804-336-6161

ASSATEAGUE ISLAND NATIONAL SEASHORE
(HEADQUARTERS)
P. O. Box 38
Chincoteague, VA 23336
804-336-6577

ASSATEAGUE STATE PARK
(HEADQUARTERS)
Route 611
7307 Stephen Decatur Highway
Berlin, MD 21811
301-641-2120

DENALI NATIONAL PARK AND PRESERVE (HEADQUARTERS)

Superintendent
P. O. Box 9
Denali National Park, AK 99755
907-683-2294
Park hours: about mid-May to
mid-September
Visitor Center hours:
5:45 A.M. to 8 P.M.
Entrance fee: $3.00 (includes shuttle bus)

DENALI PARK HOTEL
ARA Denali Park Resorts
P. O. Box 87
Denali National Park, AK 99755
907-683-2215 (summer)
907-276-7234 (winter)

WONDER LAKE LODGES
Kantishna Roadhouse
Box 130
Denali National Park, AK 99755
800-942-7420

CAMP DENALI/NORTH FACE LODGE
P. O. Box 67
Denali National Park, AK 99755

HEALY CHAMBER OF COMMERCE
(OUTSIDE LODGING)
P. O. Box 437
Healy, AK 99743
907-683-4636

DEVIL'S TOWER NATIONAL MONUMENT (HEADQUARTERS)
P. O. Box 8
Devil's Tower, WY 82714
307-467-5283
Monument hours: gate open
 24 hours a day
Visitor Center hours: opens at 8 A.M.
 April to November, closing times vary
Entrance fee: $3.00

DING DARLING NATIONAL WILDLIFE REFUGE (HEADQUARTERS)
1 Wildlife Drive
Sanibel, FL 33957
813-472-1100
Refuge hours: sunrise to sunset
Visitor Center hours: 9 A.M. to 5 P.M.
 November through April, 9 A.M. to
 4 P.M. May through October
Wildlife Drive hours: closed Fridays
Entrance fee: $3.00

SANIBEL CHAMBER OF COMMERCE
Box 166
Sanibel, FL 33957
813-472-1080

GREATER FORT MEYERS
CHAMBER OF COMMERCE
P. O. Box 9289
Fort Meyers, FL 33902
813-332-3624

EVERGLADES NATIONAL PARK (HEADQUARTERS)
P. O. Box 279
Homestead, FL 33030
305-247-6211
Park hours: open all year
Entrance fee: $5.00 (good for one week)
Camping fees: $7.00 for drive-in camp-
 sites, $4.00 for walk-in campsites

HOMESTEAD CHAMBER OF COMMERCE
650 U. S. Highway 1
Homestead, FL 33030
305-247-2332

FLAMINGO LODGE (PARK LODGING)
P. O. Box 428
Flamingo, FL 33034
305-253-2241

SHARK VALLEY TRAM
305-221-8455

BISCAYNE NATIONAL PARK
(HEADQUARTERS)
P. O. Box 1369
Homestead, FL 33090
305-247-7275

CORAL ROCK MOTEL
1100 N. Krome Avenue
Homestead, FL 33034

DON RHODES CAMERA AND STUDIO
204 Washington Avenue
Homestead, FL 33030

SOUTHERN PHOTO TECHNICAL SERVICE
14352 Biscayne Boulevard
North Miami, FL 33181
305-949-4566

KLAMATH BASIN NATIONAL WILDLIFE REFUGES (HEADQUARTERS)
Box 74
Tule Lake, CA 96134
916-667-2231
Refuge hours: sunrise to sunset
Visitor Center hours: 8 A.M. to 4:30
 P.M. weekends and holidays
Entrance fee: none

LAVA BEDS NATIONAL MONUMENT
Superintendent
Box 867
Tule Lake, CA 96134

CHAMBER OF COMMERCE
AND VISITORS BUREAU
507 Main, Suite 2
Klamath Falls, OR 97976
503-884-5193

MACHIAS SEAL ISLAND

C/O BARNA AND JOHN NORTON
(BOAT TRIPS)
R. F. D. #11, Box 340
Jonesport, ME 04649
207-497-5933

C/O EDWIN HUNTLEY (BOAT TRIPS)
9 High Street
Lubec, ME 04652
207-733-5584

C/O PRESTON WILCOX (BOAT TRIPS)
Seal Cove
Grand Manan Island,
 N.B. Canada E061X0
Boat-trip fee: $50.00

MORRO BAY

MORRO BAY CHAMBER OF COMMERCE
895 Napa, Suite A1
Morro Bay, CA 93442
805-772-4467

RICHARD R. HANSEN (GUIDE)
P. O. Box 694
Morro Bay, CA 93442
804-772-1705

NATIONAL BISON RANGE (HEADQUARTERS)
Range Manager
Moiese, MT 59824
406-644-2211
Refuge hours: daylight hours
Visitor Center hours: 8 A.M. to 8 P.M.
 daily May through mid-October,
 8 A.M. to 4:30 P.M. Monday to
 Friday in winter
Red Sleep Drive hours: only partially
 open in winter
Entrance fee: none

MISSOULA CHAMBER OF COMMERCE
P. O. Box 7577
Missoula, MT 59807
406-543-6623

OKEFENOKEE NATIONAL WILDLIFE REFUGE (HEADQUARTERS)
Route 2, Box 338
Folkston, GA 31537
912-496-3331
Refuge hours: 8 A.M. to 6 P.M. September to February, 7 A.M. to 7 P.M.
 February to September
Visitor Center hours: 9 A.M. to 5 P.M.
 September to February, 8 A.M. to 4
 P.M. February to September
Entrance fee: $3.00

FOLKSTON-CHARLTON
CHAMBER OF COMMERCE
P. O. Box 756
Folkston, GA 31537
912-496-2536

GEORGIA DEPARTMENT OF NATURAL
RESOURCES (CAMPGROUNDS)
205 Butler Street S.E, Suite 1352
Atlanta, GA 30334
1-800-5GA-PARK

PROVINCETOWN, MASSACHUSETTS

PROVINCETOWN
CHAMBER OF COMMERCE
P. O. Box 1017
Provincetown, MA 02657
508-487-3424

THE DOLPHIN FLEET
(WHALE-WATCHING BOATS)
P. O. Box 162
Eastham, MA 02642
800-826-9300
Boat-trip fee: about $16.00

PROVINCETOWN WHALE WATCH
(WHALE-WATCHING BOATS)
29 Standish Street
Provincetown, MA 02657
1-800-992-9333
Boat-trip fee: about $16.00

PORTUGUESE PRINCESS
(WHALE-WATCHING BOATS)
P. O. Box 1469
Provincetown, MA 02657
508-498-2651
Boat-trip fee: about $16.00

SAN DIEGO WILD ANIMAL PARK

15500 San Pasqual Valley Road
Escondido, CA 92027
619-234-6541
Park hours: opens 9 A.M.
Entrance fee: $14.50 (includes monorail)

PHOTO CARAVAN
15500 San Pasqual Valley Road
Escondido, CA 92027
Reservations: 619-738-5022
Caravan-trip fee: $60.00 short trip,
 $85.00 long trip

SAN DIEGO ZOO

P. O. Box 551
San Diego, CA 92112
619-231-1515
Zoo hours: opens 9 A.M.
Entrance fee: $10.75

SAN DIEGO INTERNATIONAL
VISITOR CENTER
11 Horton Plaza
San Diego, CA 92101
619-236-1212

WICHITA MOUNTAINS WILDLIFE REFUGE (HEADQUARTERS)

Refuge Manager
R. R. #1, Box 448
Indiahoma, OK 73552
405-429-3221
Refuge hours: 8 A.M. to 4:30 P.M.
 Monday through Friday
Visitor Center hours: open weekends only
 March to November
Entrance fee: none

WIND CAVE NATIONAL PARK (HEADQUARTERS)

R. R. 1, Box 190-WCNP
Hot Springs, SD 57747
605-745-4600
Park hours: open all year
Visitor Center hours: 8 A.M. to 5 P.M.
Entrance fee: none

CUSTER STATE PARK
H. C. 83, Box 70
Custer, SD 57730
605-255-4515
Entrance fee: $6.00

YELLOWSTONE NATIONAL PARK (HEADQUARTERS)

P. O. Box 168
Yellowstone National Park,
 WY 82190
307-344-7381
Park hours: open all year
 (with winter road restrictions)
Visitor Center hours: only Mammoth
 Hot Springs is open all year
 (check with the Park Service for other
 centers' hours)
Entrance fee: $10.00
 (good for one week)

TW RECREATIONAL SERVICES, INC.
(ACCOMMODATIONS)
Yellowstone National Park,
 WY 82190
307-344-7311

BRIDGE BAY RV PARK
Ticketron
Box 617516
Chicago, IL 60661
1-800-452-1111

WEST YELLOWSTONE
CHAMBER OF COMMERCE
Box 458
West Yellowstone, MT 59758
406-646-7701

f11 CAMERA
16 East Main Street
Bozeman, MT 59715
406-586-3281

INDEX